Unexpected Chicagoland

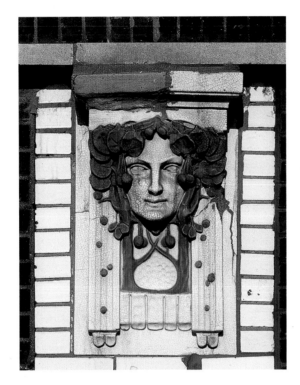

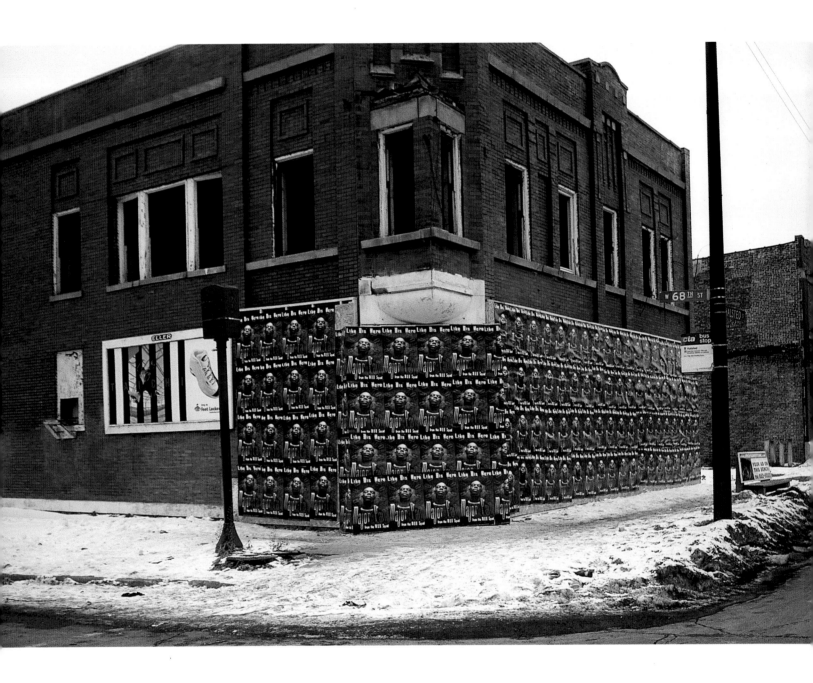

Unexpected Chicagoland

Camilo José Vergara and Timothy J. Samuelson

The New Press

New York

Unexpected Chicagoland was supported by generous grants
from the Richard H. Driehaus Foundation and the
Graham Foundation for Advanced Studies in the Fine Arts.

Published in the United States by The New Press, New York, 2001

Distributed by W. W. Norton & Company, Inc., New York

ISBN 1-56584-701-6 (hc.)

CIP data available.

The New Press was established in 1990 as a not-for-profit alternative to the large, commercial publishing
houses currently dominating the book publishing industry. The New Press operates in the public interest
rather than for private gain, and is committed to publishing, in innovative ways, works of educational,
cultural, and community value that are often deemed insufficiently profitable.

The New Press, 450 West 41st Street, 6th floor, New York, NY 10036

www.thenewpress.com

Designed by Thomas Whitridge, Ink, Inc., New York

Printed in China

10 9 8 7 6 5 4 3 2 1

ON FIRST PAGE Realistic face with a decorative, cascading crown of green leaves, characteristic of the Arts and Crafts movement. For Samuelson, decorations such as this are "a way to create a sense of beauty and dignity at low cost." Building on Ogden Avenue, west of Trumbull Avenue, Chicago, 2001.

FRONTISPIECE Wrapping around an abandoned corner building in Englewood, posters for the hip hop artist Major Pain form an art installation waiting to be discovered: the posters' colors match the dark red brick and the wall of multiplied faces gives the building life. Northwest corner of Halsted Avenue and 68th Street, 2001.

OPPOSITE Sullivanesque decorations, corner building. The Midland Terra-cotta Company supplied the pieces that the architects and builders fit together in this crosslike shape. This medallion is one of the most popular catalogue ornamentation pieces in Chicago; it can be found in commercial streets throughout the city. Cicero Avenue and Cornelia Avenue, Chicago, 2000.

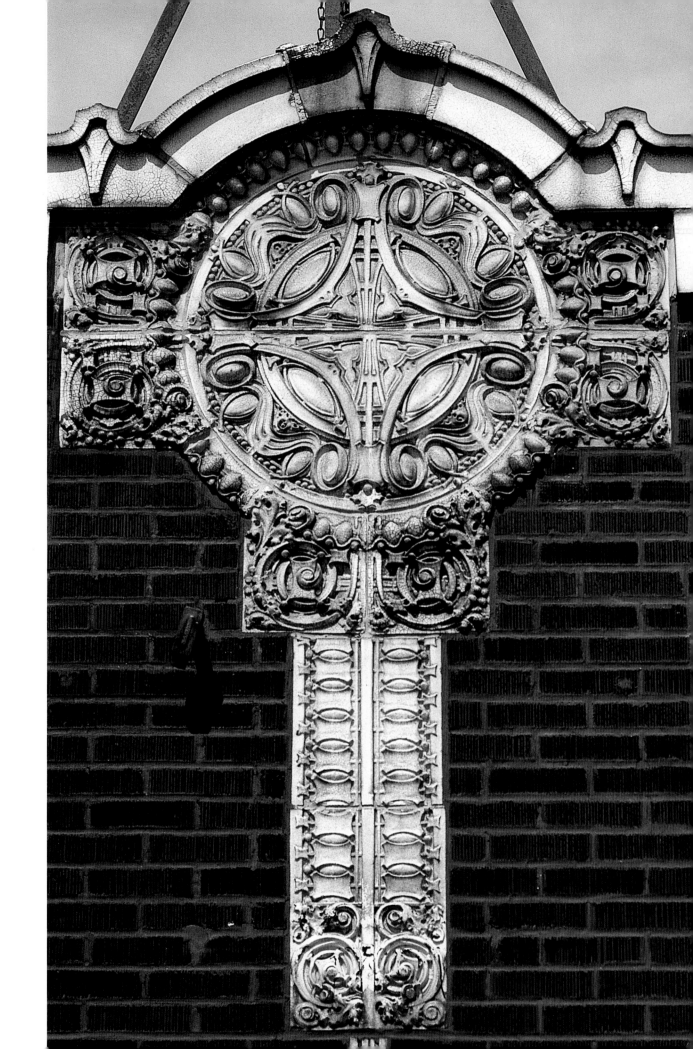

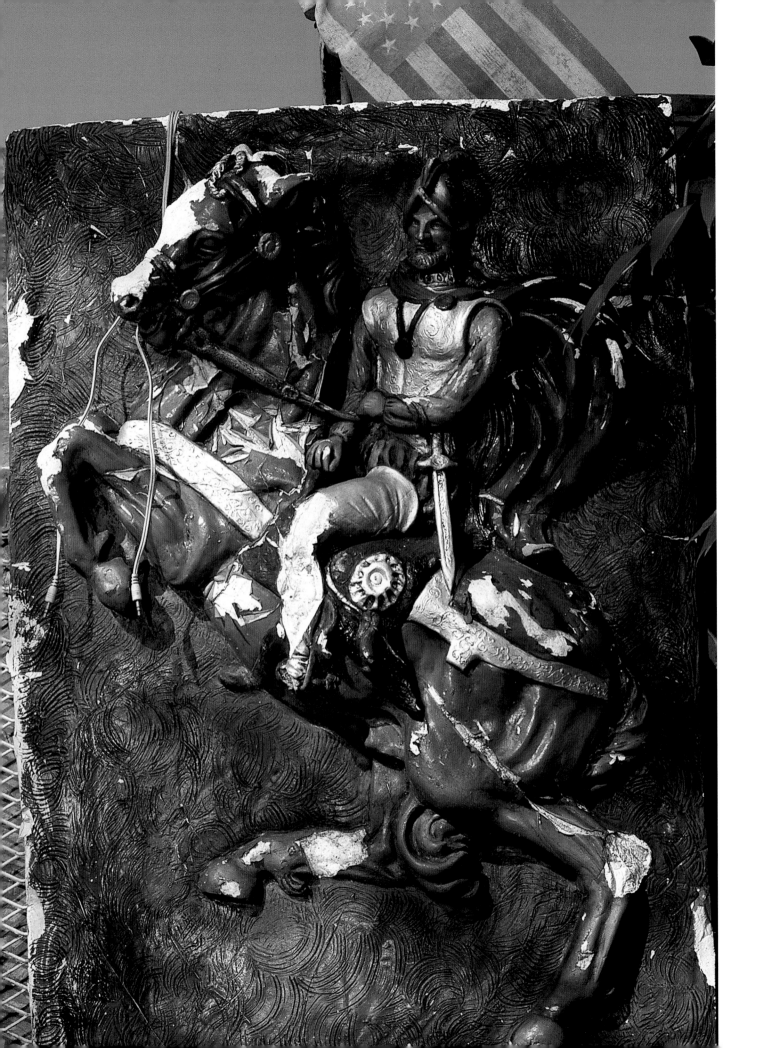

To my dear children
Charles Anthony Vergara and Virginia Inés Vergara

OPPOSITE Damaged relief of a Spanish conquistador going into
battle on a chipped horse, against a background of black smoke.
Behind the relief is a metal American flag beat out of shape, its
colors fading. The ornament was displayed in Archie Humbert's Holy
Garden, at Star Auto Wreckers, among religious statues gathered
from abandoned Catholic churches. The site is now empty, awaiting
development. State Street at 63rd Street, Chicago, 1998.

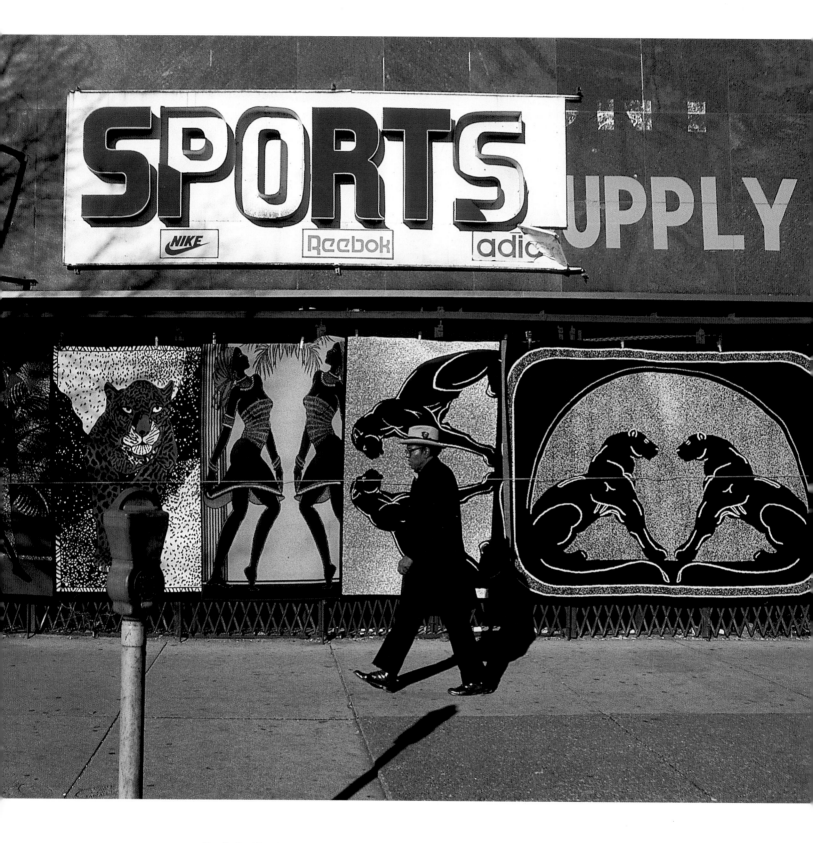

Rug display. West Madison Street by Pulaski Road. Chicago, 1999.

Contents

Foreword

Chicago is quietly losing local landmarks. With few questions and little fanfare, the combined effects of time, weather, neglect, and finances are pulling apart buildings that have lost their voices. This is an important time in Chicago history, as rapid developments begin with a blank slate without anyone asking how the future can be integrated into the past.

We know very little about the remaining fragments of quiet neighborhood structures that serve to mark a time and place. Camilo José Vergara and Timothy J. Samuelson's work helps to push these forgotten places into focus by giving the pieces of urban fabric a name and a story. Through the authors, the once-quiet buildings speak, telling us who has been there and what they have seen.

Weaving together both past and present stories of people whose lives are intertwined in the architecture, Vergara and Samuelson remind us that ordinary structures are extraordinary because of the roles they have played in the changing lives of people. *Unexpected Chicagoland* captures this ephemeral landscape through images and stories, and fights against our tendency to forget who and what was once there.

Vergara's practiced eye and Samuelson's deep knowledge provide a new lens to view the region's cultural and built environment. The Chicago Architecture Foundation is proud to be part of this collaboration.

Bonita C. Mall
Vice President of Programs and Tours
Chicago Architecture Foundation

OPPOSITE Ceiling light, elevator cab, Cabrini-Green Homes. The amber look of the plastic covering is the result of vandalism. Residents burn the material, dimming the light. 1159 North Larrabee Street, Chicago, 1998.

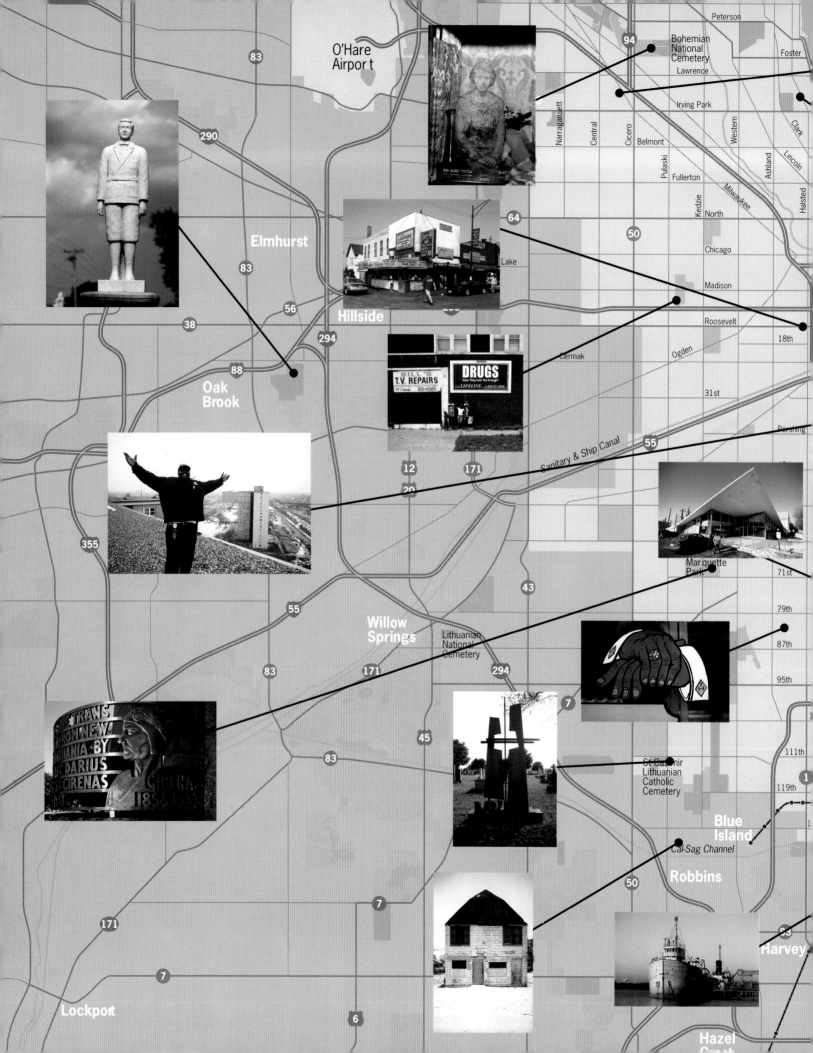

O'Hare
Airport

Peterson

Bohemian
National
Cemetery

Foster

Lawrence

Lawrence

94

Irving Park

Narragansett

Central

Cicero

Belmont

Western

Ashland

Clark

Lincoln

Halsted

Pulaski

Fullerton

Kedzie

North

Milwaukee

290

64

Chicago

50

Madison

Roosevelt

18th

Elmhurst

83

56

Lake

Hillside

Cermak

Ogden

31st

38

294

88

Oak
Brook

Pershing

55

Sanitary & Ship Canal

12

171

20

355

43

Marquette
Park

71st

79th

55

Willow
Springs

Lithuanian
National
Cemetery

83

171

294

87th

95th

7

45

83

St Casimir
Lithuanian
Catholic
Cemetery

111th

119th

Blue
Island

Cal-Sag Channel

50

Robbins

171

7

Harvey

7

Lockport

6

Hazel
Crest

Lake Michigan

Loop

Cottage Grove

South Chicago

Yates

Stony Island

90

Chicago Skyway

91

94

Torrence

Ave O

Indianapolis Blvd

Lake
Calumet

Whiting

Marktown

130th

Brainard

East
Chicago

Calumet
City

Gary

State

Hammond

5th Ave

Broadway

6

ILLINOIS
INDIANA

94 80

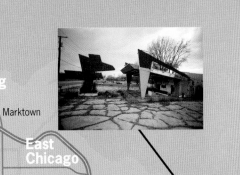

65

12

94

20

80 90

Portage

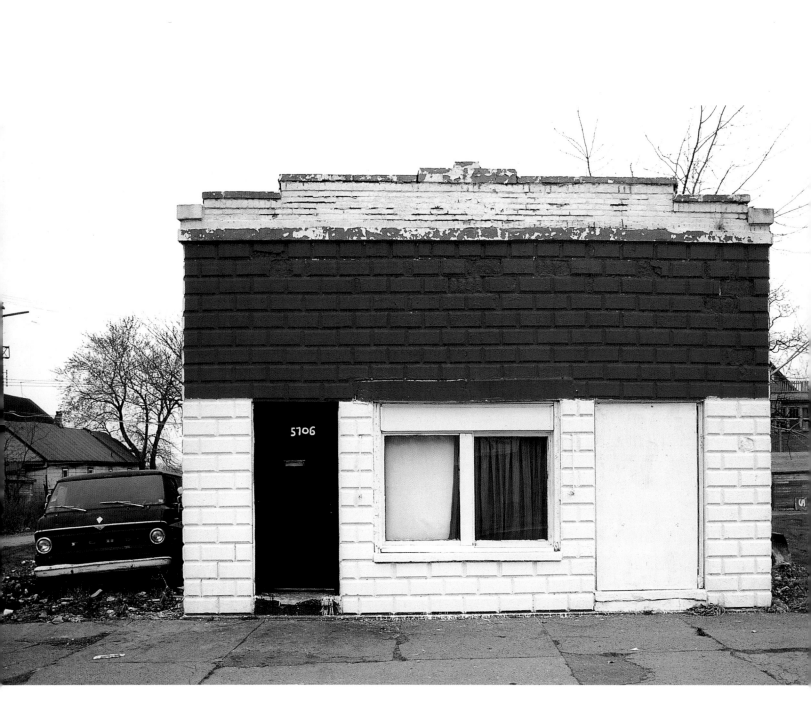

Preface

Over the course of four decades, Tim Samuelson and I have been observing the older manufacturing and commercial sections of the Chicago metropolitan region. This territory extends as far east as Benton Harbor, Michigan, and as far south as Gary, Indiana. We watched as the region fell more deeply into obscurity and decline. Now, we celebrate the fading grandeur of "the old heart of the country," the "world's industrial capital," the glow of what was once considered "America uncontaminated." *Unexpected Chicagoland* documents the effects of time, technology, commercialism, traditional culture, and disinvestment on a built environment now gone gritty.

This project emerged from a previous collaboration between us. Samuelson directed the selection of two hundred of my photographs for the Chicago Historical Society, purchased through an initial grant from the Richard H. Driehaus Foundation. Later, when I asked Samuelson to review the Chicago entries for my book *American Ruins* (1999), he sometimes added entire paragraphs, often including vivid stories. This book is much more of a collaboration. I have written, edited, and illustrated the text with my photographs, but *Unexpected Chicagoland* could only have taken shape via our continuous dialogue.

SAMUELSON

I wanted to see Chicagoland through Tim Samuelson's eyes, to listen to his stories, to see his arms go up as if he were playing magic tricks, and to share his childlike enjoyment of buildings as well as his scholarly expertise. People, trades,

OPPOSITE Once a storefront, the facade of this dwelling, with its starkly bold palette and arrangement of rectangles, reveals a modernist sensibility where one would hardly expect it—in a drab, run-down neighborhood. The house stood at 5706 South State Street, Chicago, 1986.

RIGHT Tim Samuelson describing the interior of the Meyercord Company office. 5323 West Lake Street, Chicago, 2000.

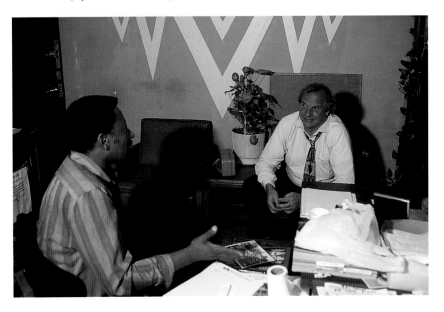

ABOVE Northeast corner of West Madison Street and Western Avenue, Chicago, 1989.

LEFT Northeast corner of West Madison Street and Western Avenue. After this photograph was taken, a sign appeared announcing the coming of a Walgreens drugstore. Chicago, 1994.

materials, and practices come newly alive for me in his descriptions. Going beyond physical design and biographies of architects, his interests encompass myriad social relations that shape the urban environment. Following Tim around, I took notes, formulated questions, and composed images in my mind to later photograph and then arrange on a page. With Tim along, I attached more meaning to places. Why was a grown man in a business suit getting so excited about these buildings? "It is an aesthetic thing: a building that I find pleasing and a historical basis that enhances the aesthetics," he said. But that was not all. To him, "many of these buildings represent twists of fortune, buildings that have changed in their uses in their journey through time. Buildings that had been put on a pedestal by architectural historians, but that have been humbled."

Tim, a pedestrian and a user of public transportation, had "to get off the bus" when he visited buildings. He walked around the sites, talked to people, and returned to visit them again. He had to see all this from the perspective of somebody on the street, not through the windshield of a car.

When Tim looks at a building, he pictures it as it was when it was new, then as it grew old, and sometimes as it became abandoned and was even demolished. He looks behind layers of paint to find the original colors, and, searching for pieces of decoration, he rummages through the debris now filling basements of demolished structures. Tim has probably witnessed more demolitions, board-ups, and burnings of notable edifices in the Chicago area than anybody else.

"Buildings transmit very strong feelings to me," Samuelson explained. "I have gone through my whole life finding buildings that are outcasts and getting the energy out of them. I do this to satisfy and to amuse myself."

Original stone ornament peeks through modern siding on a classical-style commercial building. 4034 West Madison Street, Chicago, 2000.

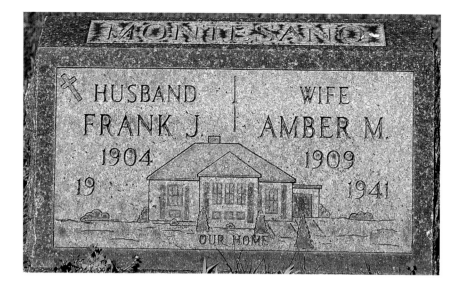

THE CITY'S RUSTY HEART

We are middle-aged, Tim born and raised in Chicago, I growing up in a small town at the southern end of the world. Yet we both are moved by Chicagoland's Rust Belt, with its enormous factories and once-prosperous commercial buildings.

What gives cohesion to this book is the intensity of our memories. We have collected images that persist in our minds, pieces of our dreams and obsessions, chosen because of the power they have over our imaginations and because we believe they will resonate in those of others. We see billboards announcing plans for artist colonies and coffeehouses, but they seldom materialize. We follow efforts to preserve buildings and commercial blocks, and even entire industrial areas, such as the planned community of Pullman. We have spoken to public officials who are searching for funds to wipe out the remains of the old, hoping to bring in new life. The same section of Hammond, Indiana, has been variously described as "a God-forsaken place," "an obsolete section of downtown," or "an underutilized area, an urban renewal area, and an arts and entertainment district." Local residents see many of the buildings and objects included in this book as eyesores that should be demolished.

There is no longer any need for people to live in ethnic bastions, but we found strong expressions of ethnicity preserved in cemeteries. Unlike the neighborhood, the cemetery is a destination. Says Samuelson: "Nobody is going to be moving out, and the rest of the family is there. People come back to the cemetery. They are not going to visit their former neighborhoods, the businesses they grew up with are gone, their friends have died or moved away, and the new residents make them feel uneasy, but the cemetery has continuity; everybody is there." Samuelson suggests, for example, that for Lithuanians, visiting their cemeteries is like visiting the old neighborhood. They tend their family graves and walk around the grounds, visiting the graves of other people they knew.

Does an understanding of Chicagoland have to begin in Europe? Yes and no. Immigrants brought their cultures with them and adapted them to the new sur-

Simple marker with image of a bungalow inscribed "Our Home," 1941. Montesano plot, Oakridge Cemetery, Westchester, Illinois, 1986.

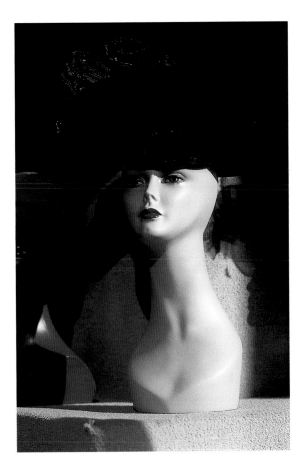

A display of hats at E. M. Fashions included this long-necked mannequin. The black felt hat was topped with material resembling dragonfly wings. 3952 West Madison Street, Chicago, 1999.

roundings. Old World forms were often replicated on a larger scale, used for different functions, placed in different contexts, and built using new materials, thus transforming their meanings.

Yet vernacular forms such as motels, fast-food franchises, road signs, and futuristic ruins have only remote links to Europe. A certain kind of hardheaded practicality seems peculiar to Chicago. And the commercial, political, and religious art of the ghettos would certainly look out of place on the walls of foreign cities. In addition, Chicagoland is defined by the inimitable work of its famous architects.

Then there are the urban environments described by writers such as Nelson Algren, Jane Addams, and Studs Terkel, on the one hand, and those of architectural historians on the other. These descriptions seldom merge. The former group thrives on the everyday and the ordinary, the latter on urban environments of distinction. One is mostly concerned with life as lived in the buildings, the other with the buildings themselves. In *Unexpected Chicagoland*, we hope to reconcile these different points of view.

During the 1920s and 1930s, painters Charles Burchfield and Charles Sheeler and photographer Walker Evans were attracted to urban scenes like those that today are left behind. But the meaning of these places, of course, has changed dramatically since then: smokestacks have stopped belching, some factories are half demolished and others completely gone, steel bridges and cargo boats have acquired a thick patina of rust.

Our knowledge of the Chicago region has been developing long enough for us to become fond of its offbeat features. We have selected houses, factories, churches, motels, office buildings, bridges, signs, and funerary monuments, some more than a century old, others relatively new. We include examples of rarely seen work by some of the greatest architects who worked in the Chicago area: Louis Sullivan, Frank Lloyd Wright, and Walter Burley Griffin. We nevertheless have stayed away from the city's familiar architectural icons, instead selecting historically and visually revealing structures from the low-income urban fringes.

Yet social justice is not our main theme. We believe that schools should be places of learning, located in good, comfortable buildings; hospitals should provide quality care; the police should be visible and respond quickly to danger; sanitation departments should pick up garbage. Basic needs such as clothing and food need to be provided for, and people should have access to meaningful jobs. It is tragic that this is not happening. Some may consider it frivolous that we limit our focus to the interaction of identity, memory, and architecture. But the ghosts of deindustrialization have power over our imaginations and we decided to follow their lead.

Our mission is a reverse search for El Dorado: in places that once were seen as the promised land, we search for the debris of history. Walter Benjamin's analysis of the Paris Arcades, *The Arcades Project*, has been a source of inspiration for us. Like him, we seek "the world of industrial objects as fossils, as the trace of living history that can be read from the surfaces of the surviving objects," "the stuff of childhood memories," "residues of a dream world," "the objects that have begun to be extinct," "things that are freed from the drudgery of being useful." "[In the Arcades] we relive, as in a dream, the life of our parents and grandparents." The past haunts

the present. As Benjamin's interpreter Susan Buck-Morss writes in *The Dialectics of Seeing:* "In the era of industrial culture, consciousness exists in a mythic dream state, against which historical knowledge is the only antidote. But the particular kind of historical knowledge that is needed to free the present from myth is not easily uncovered. Discarded and forgotten, it lies buried within surviving culture, remaining invisible precisely because it was of such little use to those in power."

The leftovers that we have drawn attention to in *Unexpected Chicagoland* might be thought of as fragments of an American Atlantis that many have given up. It is our hope that through these images and our commentary, readers can begin to reconnect to a world of symbols that has become distant and almost forgotten.

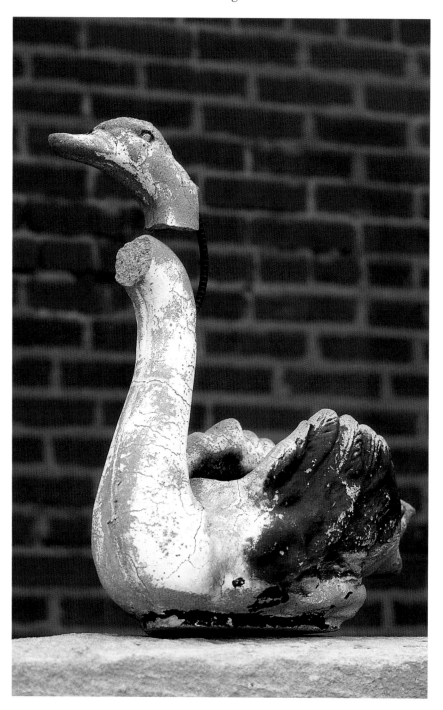

Planter shaped like a swan, with its neck broken. Such planters are popular in Chicago. This one has become the emblem of the Fourth Ward Department of Streets and Sanitation. Cottage Grove Avenue near 44th Street, Chicago, 1998.

Unexpected Chicagoland

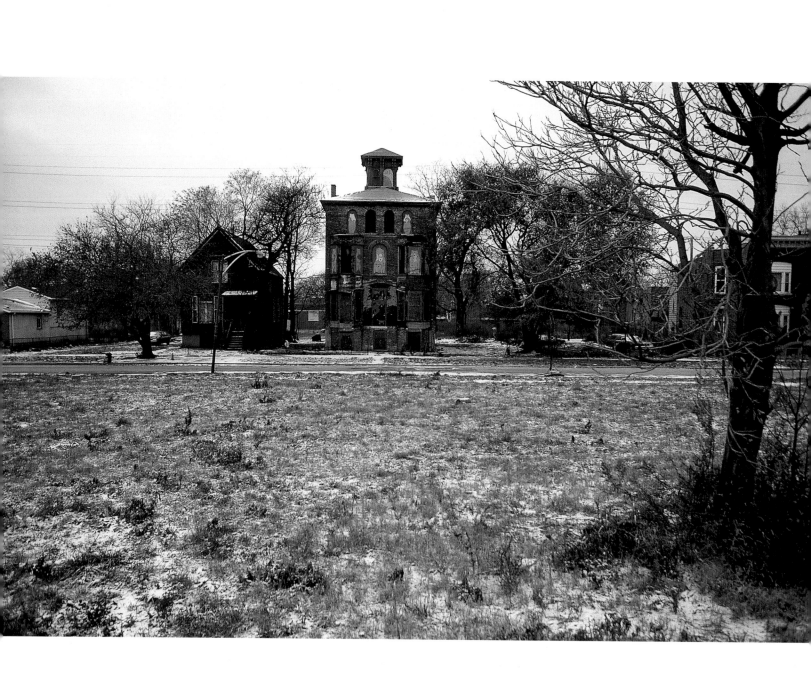

Nineteenth-Century Survivors

*Raber House, 1870, now the Fishbowl House,
stranded on the South Side of Chicago*

Built originally as an isolated country house, it was eventually surrounded by the city but now stands alone again. In the 1890s, the cupola was removed to make way for an extra story and reset on its new base. Bay windows were installed at the same time. The Raber House resembles the haunted houses Charles Addams made famous in his cartoons.

In a 1874 description by Everett Chamberlin, the Raber House is seen as "the most attractive and home like residence in the village. As will be seen, the house stands in the center of handsomely arranged grounds, consisting of six acres, and although the building itself is not remarkable for its beauty, its surroundings are such as to render the general view very inviting. Within the enclosure are finely graveled walks and drives, bordered with beautiful arbor vitae hedges. Miniature lakes, filled with gold-fishes and other pleasing features, are to be met at every hand.... The premises are considered worth $75,000 at the present time."

Architect Graham Shane, upon seeing a photograph of the mansion, was surprised by the view of an early Victorian house rising in the middle of an overgrown lot. The house, he said, is of the type that ship captains built by the ocean in New England. The cupola is where captains' wives would go to look out for their husbands away at sea. He admires the brickwork and comments that in Maine such houses would be built out of wood.

Now the Raber House is boarded up. The house has lost its porch; it once had stairs going down for the servants and up for the owners. As a community beautification project, fish were painted on the boards. A neighbor calls the Raber House "spooky" and would like "to see them do something about it." Samuelson has a line drawing of the building back when it had a garden and a fishpond. "Now the fish are in the windows," he observes.

OPPOSITE Raber House in winter. Some of the boards have fallen off the building and the rest are fading. 5760 South Lafayette Avenue, Chicago, 2000.

BELOW LEFT Raber House before the addition of bay windows and an extra story, seen in an 1870 illustration in *Chicago and Its Suburbs* by Everett Chamberlin.

BELOW RIGHT A painting of a scuba diver welcomes passersby to the Raber House, also known as the Fishbowl House.

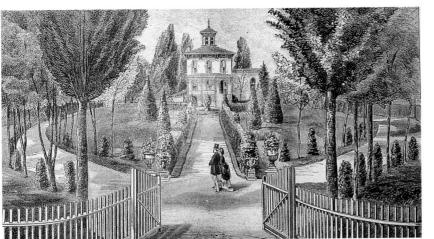

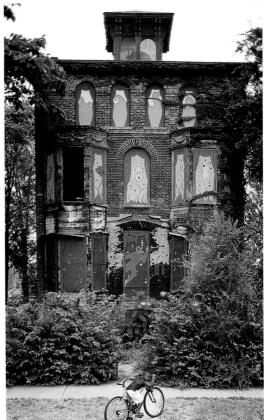

Muddy Waters House, South Side, Chicago, 1889
Here is a house that was sitting in limbo for about four years. The estate of Muddy Waters was trying to sell it to a family member. The building was wide open, and the estate could not adequately watch over it or protect the nineteenth-century interior features. Twice while Samuelson worked for the city, it appeared on the demolition list.

Local activists, afraid that the house would be torn down, stabilized it, fixed the roof, and cleaned out the litter and debris. To attract attention to the building and make the neighbors more inclined to defend it, they hired an artist to paint the boards sealing the windows with scenes from the family life of Muddy Waters. Now the house is again a focus of neighborhood pride, and the city has far less of an incentive to demolish it. This unusual approach has bought time:

Nineteenth-century house once owned by the legendary blues singer Muddy Waters. 4339 South Lake Park Avenue, Chicago, 1964. Photograph by Sigmund J. Osty, courtesy of the Chicago Historical Society.

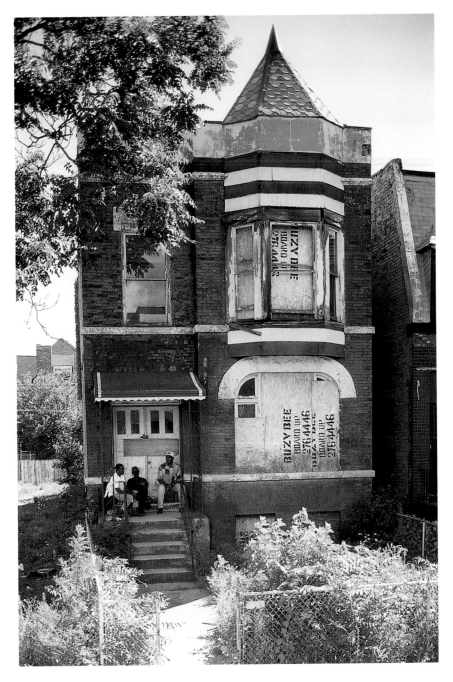

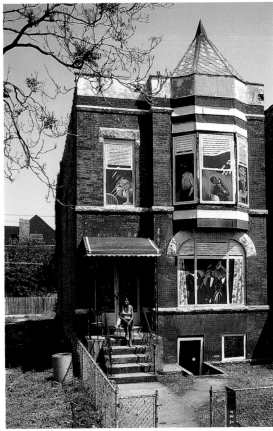

until the murals fade and the boards warp and fall, the house will be less vulnerable to arson, squatters, and the elements. And when restoration becomes possible, the new owners are likely to find a house that will be less expensive to rehabilitate.

The Muddy Waters house presents a problem. Should it be restored to its nineteenth-century form? Or should it preserve the improvements that its celebrated owner added in the 1960s: a wooden panel over the door, a metal canopy, and sheet metal on the bay windows?

Neo-Gothic entrance, a fragment of a Louis Sullivan building from 1891

Fragments have power. "It is like finding a beautiful leaf pressed and dried inside an old book. It may not give the idea of the whole tree, but it is beautiful in itself," says Tim Samuelson. Others are untouched by its appeal. An employee of the Erotic Warehouse, the company that now occupies the building to which the entrance is attached, walks by it every day.

He expressed surprise to know that he had been passing by an architectural gem without ever noticing it. Samuelson, a believer that great architecture has an impact on ordinary people, comments, "A little element like that wouldn't impact on everyone," adding that the former occupants of the building were aware of the entrance.

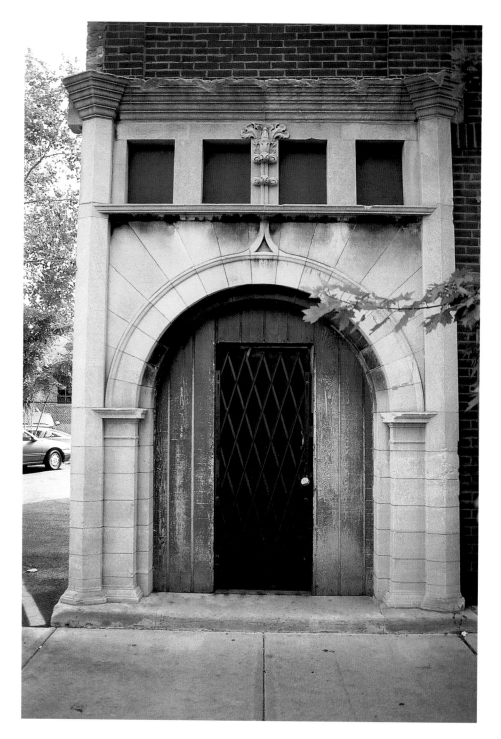

Entrance to long-demolished apartment building, designed by Adler & Sullivan, now part of the Erotic Warehouse, an adult bookstore. The original arched entrance was narrowed by additions to accommodate a security door. Elizabeth Street north of Randolph Street, Chicago, 2000.

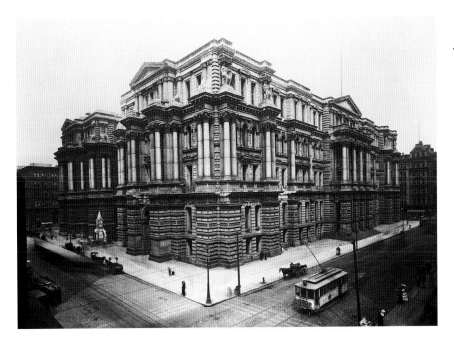

Neo-Gothic monument with a bronze statue of the youthful Christopher Columbus cast in Rome, South Chicago, 1892

"The Discoverer of America, 1492" is inscribed on this statue of Columbus shown planning his expedition. I am surprised by the figure's melancholic expression and unheroic stance. Youthful and brooding, the figure stood in front of City Hall until 1906, when the space it occupied was taken over by a building. The ice water fountain that the statue decorates was a public donation to the city of Chicago by John B. Drake in 1892, at the time of the World Columbian Exposition.

In an old industrial neighborhood such as South Chicago, one would expect to find a war memorial: a tank, a piece of artillery, or a doughboy, not an elaborate stone monument in the Gothic style, with a bronze life-size figure dressed in Renaissance garb. Neighborhood residents are barely aware of the presence of the statue of the navigator. It stands on a corner crisscrossed by wires, among lampposts and heavy trucks, on a heavily traveled avenue. I am reminded of the Austrian writer Robert Musil's observation, quoted in "The Visibility of Monuments": "There is nothing in this world as invisible as a monument. They are no doubt erected to be seen—indeed to attract attention. But at the same time they are impregnated with something that repels attention, causing the glance to roll off, like water droplets off an oilcloth, without even pausing for a moment."

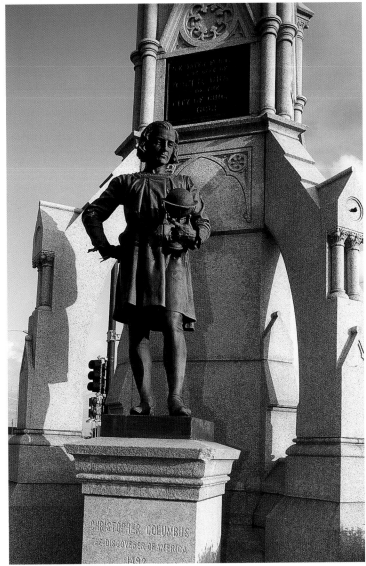

ABOVE Chicago City Hall–Cook County Courthouse on public square surrounded by LaSalle, Randolph, Clark, and Washington Streets. J. J. Egan, architect (photo ca. 1892). Historical photo. On the left, dwarfed by the grand public building, is the ice-water fountain with the statue of Christopher Columbus. Courtesy of the Chicago Historical Society.

OPPOSITE Ice-water fountain with a statue of Christopher Columbus, a gift to the city of Chicago by John B. Drake in 1892. I am surprised to find this well-wrought statue of Columbus exiled from the center of the city. Once an unshakable hero, the explorer is regarded with ambivalence today, his discovery renamed an encounter. Yet this is no revisionist statue. The figure reminds me of Hamlet pondering Yorick's skull—here, the globe. Intersection of Commercial and South Chicago Avenues, Chicago, 1999.

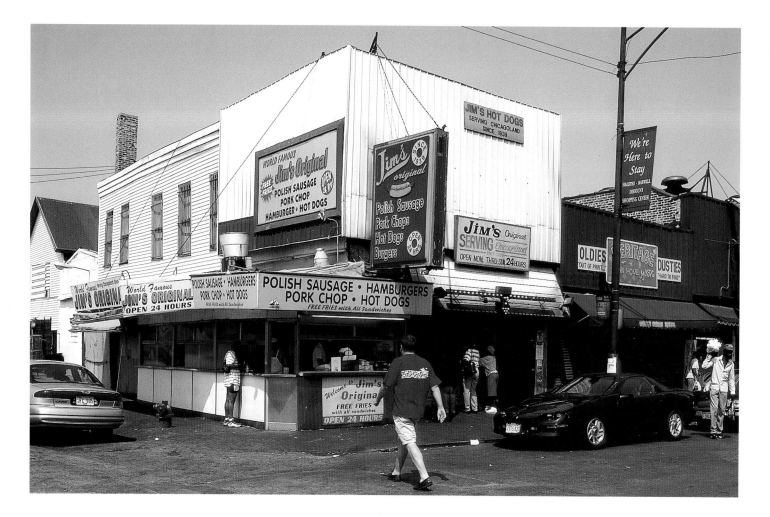

Jim's Original on Maxwell Street, Chicago,
"World Famous Since 1939"

Jim's is a little place that offers good food in what
began as an unpretentious Chicago cottage dating
from the 1870s. For generations, patrons have
declared, "This is the place to get a hot dog." Even
blindfolded, you could find Jim's by following the
smell of onions cooking. In small towns in Illinois
and Indiana, Jim's symbolizes the Chicago hot dog.

Much of the Maxwell Street area has been demol-
ished to make room for buildings and facilities for
the University of Illinois Chicago Circle Campus,
and the condemnation of buildings continues.
George, the manager of Jim's, tells me: "We are
staying here, there is no change. We have been at the
site for seventeen years." Professor Marshall
Berman comments, "The schmucks [the University
of Illinois] don't realize this is a treasure."

Jim's Original Hot Dogs,
northwest corner of Maxwell
Street and Halsted Street. The
structure, an original Chicago
cottage from the 1870s, has
been covered over after
extensive remodeling. Chicago,
2000.

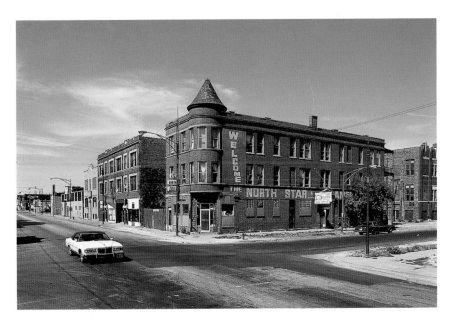

Turrets commanding the corner

Turrets enlarge a building's space and, extending over the street, offer a view of what transpires outside. They are common in Chicago because such a large percentage of the city's buildings date from the late nineteenth century, when these forms were popular. Interest in them declined as people turned away from Victorianism as being old-fashioned. New styles meant simplified forms. Furthermore, when the city decreed at the beginning of the twentieth century that any structure that encroached on the public domain had to be taxed, turrets became more costly. Even now, people with preservationist inclinations find it too expensive to replace the sheet metal details that wrapped around turrets.

Turrets were built at a time when labor and materials were inexpensive, and skilled carpenters could coax wood into shapes that gave buildings interesting profiles and a place for rich details. Nowadays, the challenge is to find an inexpensive way to reclad a round or octagonal surface. The material best suited for turrets is galvanized iron, but it rusts. To cover the rust, building owners have to improvise, using shingles, tar paper, and sheet metal, sometimes leaving the old material visible underneath the new coverings. Some people paint the decorative sheets green to make them look like oxidized copper; others give up struggling to approach the original design. Instead, they nail down roofing paper or plain pieces of metal on their turrets and change the shapes and sizes of the windows.

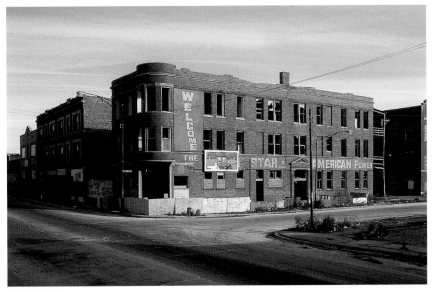

The North Star American Power building was of the type that defined solid, comfortable mixed-use construction in Chicago. A corner brick building with a turret, its most distinguishing features were its grandiose name and the word "Welcome" painted in two-foot-high gold letters across the facade.

ABOVE The North Star American Power building. This structure once housed the North Star Fish and Meat Market run by an old preacher and a place that, as its sign notes, gives "free clothing for the needy daily." Northeast corner of Pulaski Road and 13th Street, Chicago, 1988.

MIDDLE The abandoned North Star American Power building, its tower long gone. Chicago, 1994.

BELOW Empty lot left after the North Star American Power building was demolished. Chicago, 2000.

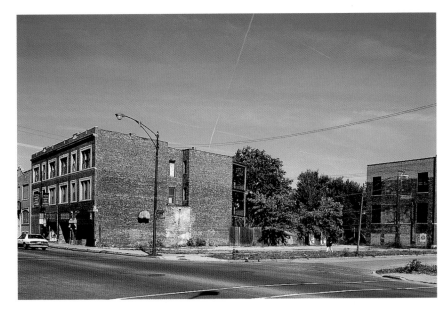

Ironically, in 1988, the building suggested the opposite of North Star American Power; it housed a free clothing distribution center for the needy and a fish market run by an old preacher. Even those uses were soon forgotten after the building was torn down sometime between 1994 and 2000. A woman at Petty's Exterminating, a block south, recently told me: "I don't remember a fish market or a tower or a place that would give away clothes."

Turrets give presence to a corner and provide a place to see down two streets. For architect Graham Shane, their disappearance represents the breakdown of the block. Although they are a very powerful architectural element, few modern architects ever use turrets. They are relegated to the realm of retro.

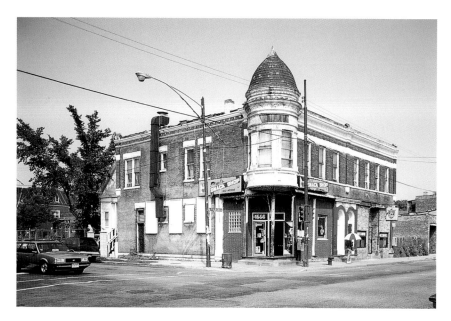

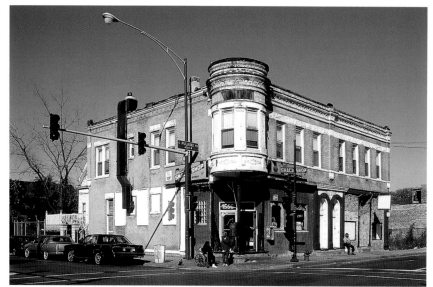

ABOVE Originally a drugstore, Paul's Snack Shop had a turret in need of repair. According to the owner, Paul Shields, actress Kim Novak grew up in this building and attended nearby Penn Elementary School. 1556 South Pulaski Road, Chicago, 1993.

Paul Shields, a Chicago policeman for thirty years, had a tower over his store, Paul's Snack Shop, but, faced with expensive repairs and no financial help from the city, he decided to "make it flat." Shields tells me that losing the tower "does not make a difference." His associate, Arthur Williams, explains why the tower was taken down: "There was a crack and the pigeons had started nesting there, you could hear them. He [Shields] could have fixed it, but he said, 'Let it go.' See, people who stand down there [at the entrance], and also people coming to the restaurant, would get shit on their heads." Chicago, 2000.

House with repaired tower. Northeast corner of St. Lawrence Avenue and 42nd Street, Chicago, 2000.

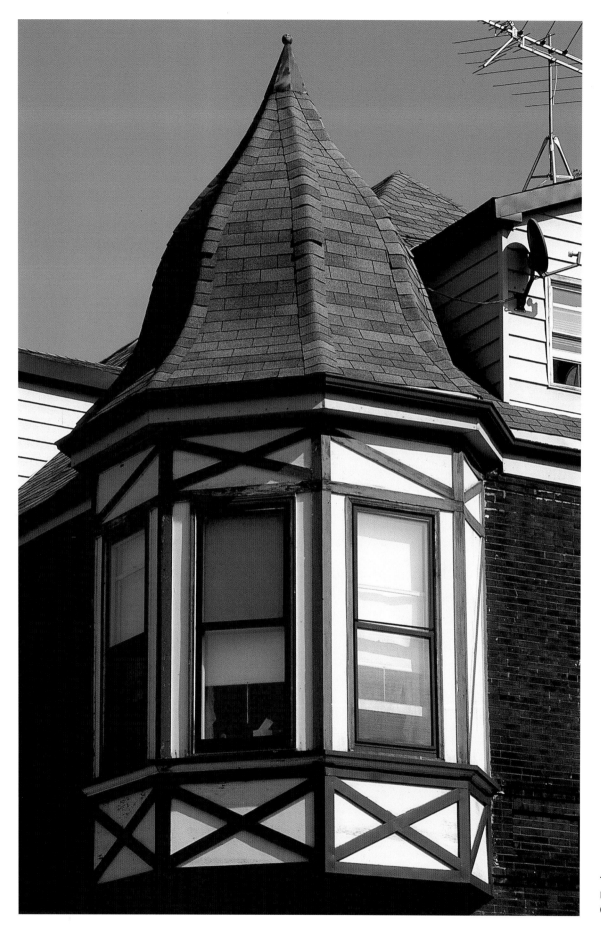

Tudor tower. 8501 South
Brandon Avenue, South
Chicago, 2000.

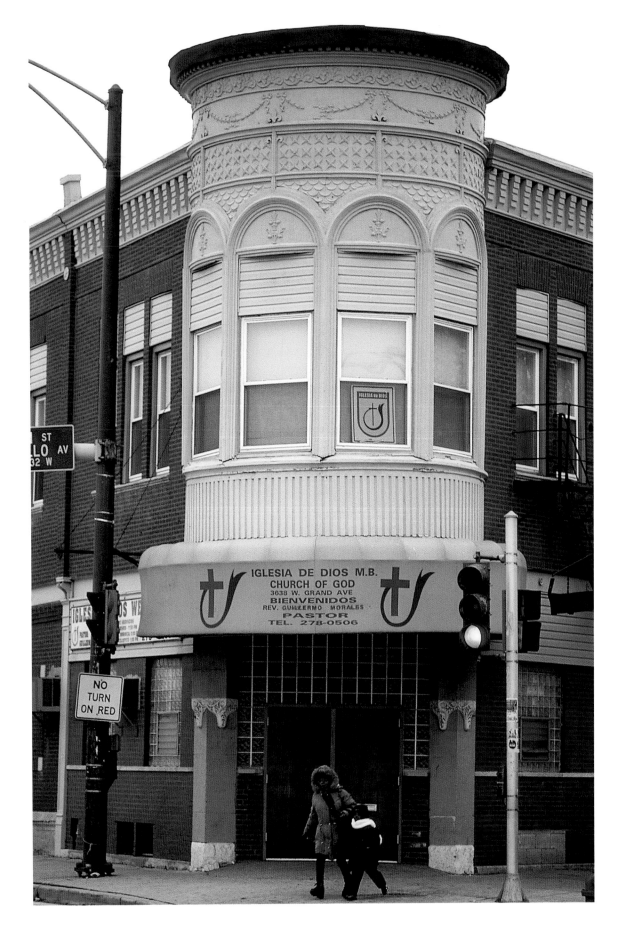

Tower, Iglesia de Dios M. B.
3638 West Grand Avenue,
Chicago, 2000.

Turret covered with shingles.
Southeast corner of 75th Street
and Dobson Avenue, Chicago,
2000.

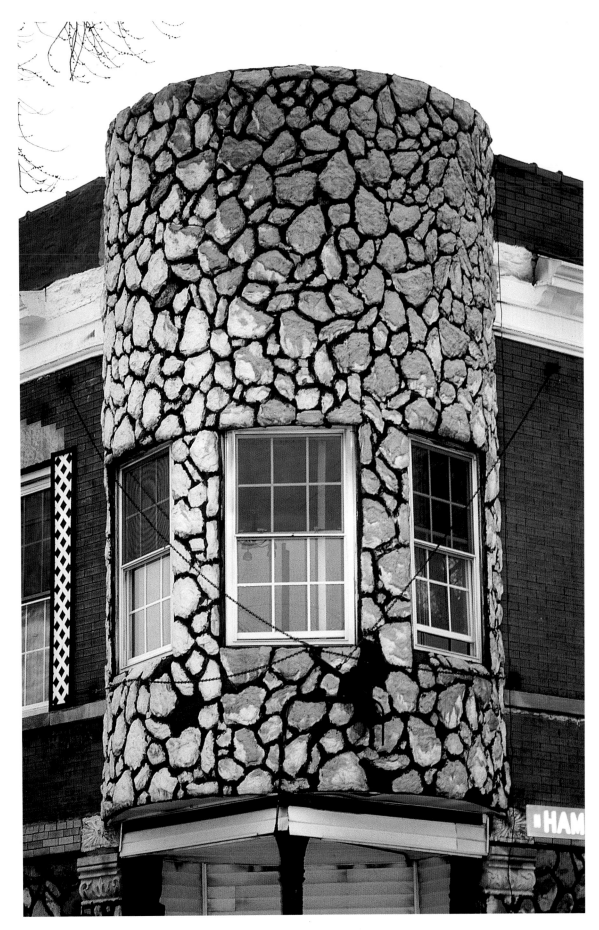

Turret covered with artificial stone siding. To Samuelson, stone "is not a form you would associate with a turret because it does not look lightweight. It is disquieting, it challenges gravity." Northwest corner of Hamlin Avenue and Ohio Street, Chicago, 2001.

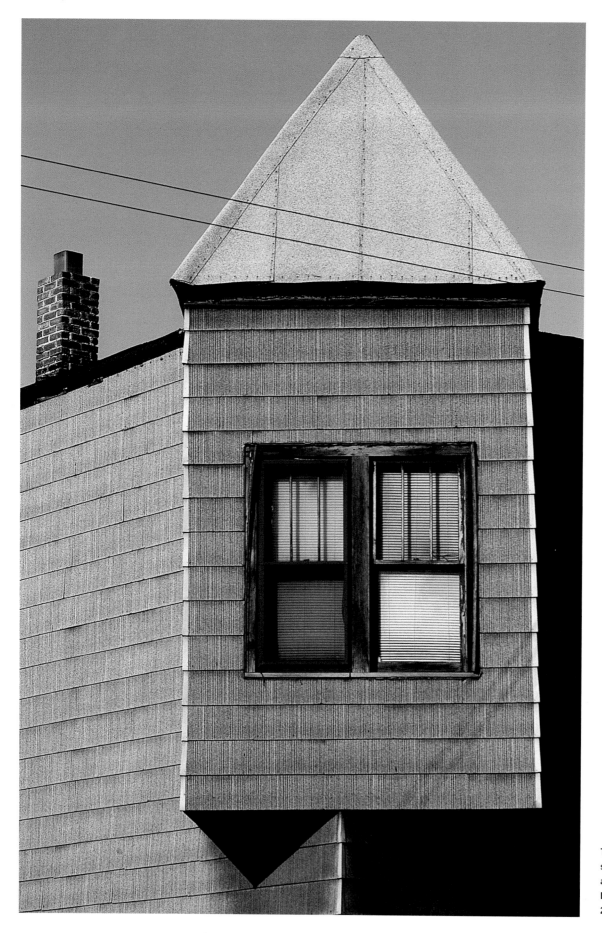

Turret juxtaposing bold, angular shapes, something modern architects try to do. 2524 West Diversey Avenue, Chicago, 2000.

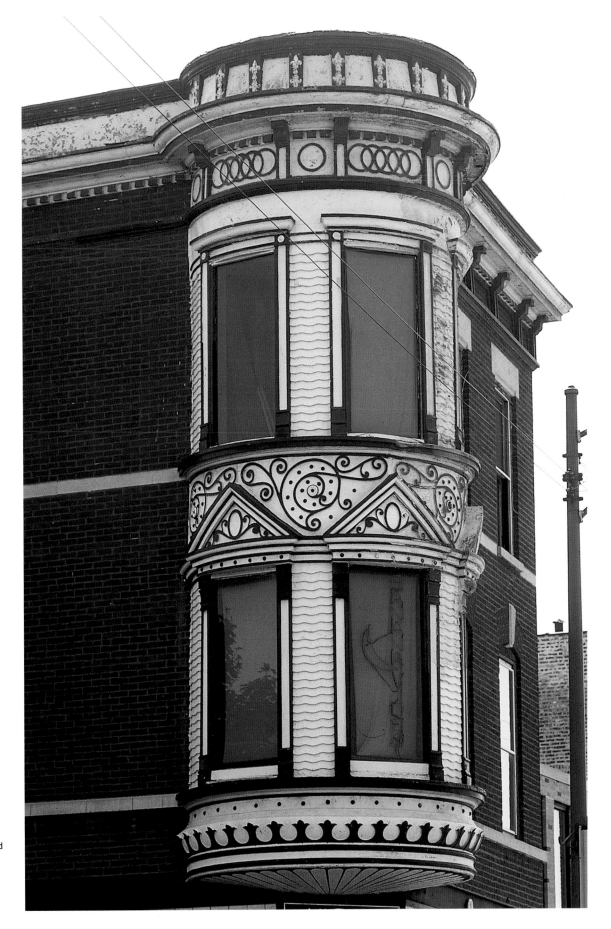

Turret over Different Strokes Painting, a testament to the craftsmanship that was available and affordable to architects and builders in the late nineteenth and early twentieth centuries. What appears to be a simple panel superimposed on a curved surface had to be cut and fitted precisely to match the tower's contour. Southwest corner of Clark and Argyle Streets, Chicago, 2000.

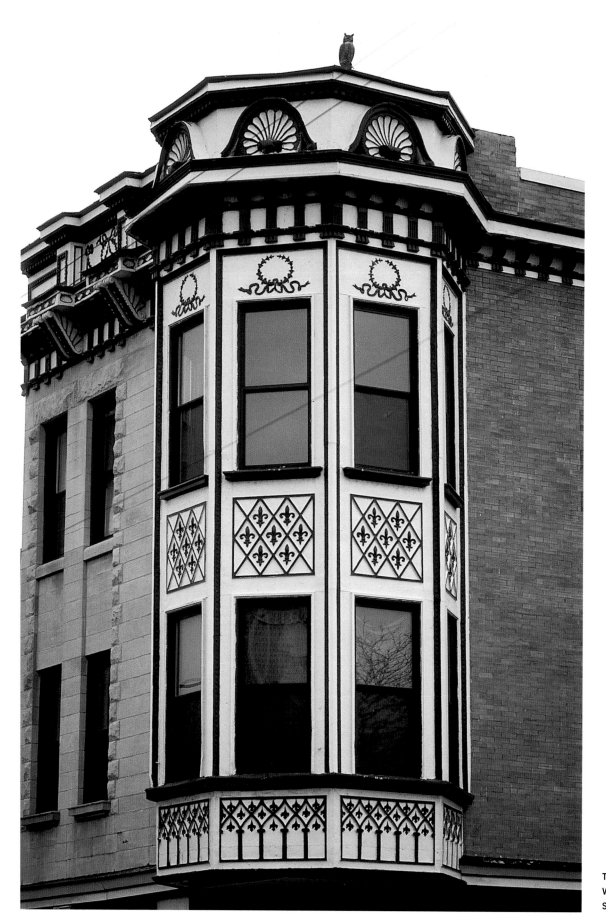

Turret. Northwest corner of
Wolcott Avenue and Division
Street, Chicago, 2001.

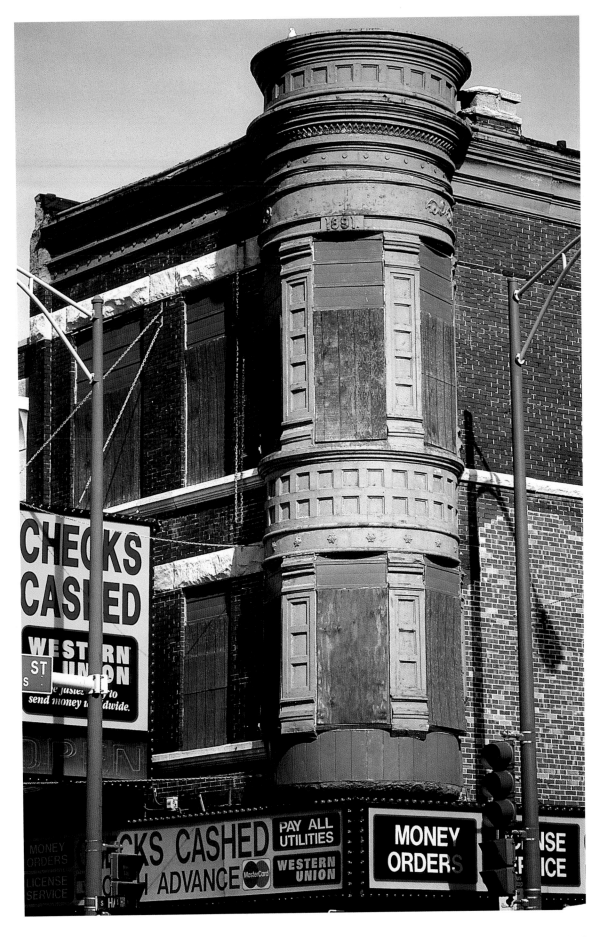

Turret built in 1891; now its windows are sealed. Northeast corner of Halsted Street and 59th Street, Chicago, 2000.

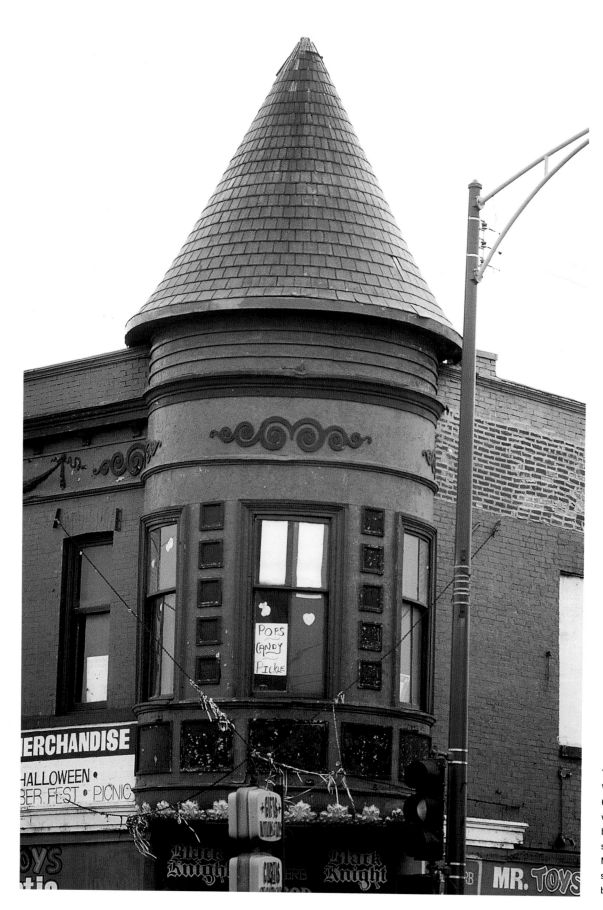

Turret, southeast corner of West Madison Street and Cicero Avenue. Mr. Toys, a variety store located in the building for forty years, has survived four fires. According to Nefertiti, the owner, the tower symbolizes the strength of the business. Chicago, 2000.

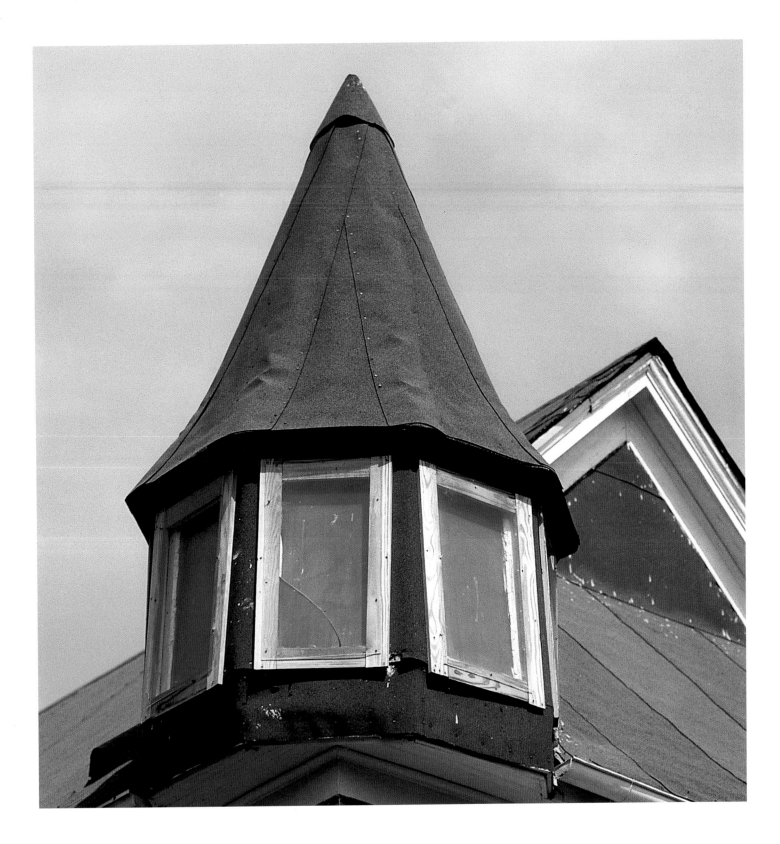

Turret covered with tar paper, resembling a witch's hat.
1712 Devon Avenue, Chicago, 2000.

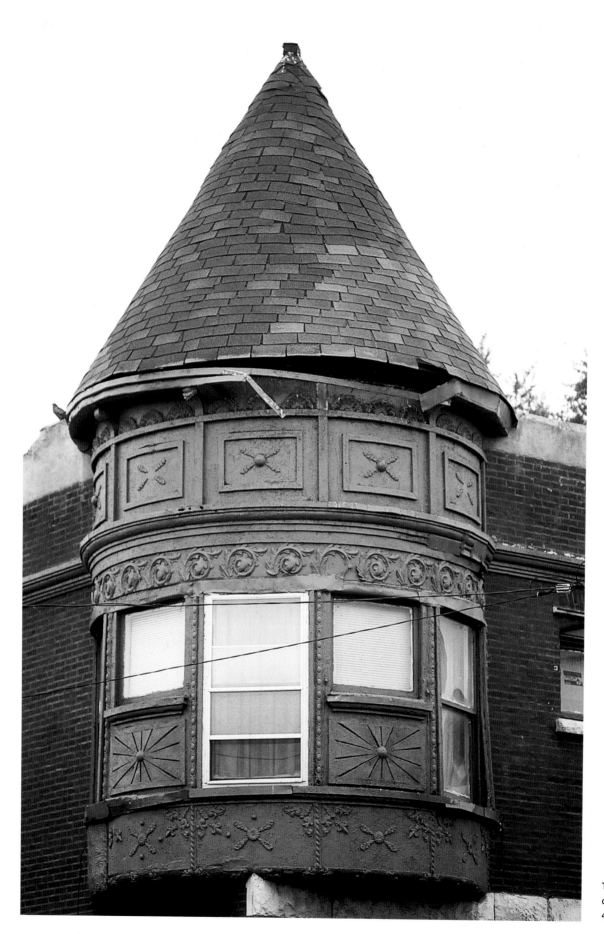

Tower in disrepair. Southeast
corner of Calumet Avenue and
44th Street, Chicago, 2000.

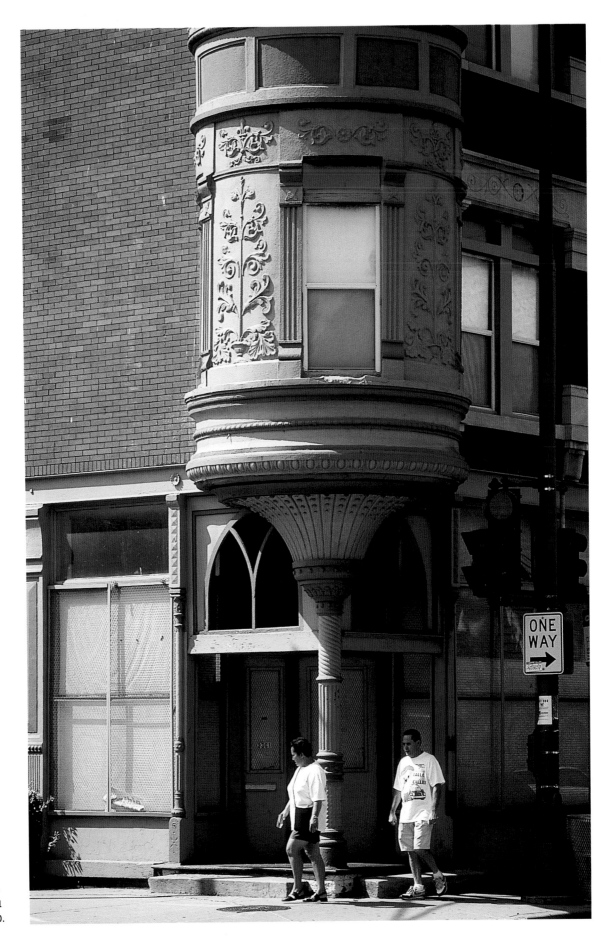

Turret, detail of the base with
an ornate support pillar. 2301
North Avenue, Chicago, 2000.

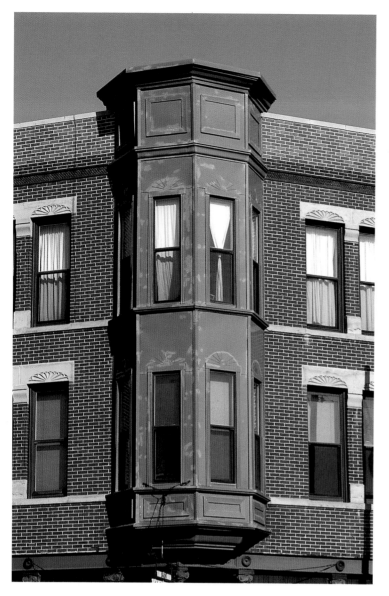

ABOVE Old turret reclad. According to Samuelson: "They did a conscientious job. They rehabbed the tower in sheet metal and simplified it. While being repaired, it lost half of its detailing, metal profiles, shapes, coves, and brackets—every profile that you put in there cost you money." 2167 North Clybourn Avenue, Chicago, 2000.

RIGHT New turret, a picturesque element recalling the old neighborhood before the high-rises (the Chicago Housing Authority's Henry Horner Homes). A resident named John compared his turret to the campanile of a nearby church: "They are there to make the house look good," he said. 2158 West Randolph Street, Chicago, 2000.

Turret on a house being built in a neo-Victorian style, part of a development called "Old Irving Pointe." An architect with whom I spoke expressed regret, as is common in his profession, at the popularity of "fake" styles like this. He ridiculed people's need to "hug their little village" and encouraged architects to design affordable housing that is not kitsch. Milwaukee Avenue, Chicago, 2001.

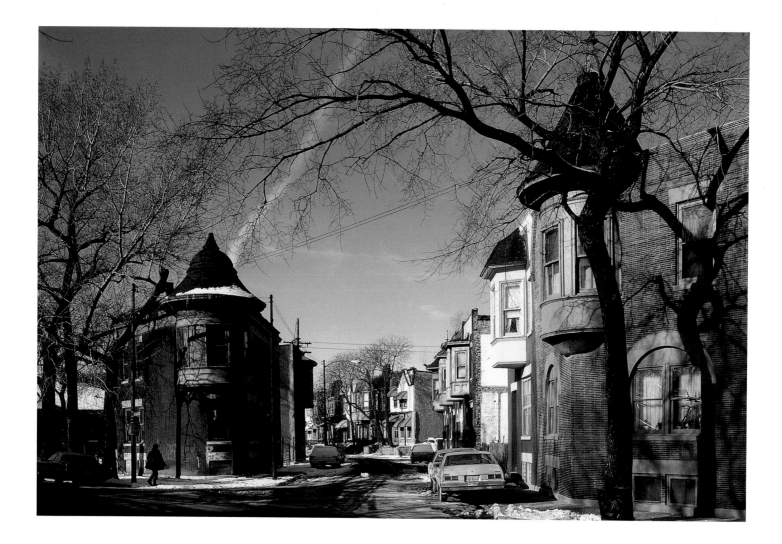

Distinctive Popular Housing

Samuel Eberly Gross,
the high priest of home ownership, Chicago

In late-nineteenth-century Chicago, real estate promoter Samuel Eberly Gross was preaching the gospel of "Own your own home." Buying up large tracts of land in outlying parts of Chicago and the suburbs, Gross dotted the cityscape with housing developments that were custom tailored for their individual neighborhoods, ranging from $1,200 cottages in working-class industrial neighborhoods to more substantial rowhouses targeted at the city's growing numbers of professional office workers.

With a Barnum-like promotional flair, Gross blanketed the city with illustrated booklets, flyers, and maps extolling the promise of a better life for purchasers of his houses and the financial wisdom of being a home owner rather than a renter. A cartoon drawing included in many of Gross's catalogs showed images of "The Renter" having his belongings dumped into the street, while another image depicting "The Owners of a House" showed a contented family relaxing in a cozy parlor.

Time and circumstance have led to some ironic turnabouts in many of Gross's developments. Some of the modest cottage developments are now in the heart of trendy neighborhoods, where a single dwelling can sell for a million dollars. In contrast, many of the more upscale developments have fallen

View northwest from Fifth Avenue and Monroe Street along one of Chicago's rare winding streets, 1981.

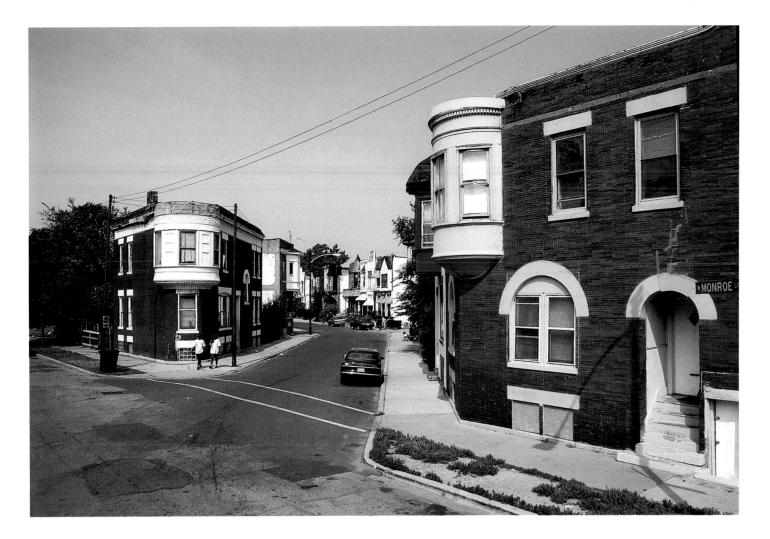

into disrepair, with former single-family houses being cut up into rental apartments or rooming houses.

One of Gross's more upscale developments was a group of adjoining rowhouses erected in 1887 on the West Side from plans by Swedish-born architect L. Gustav Hallberg. Each house was individualized. Variations in the roof lines, dormers, bays, porches, and other architectural details gave owners the sense of having a home that was uniquely their own. The row was tied together visually through common materials and repeating architectural details.

If one visits these houses today, it's evident that the carefree family shown in Gross's advertisements no longer lives here. Multiple mailboxes and doorbells on many of the houses testify that Gross's credo of "Own your own home" has also departed. The planned individuality of each house is one of the few Gross features that still remain, but this has evolved far beyond anything their idealistic original

developer ever imagined. Houses have been painted different colors, and the original doors, windows, and porches have been altered to suit the needs, tastes, and finances of successive owners. Even elements that once were common to all units have been discordantly changed from house to house. As fragile nineteenth-century building materials deteriorated, they were replaced by cheaper improvisations. Even more telling are the gaps of vacant land resulting from fires and abandonment.

This block of houses on West Madison Street and Sacramento Avenue was meant to provide standardized, affordable dwellings. A description from the period of the stores and houses for sale reads: "These handsome, well-built stores and flats are located on Madison St., between Sacramento Ave. and Gross Terrace.... They are well rented to good, prompt paying tenants. Five already sold, only three left." The prices ranged from $5,000 to $5,500.

ABOVE Rowhouses erected in 1887 from plans by Swedish-born architect L. Gustav Hallberg. View east from Sacramento Avenue along Fifth Street, Chicago, 1988.

MIDDLE Block of stores and apartments built by the developer Samuel Eberly Gross in 1885. View southwest from Sacramento Avenue along West Madison Street, Chicago, 1987.

LEFT The same block fourteen years later. Chicago, 2001.

Marktown, East Chicago, Indiana, founded in 1917, Howard Van Doren Shaw, architect

A cousin to Pullman, Marktown, built almost four decades later, is a housing development designed by Howard Van Doren Shaw for the Mark Manufacturing Corporation. It was part of an attempt to create an ideal company town in an industrial area of northwest Indiana—a place to keep workers happy and healthy through good design and pleasant working conditions.

Marktown was built as a bicycle village. There was no need for parking, garages, stables, or carriage houses—no worker lived more than four blocks from the Mark Manufacturing Corporation. Shaw envisioned the housing as smaller but of comparable quality to that found in the wealthy suburb of Lake Forest, Illinois, which he also designed. There is no room for trees along the streets, but flower boxes on the side walls of the houses give a warm feeling to the blocks. The development has a town commons called Market Square; everything opens up to this green space. Despite its lack of details to relieve the flatness of the walls, Marktown has been compared to "an English village."

ABOVE View along School Street toward Spruce Street, Marktown, East Chicago, Indiana, 1999.

MIDDLE View from Liberty Street and Spruce Street, Marktown, East Chicago, Indiana, 2000.

RIGHT View from Prospect Street and Pine Street, Marktown, East Chicago, Indiana, 2000.

George Pullman's Dream, in Ruins, Pullman, Chicago

Pullman was an experimental town built in a remote location, away from what were perceived as the evil influences of the city. The town had factories, houses, schools, a church, and stores, but no saloons, and it did not allow prostitution or gambling. George Pullman's vision of a workers' utopia was very paternalistic. He kept control of the community he founded and that bore his name because he felt he could not trust others to operate it and to respect its architectural integrity. In addition to manufacturing railroad cars, it attracted several other industries, some owned by Pullman. Whole blocks in Pullman were conceived of as a single architectural composition, but now people have altered facades and destroyed the balance.

Pullman is significant as an early example of town planning, as a symbol of the struggles of labor, and for its role in the history of transportation.

"A spectacular ruin," Pullman's main building and clock tower, Solon S. Beman, architect, 1880
Pullman's main building, with its clock tower, was highly picturesque and both the center and the dominant symbol of the town. Now in ruins, its clock once chimed the hour. The front of the building faced Lake Vista, a three-acre artificial lake from whose center a tall column of water shot high into the air. Lake Vista served the dual purpose of providing water for the steam engines that powered the town and giving a parklike appearance to one of the largest industries in the nation—in 1910, Pullman was one of America's ten largest corporations. The Pullman Works closed in 1981.

David F. Cook, the architect responsible for stabilizing the main building after a fire in 1998, declared the structure itself "not a spectacular gem

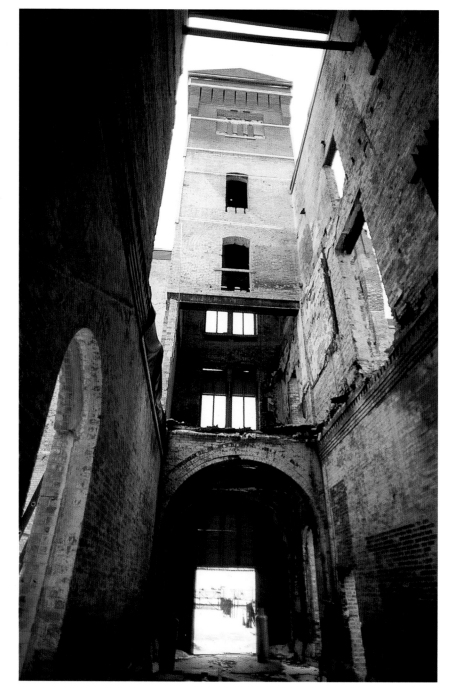

Pullman; view of the ruined tower from behind. Chicago, 2001.

or a cutting-edge building or a visionary building, just a fine building." Cook finds the present ruin "incredibly powerful." He would have liked to see it left alone. "In Europe you find so many old castles and abbeys kept as ruins," he remarked.

The state legislature plans to renovate the building and turn it into a museum. To this end, it has appropriated an additional ten million dollars to construct a new roof, floors, and windows. The legislature wants to develop the surrounding area into a park with informative displays about the Pullman experience, bringing the total to an estimated two hundred million dollars.

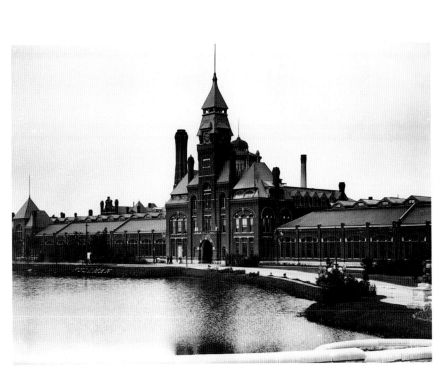

LEFT Pullman Administration Building and Car Works. Courtesy of the Chicago Historical Society. In 1910 the Pullman Company was one of the ten largest corporations in the nation. South Cottage Grove Avenue by 111th Street, Chicago, 1999.

BELOW LEFT Ruins of Pullman administration building and clock tower after the fire of 1998. Solon S. Beman, architect, 1880.

BELOW RIGHT Pullman; workers stabilizing the remains of the main building and clock tower. Chicago, 2000.

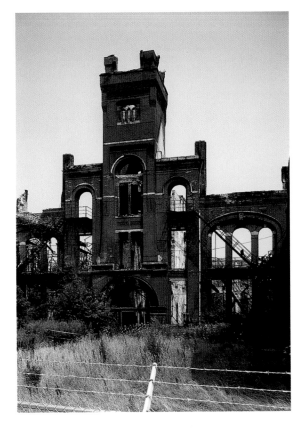

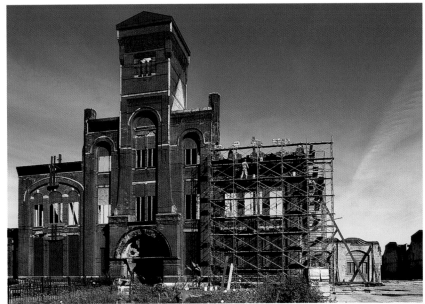

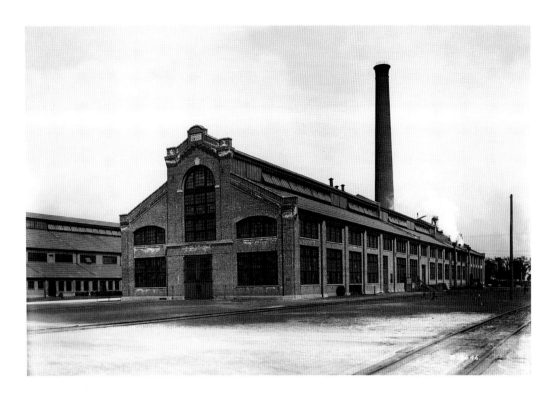

ABOVE Pullman, 1915.
Courtesy of the Chicago Historical Society.

BELOW Pullman; industrial ruins.
South Cottage Grove Avenue by 111th Street,
Chicago, 1999.

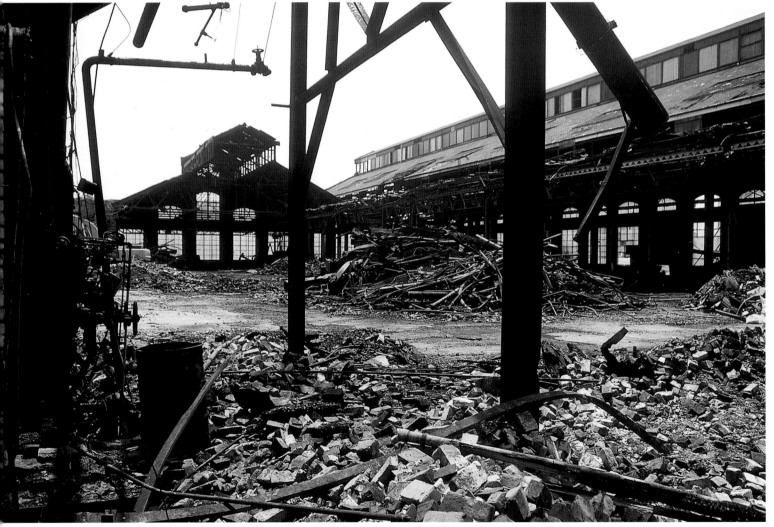

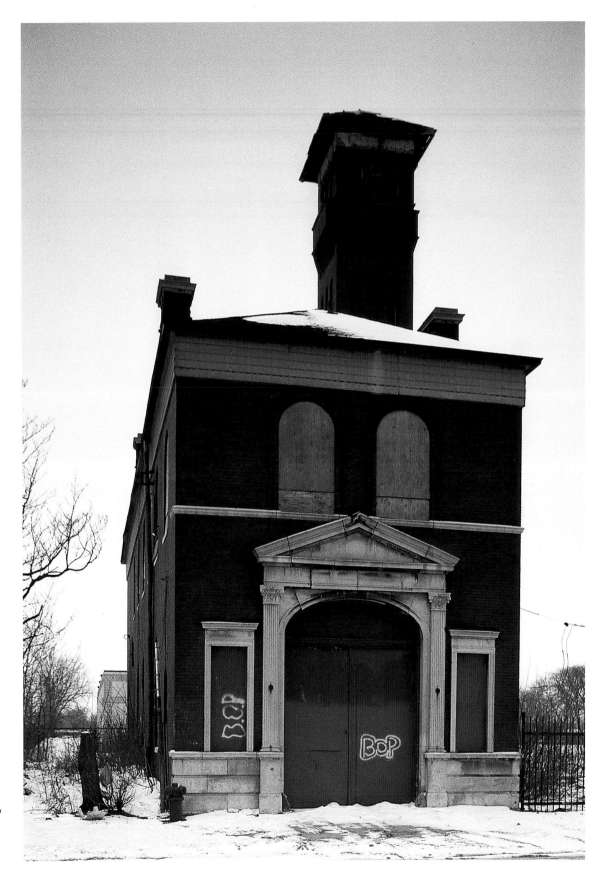

Former North Pullman fire station. Solon S. Beman, architect, 1894. This building was one of the last to be built when Pullman had hopes of being a viable company town. The tower was used to hang up the wet fire hoses to dry. 623 East 108th Street, Chicago, 2001.

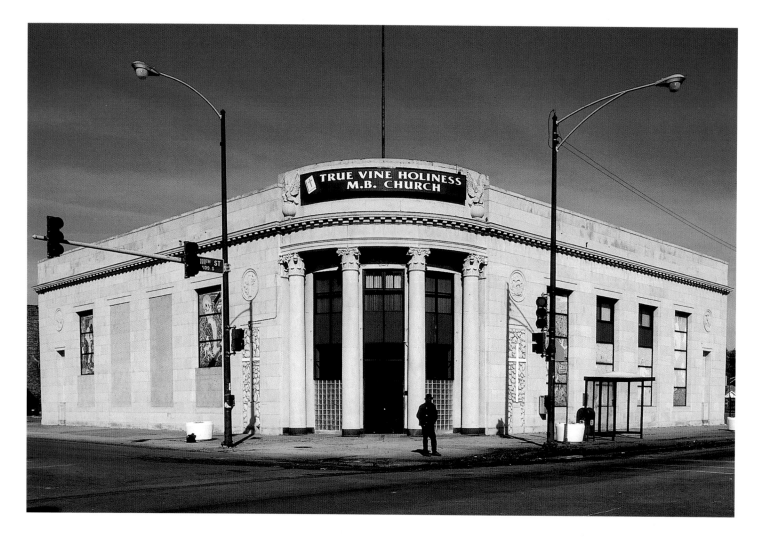

Pullman Trust and Savings Bank,
by Howard Van Doren Shaw, 1924.
Now True Vine Holiness M.B. Church

This grand building with a classicizing portico repre-
sents the peak of Shaw and Associates' work. The
architecture of banks is meant to impress, and its style
could be easily applied to a church. Once a temple to
the Almighty Dollar, True Vine Holiness M.B. Church
is now a black Christian church. A member of the con-
gregation remarked to me, "It is a church now. It
makes no difference that it was a bank."

The eagles on both sides of the classical portico
have lost their heads. Samuelson gives what he
thinks is a likely explanation: "Through freeze and
thaw, one fell on the street, then the owners panicked
[that the remaining head might fall on a passerby]
and decided to knock down the other."

Asked about how the interiors had been changed
for religious purposes, Joe, the maintenance man,

replied, "We did a lot of rehabilitation. We painted
it, we put in partitions, built additional rooms, and
we put in an elevator that goes from the basement to
the third floor." A painting of a Bible hangs next to
the former bank vault. "So that God will watch over
our money and multiply it," a church official
explained.

True Vine Holiness M. B. Church, formerly the Pullman Trust and
Savings Bank. Howard Van Doren Shaw, architect, 1924. 111th
Street and Martin Luther King Jr. Drive, Chicago, 2000.

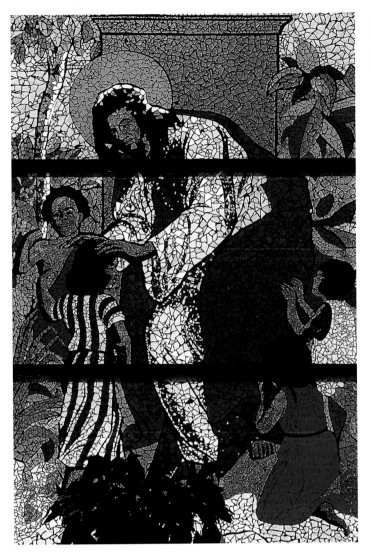

ABOVE LEFT True Vine Holiness M. B. Church. The stained-glass window showing a black Jesus in a tropical setting is an example of the church's Afrocentrism and expresses the congregation's liking for bright colors. Chicago, 2000.

ABOVE RIGHT True Vine Holiness M. B. Church, stained-glass window. One observer remarked: "You would have never expected Moses to be with all those tropical plants." A minister replied that he knew that the Holy Land was not like this, but that the color was there to attract people. Chicago, 2000.

RIGHT A box to deposit offerings at True Vine Holiness M. B. Church is a modern echo of the building itself, a former bank. Chicago, 2000.

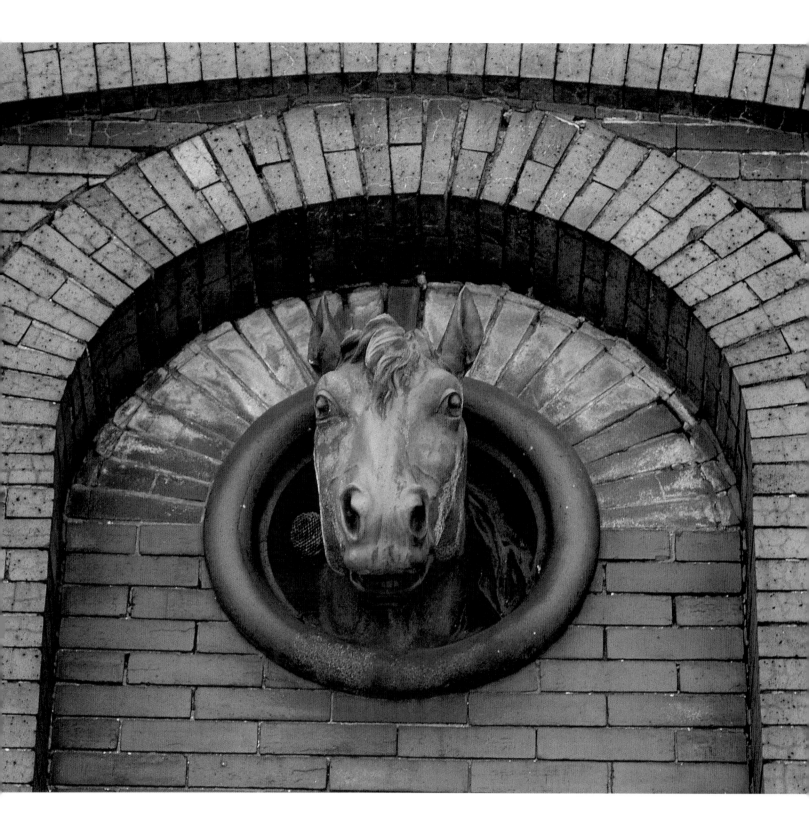

Terra-cotta horse head decorating a former beer distributing warehouse in Pullman
The head on this building was executed by Northwestern Terra-cotta Company as an example of a stock design that could be purchased from their catalog. Normally, this motif would have been used to decorate a stable, but it was appropriate here as well, because the horses that pulled the beer wagons were stabled inside. Samuelson remarks: "When I pass by it on the train, I'm afraid to look. I expect to see a big hole in the wall. The head has stuck a lot longer than circumstances would predict. It is too heavy, they need scaffolding to get that down."

OPPOSITE Terra-cotta horse head. Samuelson comments that the piece probably owes its survival to its weight. The head, with its upturned ears and wide-open eyes, seems eager to pull its load of beer on Chicago's streets. Pullman, Chicago, 2001.

Hammond's Second Coming:
"Not Quite What City Hall Had in Mind"

"The world's largest Sunday school,"
State Street, Hammond, Indiana
Since the steel mills and the factories closed, down-town Hammond is deserted during the week. But, as many of the commercial buildings have been turned into churches, worshippers crowd into the area on Sundays to attend services.

On a sign left behind in the decaying downtown, this block is described as Hammond's New Downtown Arts District, offering spacious lofts and condominiums from $160,000. Another sign adver-tises Santos, a carpet store that never existed. It was erected by a television crew filming an installment of *Final Edition*. A security guard at the courthouse said, "This is a redevelopment zone. It is going to be bulldozed. They will have doctors' and attorneys' offices and hot dog stands."

Under the leadership of Pastor Jack Hyles, the First Baptist Church started buying downtown com-mercial buildings in Hammond. Mr. Anderson, a church member, compares the reuse of the buildings to a religious conversion, explaining, "The buildings were all changed like a person that was a sinner and then converted to the glory of God." As if to keep the religious takeover secret, the facades of the storefronts have kept their original names.

On Sunday in downtown Hammond, two hun-dred buses converge on the world's largest Sunday school. The buses bring in about 8,000 people, many of them Latino children from the metropolitan area. Presided over by a large mural of Pastor Jack Hyles and his wife, crowds of people, including the blind, the mentally handicapped, the deaf, and Latino church members attend Sunday school in their own separate spaces in former appliance stores, depart-ment stores, and furniture stores. Mr. Anderson

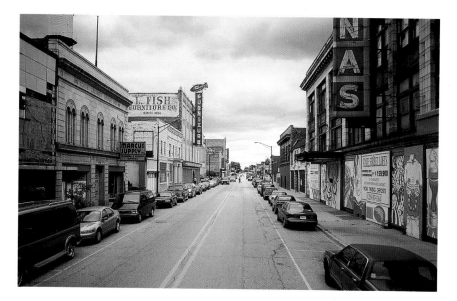

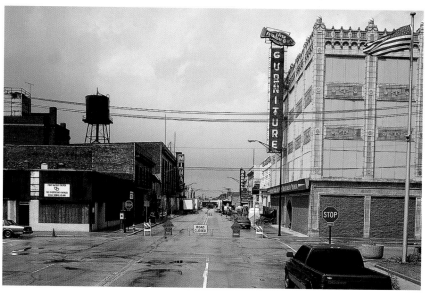

ABOVE View along State Street toward Sibley Street, downtown Hammond, Indiana, 1999.

BELOW View along State Street from Sibley Street during the filming of a bank holdup for the television series *Final Edition,* Hammond, Indiana, 1999.

seems resentful that outsiders take the former L. Fish store for a vacant furniture store rather than what he claims is the second largest church in the state of Indiana.

According to Christopher Meyers, the First Baptist Church religious complex is better than "block upon block of nothing." Joe, a local reporter, comments: "It was not bad, but it was not quite what City Hall had in mind. They took things over so that the buildings would not collapse and so that downtown would not become a place where bums and drug addicts congregate." The First Baptist Church plans to build a large new, two-story building and to demolish old structures, thus destroying part of this ghost downtown.

Furniture and jewelry stores clustered in this

area. A two-block-long section of State Street has been declared a National Historic District. The buildings were built between 1890 and 1900 and in the 1920s. Their facades are rich in terra-cotta details and have a strong character. Brian Poland of Hammond's Economic Development Office calls the buildings diamonds in the raw, ready for reuse.

Detail of the boarded-up Seiffert Furniture store, part of a National Historic District. The ground floor is used by the First Baptist Church of Hammond. State Street, Hammond, Indiana, 2000.

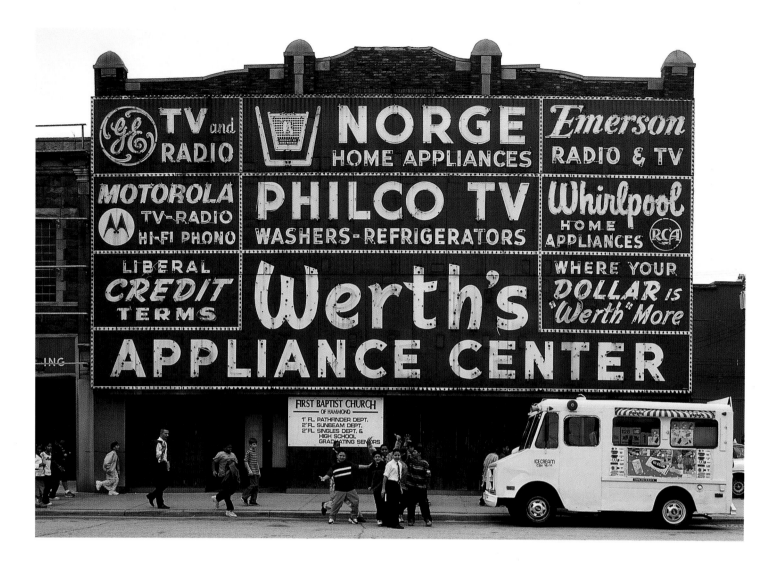

GE TV and RADIO

NORGE HOME APPLIANCES

Emerson RADIO & TV

MOTOROLA TV-RADIO HI-FI PHONO

PHILCO TV WASHERS-REFRIGERATORS

Whirlpool HOME APPLIANCES RCA

LIBERAL *CREDIT* TERMS

Werth's APPLIANCE CENTER

WHERE YOUR *DOLLAR* IS "Werth" More

FIRST BAPTIST CHURCH
OF HAMMOND
1" FL. PATHFINDER DEPT.
2" FL. SUNBEAM DEPT.
2" FL. SINGLES DEPT. &
HIGH SCHOOL
GRADUATING SENIORS

Former Werth's appliance center, now used by the First Baptist
Church of Hammond. The church plans to demolish the building to
make way for a parking lot. State Street, Hammond, Indiana, 2000.

*Former Werth's appliance center, now part of the
First Baptist Church of Hammond, Indiana*
The commercial signs were erected right after
World War II. This little bit of Times Square in
northwest Indiana must have presented quite a spec-
tacle when lit up at night. Pure electronic salesman-
ship of this kind was designed to have an impact on
everybody passing by. To put the signs there, the
wall surfaces had to be evened out, which meant the
removal of windowsills and decoration. "These
appliance places would sell everything—refrigera-
tors, hi-fis, stoves. They would get the manufactur-
ers to pay part of the cost of their signs," according
to Bill Ganley, a neon expert with White Way in
Chicago. The church plans to demolish the building
to make room for parking.

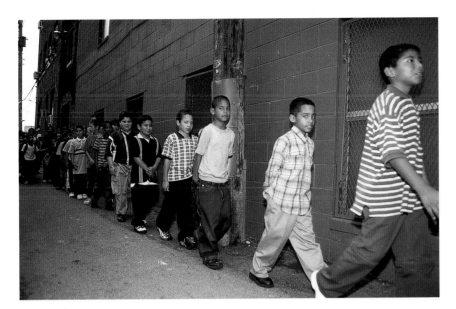

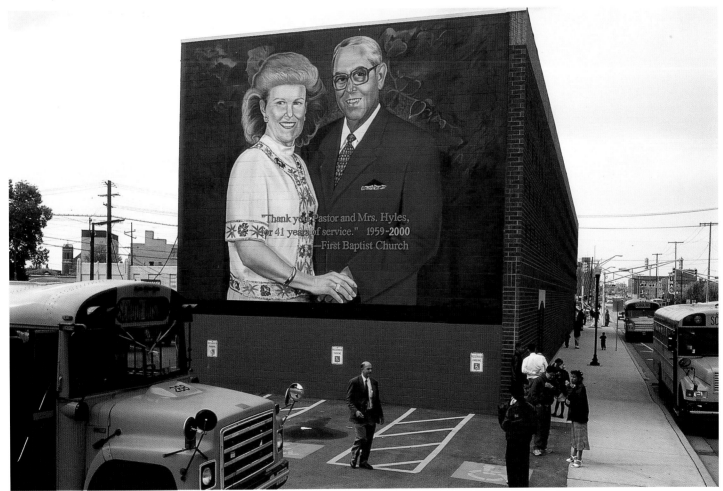

LEFT Latino boys going to Sunday school.
Sibley Street, Hammond, Indiana, 2000.

BELOW Three-story mural of Pastor Jack Hyles (died 2001)
and his wife presiding over the religious complex that has replaced
the commercial downtown of Hammond, Indiana, 2000.

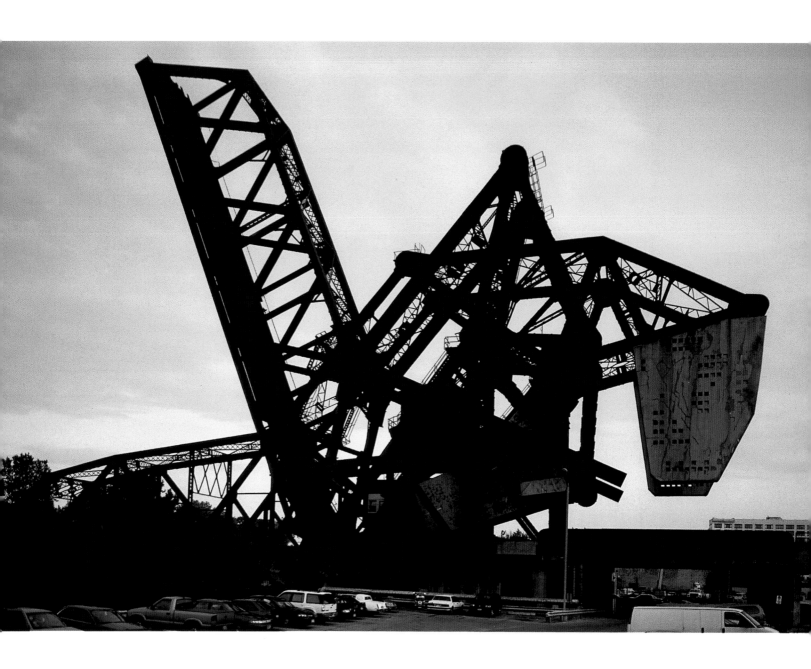

Chicagoland's Rust Belt: Bridges and Boats

Several complex bridges from the turn of the twentieth century, combining utility with beauty, form a distinctive presence in Chicago. The low price of steel made these bridges possible. The versatility of their material means that they can span great lengths horizontally or stack up vertically, carrying great weight while taking up little space. Control houses nest on some of the bridges, adding a contrasting note of domesticity. From inside the houses, a worker spotting an incoming train would close the bridge or, in the case of a boat, pull the levers to open it.

Unlike the great bridges that arch high, allowing uninterrupted water traffic underneath, Chicago bridges are low, so they have to be raised up to accommodate boats passing under. Raising them requires that a big piece of concrete be pressed down on cables, a dramatic display of brute force and simple physics. Samuelson remarks, "One of the nice things about these bridges is that they don't hold any secrets regarding what they're about. Anyone can understand how they work."

During the first quarter of the twentieth century, under the influence of Daniel Burnham's 1909 Chicago Plan and the City Beautiful movement, Chicago clad its downtown bridges with neoclassical ornamentation. In the industrial areas, however, the city was unwilling to invest in aesthetics. Sam Guard, a contract administrator, comments, "These bridges are a thing of beauty if you think that simplicity is beauty. They had an engineering look; they were erected using less metal, less work, and less expense."

"These bridges were built to last, and they are lasting," says Professor Marshall Berman. "We live in a throwaway economy. If anything is old it has to be torn down. Chicago was built of quality materials to be an industrial capital forever." Berman adds: "The crumbling of social relationships, not of materials, turns structures into ruins."

OPPOSITE St. Charles Air Line Bridge, Illinois Central Railroad, erected in 1917 by the Strauss Bridge Company of Chicago. A. S. Baldwin, chief engineer. It was called "Air Line" bridge because the St. Charles Railroad was an elevated line running above street level on viaducts and embankments between the city and the western suburbs. At the time it was built, it was the largest bridge of its kind in the world. Then, in 1931, it was shortened and relocated. South branch of the Chicago River at 1500 south, Chicago, 2000.

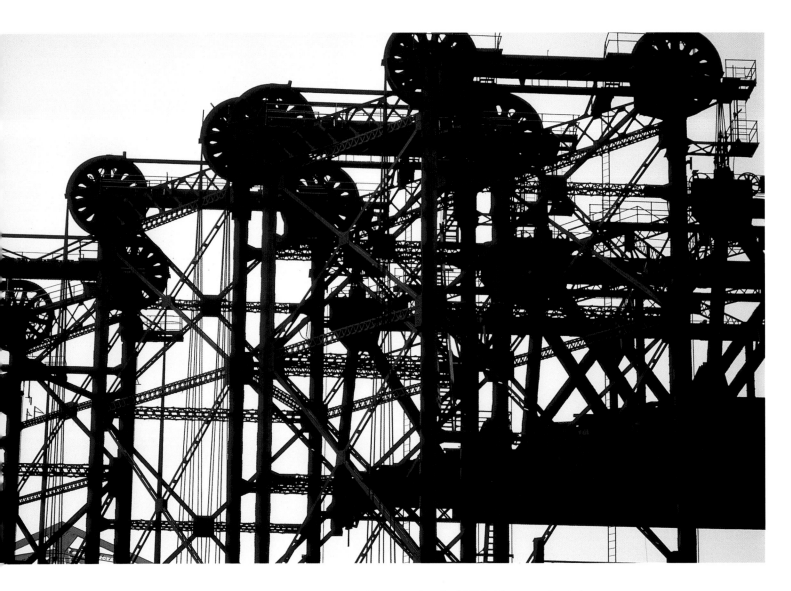

Golden rust: Vertical lift bridge over the Calumet River by 96th Street, South Chicago

This railroad bridge can switch quickly to let boats through. Seen from the Chicago Skyway, it will always signal for me the entrance to Chicago, a city that I have approached from the east a great many times over the course of thirty-five years. Until recently, one could see the gigantic silos of the former Falstaff Brewery presiding over a gray industrial landscape. The sulfur smell of the oil refineries diminished from this point north as industry gave way to Chicago houses.

Vertical lift bridge over the Calumet River at 96th Street, detail. The perforations in the wheels were designed to lighten the bridge's weight. Chicago, 1999.

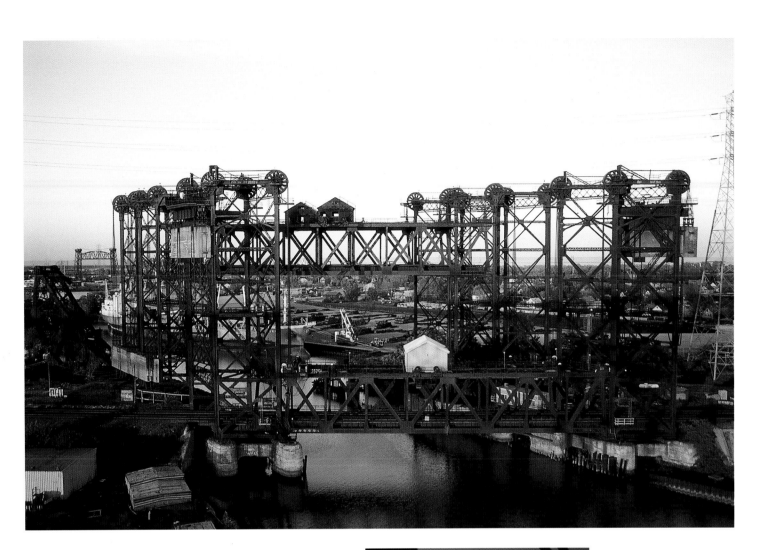

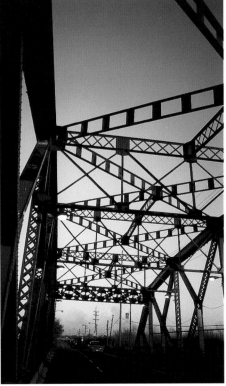

ABOVE Vertical lift bridge over the Calumet River at sunset.
J. A. L. Wadell, engineer, ca. 1915. The bridge emits an intense
golden glow. "There is a little house right in the middle of this thing.
A sweet domestic sight," commented Sam Guard. View north from
the Chicago Skyway, 96th Street, Chicago, 2000.

RIGHT A long-span steel bridge over the Calumet River,
the epitome of early-twentieth-century engineering.

The J. B. Ford, *"the boat that never leaves the dock," Calumet Harbor by 130th Street, ca. 1904*
The *J. B. Ford,* a Great Lakes freighter, was built in Cleveland nearly a century ago. It was decommissioned in 1985. It used to be a cargo ship and was converted into a cement hauler in the 1950s. Today, in an age of automation, the boat lacks the technology to operate efficiently. The cost of keeping the vessel operating is prohibitive for the owners. So the *J. B. Ford* remains at the dock, where it is used to store dry bulk cement.

According to ship captain Wally Watkins, each of these freighters had her own style. Upon seeing them crossing the horizon line, sailors could tell the name of the vessel by the curvature of the hull and by the different levels of the decks.

People in the shipping business are fascinated by the *J. B. Ford.* They talk enthusiastically about her triple-expansion, steam-driven engine that burns Number 6 fuel oil to boil water and produce steam. They marvel at what causes the pistons to move up and down and are surprised by the lack of vibration. According to Captain Watkins, the steam engine runs like "a fine-tuned sewing machine." He adds, "There aren't many boats like that. The Smithsonian would like to have the engine."

Local people see the *J. B. Ford* as a defining fixture of the community and call it "the boat that never leaves the dock." Tim Samuelson, surprised to see a ship that old still floating, is delighted with the shape of its small pilot house and wonders if the engine still runs. He comments, "You only see ships like that underwater, as shipwrecks."

Though visible, the *J. B. Ford* evokes a submerged part of Chicago's history, the beginning of the era when freighters brought iron ore to the steel mills of the city's South Side. It remains functional, but its true use and value are buried. It thus occupies, along with other remnants of Chicago's industrial past, the transitional realm I've described in the preface as an American Atlantis.

J. B. Ford, ca. 1904, a Great Lakes freighter now used to store cement. Calumet River by 130th Street, Chicago, 1999.

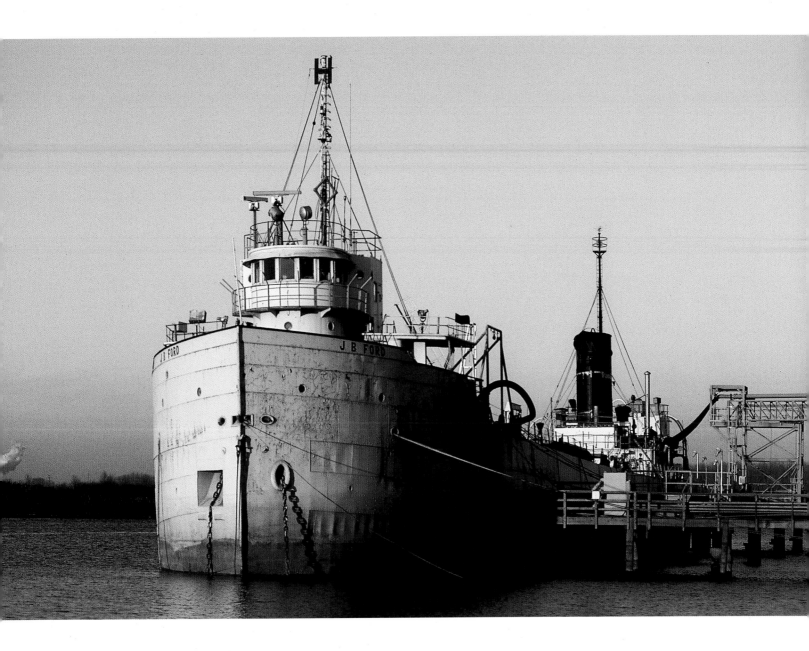

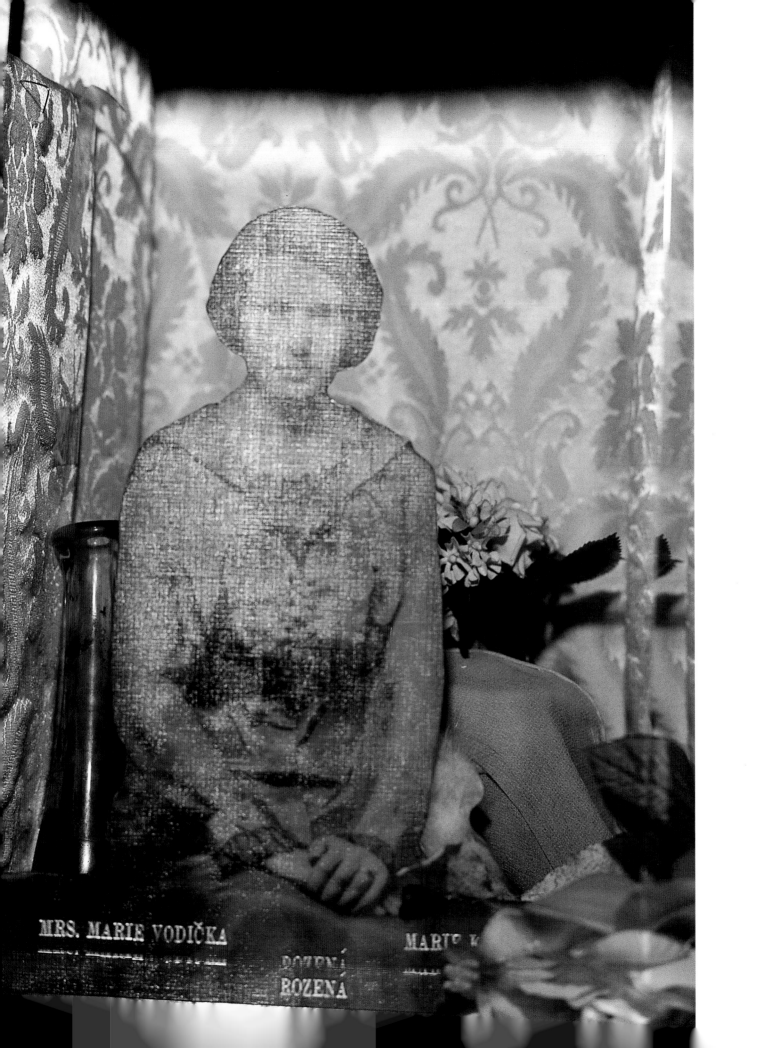

Bohemian National Cemetery

Columbarium niches, Bohemian National Cemetery, 1919: Ordinary life as Paradise

Rarely do I encounter interiors as moving as the rows of thousands of niches in the columbarium of Bohemian National Cemetery. Inside the niches, the urns are placed against white and pink backgrounds of tufted satin. Other typical decorations include artificial flowers and figurines. Most striking are the images of the person memorialized. I feel that I am intruding into a very private space where the deceased are presented in photographs as if they were still alive: having a cup of coffee, sitting on the front porch, or standing by a picket fence. The columbarium was built for Czech rationalists—non-believers—hence the absence of crosses, angels, the Blessed Virgin, and views of Paradise. Without symbols of the afterlife, the displays' homey decorations and old snapshots of the departed in their former domestic settings place primary value on this world—on everyday sociability, affections, and comforts. At the center of the chapel hangs a large American flag.

The placement of photographs within the niches follows certain patterns. For example, the portraits of different family members are usually the same size and arranged according to the chronology of deaths. Unlike family tombstones, where the position of names and images is permanent, in niches the memorial to the most recently deceased person may be placed closest to the viewer. Photographs of those who died young are generally given prominence. The concentration, variety, and character of the motifs, and their arrangement in a small space behind glass, intensifies the brief glimpses offered into family lives, beliefs, and aspirations. And the similarity of the colors, objects, urns, and backgrounds of the niches gives the columbarium a feeling of community.

OPPOSITE Spectral cutout portrait of Mrs. Marie Vodička. Chicago, 2000.

ABOVE Crematorium building in the shape of a church, the "Mother Monument" by Albin Polasek in front, 1914. Bohemian National Cemetery, 5255 North Pulaski Road, Chicago, 1986.

During a recent visit, I asked one of the Mexican cleaning ladies what she thought of the niches. She said, "It is a good thing to remember our loved ones, to keep memories," but adding, "I believe that, being dead, nothing exists."

Imagining the columbarium of the future as a video display, I envision niches where episodes of our lives would appear on screen: family scenes of quiet happiness, depictions of unfulfilled longings and of injustices that were never set right. Still others would show us dancing as in a trance, making time stand still.

Would video niches give us some cold form of immortality? According to Phil, the cemetery administrator, there are still some niches available for about six hundred dollars.

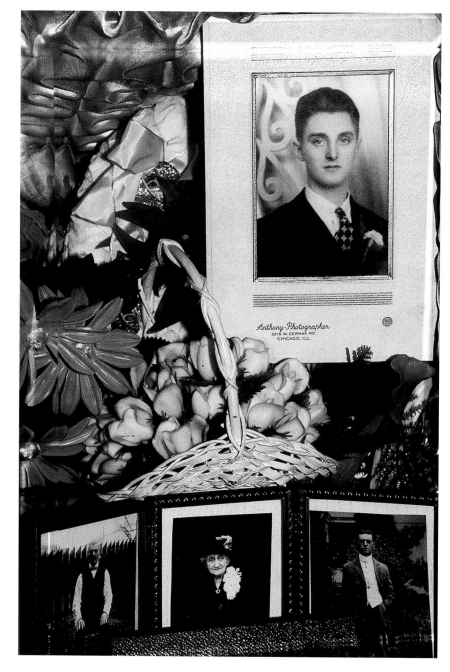

A man resembling the young Franz Kafka takes a prominent position in the Rodina Maivald niche. He is nameless, though the photographer's studio is clearly labeled. Chicago, 1985.

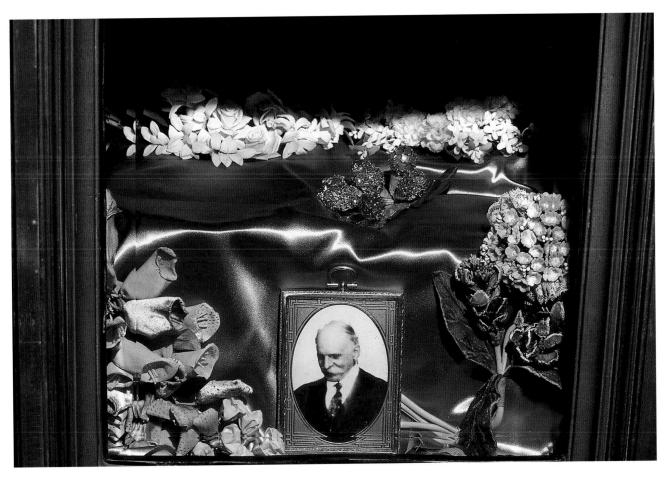

ABOVE This portrait of a distinguished patriarch with a reflective air is enshrined in a setting of lustrous pink satin and dainty artificial flowers. Chicago, 1986.

RIGHT In the most exclusive section of the columbarium, large niches are surrounded by carved wooden frames; inside, the lavish urns double as monuments. Chicago, 1986.

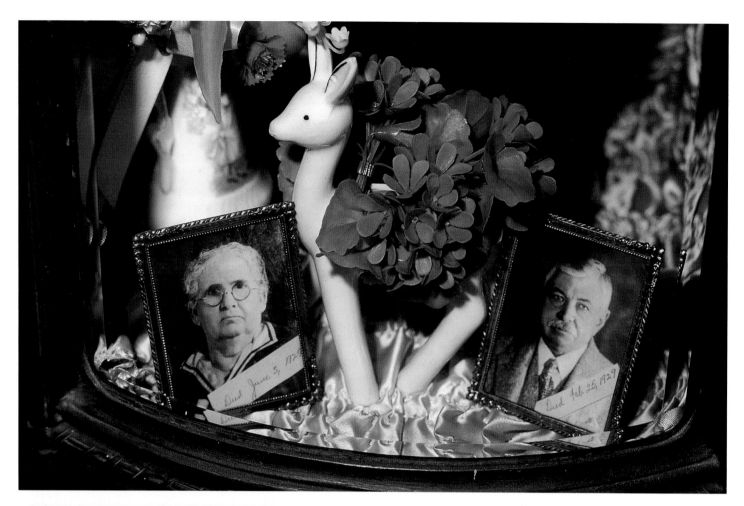

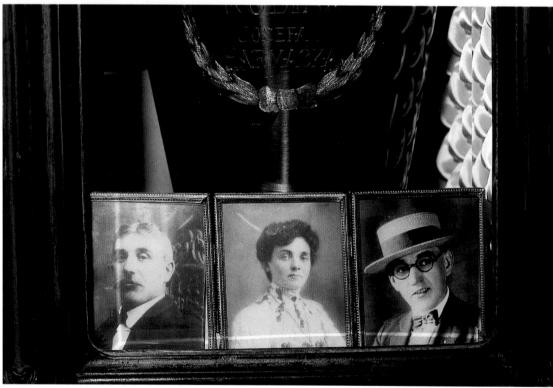

ABOVE Two grim portraits of a couple who died in 1929, with the dates of their death handwritten on their chests as if this were all there is to know about them. Placed behind the photos, softening the message, is a flower pot shaped as a fawn, with mauve flowers. Chicago, 2000.

LEFT Three formal portraits of members of the Rodina-Harmacka family. The urn looms large behind the small photographs. Chicago, 2000.

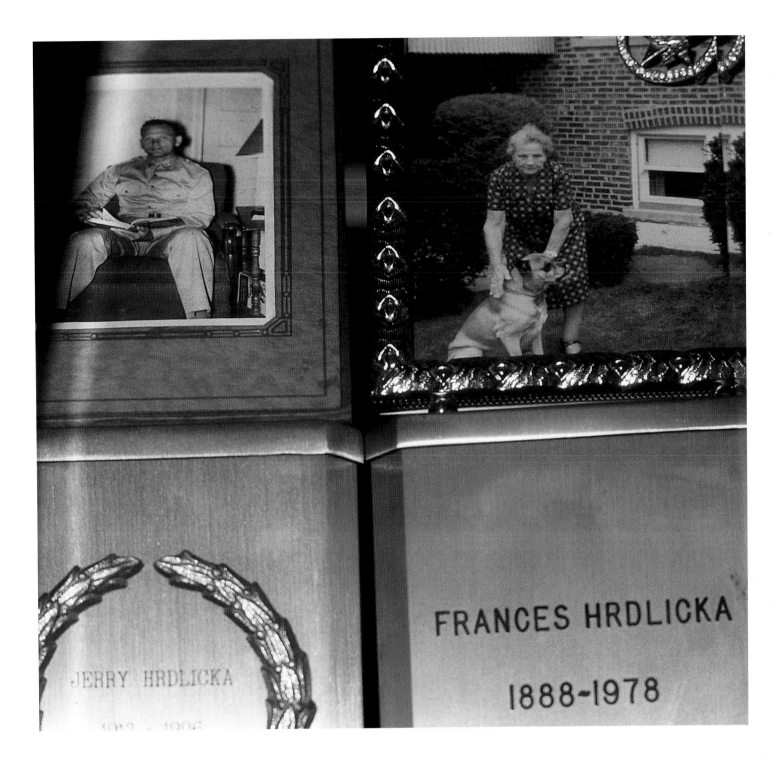

JERRY HRDLICKA

FRANCES HRDLICKA

1888-1978

The Hrdlicka niche has a photo of a soldier next to one of an old
woman and her contented dog. Chicago, 2000.

ABOVE Formal portrait photographs are grouped with a snapshot
of a couple smiling on the beach. Chicago, 2000.

BELOW Everyday life frozen into two casual snapshots.
Chicago, 2000.

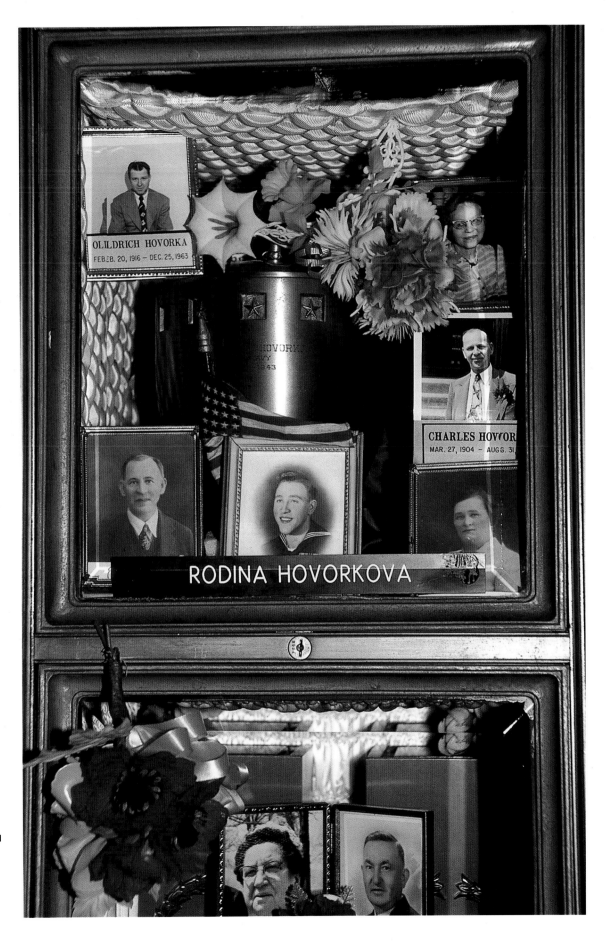

Niche in a patriotic mode with an American flag. A sailor killed in World War II holds the central place. Stars and the inscription "1943" are engraved on the urn. Chicago, 1985.

OLILDRICH HOVORKA
FEBEB. 20, 1916 — DEC. 25, 1963

CHARLES HOVVOR
MAR. 27, 1904 — AUG 6. 31.

RODINA HOVORKOVA

Art Moderne

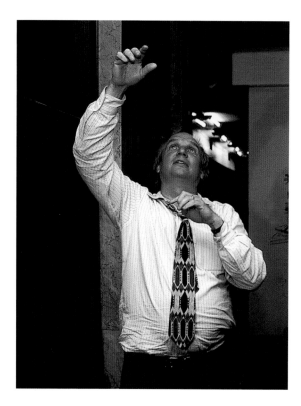

Art Moderne office building on Lake Street, Abel Faidy and Julius Floto, architects, West Side, Chicago, 1938

This building has a monumental character reflecting the influence of Erich Mendelsohn. Faidy was a pioneer in the use of modern materials, such as glass blocks and Formica. Originally, a central bay of glass bricks rose from a wide transparent glass door. The company that sold the blocks advertised them by showing photographs of this building at night with the light coming through. This is one of the few examples of Faidy's works that survives, the rest having fallen victim to remodeling.

The offices and design studio for Meyercord, a decal company whose factory was located across the street, were once housed in this building. Now it serves as the William V. Banks Grand Lodge as well as a social service organization, Human Needs Center.

Tim Samuelson explained to Grandmaster Lee Cross that Faidy was a visionary designer. Cross had a different impression. To him the building is old and looks like a bomb shelter. He repeatedly remarked that it was linked by a tunnel to the former factory across the street; in his eyes, the underground gives the building a hidden life, a mysterious character. Samuelson remarked that, on the contrary, the tunnel was there merely to facilitate movement back and forth between the buildings, and that it was used to send heat from the plant during the winter.

Perhaps bothered by hearing such an elegant, glassy building described as a bomb shelter, Tim commented that Cross was "taking the visceral message" of the building, its "strength and solidity."

Tim Samuelson describing the interior of the Meyercord Company office. 5323 West Lake Street, Chicago, 2000.

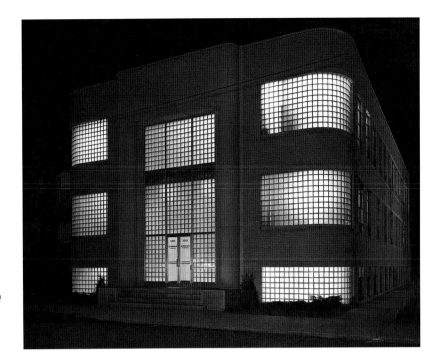

RIGHT The Meyercord
Company lit up from inside,
Chicago, 1938.

BELOW Glass office building of
the Meyercord Company, a
manufacturer of decals.
Chicago, 1999.

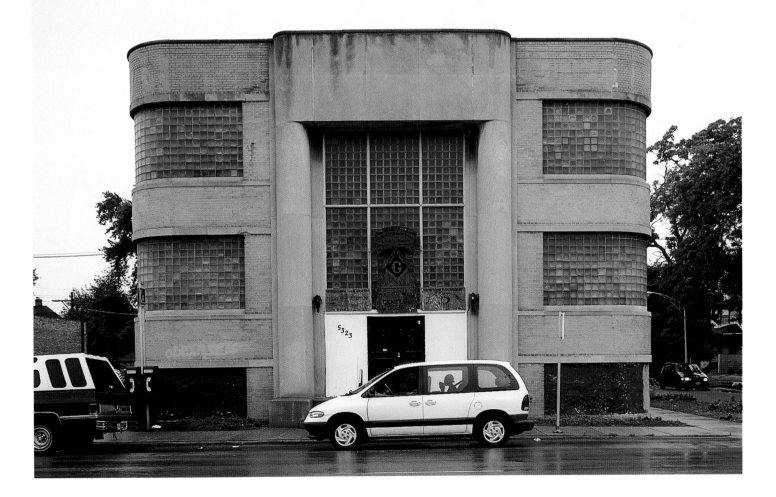

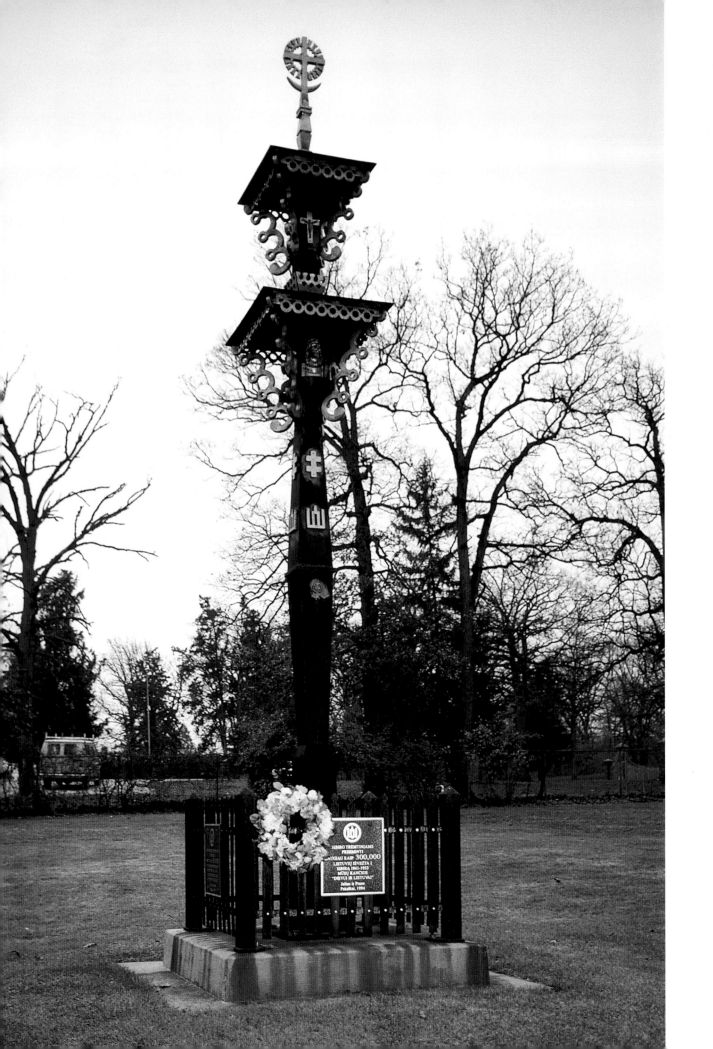

Lithuanian Art Deco

The Chicago region has the largest concentration of people of Lithuanian ancestry in the United States. They pride themselves on being a creative, socially progressive people who open their souls through art. In their cemeteries, it is common to find markers reading "poet, philosopher, scholar." The Art Deco style was in vogue when their nation became independent, and it is a style with which they continue to identify.

Office building, Lithuanian National Cemetery, Justice, Illinois, 1937
Shaped like an oversize mausoleum, this building has an extraordinary tower that does not match the rest of the building. When a funeral procession enters the cemetery, loudspeakers in the tower play chimes.

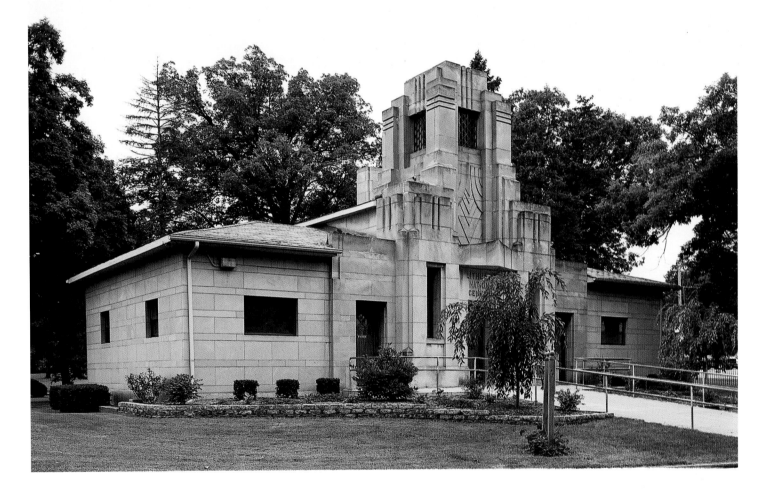

OPPOSITE Cor-ten steel version of a wayside cross made of wood; Julius Pakalkai monument, 1994. Lithuanian National Cemetery, Justice, Illinois, 2000.

ABOVE Office, erected in 1937. Lithuanian National Cemetery, Justice, Illinois, 2000.

Preserving traces of Lithuania:
Traditional wayside crosses in New World guises
Wayside crosses made of wood are part of the
Lithuanian-American heritage. But Chicago ceme-
teries do not allow wood to be used in monuments
because it rots. So sculptors inspired by traditional
crosses make substantial new versions of stainless
steel or of Cor-ten steel (steel meant to acquire a
protective coat of rust).

The wayside cross placed by Mr. Julius Pakalkai
in his family plot in the Lithuanian National
Cemetery in Justice, Illinois, illustrates changes of
scale, materials, and meaning as these symbols of
Lithuania were transplanted to Chicagoland. There
is nothing fragile or delicate about this monument, a
Cor-ten steel version of a one-foot wooden wayside
cross. It is about ten times the size, and hundreds of
times the weight, of the original, standing firmly on
a concrete base. It has shiny brass details and a
plaque commemorating the three hundred thousand
Lithuanians who died at the hands of the Soviets. In
a region where "people are born mechanics," who
can "do anything with their hands," according to the
writer John Gunther, the Pakalkai cross bears wit-
ness to the craftmanship of the builder, who greatly
enlarged the sculpture while remaining faithful to its
form.

More often, crosses of a kind that had remained
unchanged for hundreds of years are now reconceived
in loosely modernist styles. Yet they still link up mean-
ingfully with traditional Lithuanian types. Unlike Old
World monuments, the new crosses do not tilt or fall
down or age. To some Lithuanians, the new crosses
lack feeling, because their new materials do not reflect
the hand of an artist or the passage of time.

I photographed the most representative of the
Chicago-style Lithuanian monuments, and much
to my surprise I discovered that they were the
work of a single artist, Lithuanian-born Ramojus
Mozoliauskas. He claims to respond to "the simple,
primitive forms of the wayside crosses." He notes:
"Lithuanians used to be pagan. They worshipped
the sun and thunder. They converted to
Christianity much later than other European

nations." He admires the work of artisans with
pagan roots, "regular people who did not believe
they were doing a statue of God, but that they
made a God."

Mozoliauskas says that he makes his monuments a
"little more abstract, based in Lithuanian feeling."
Political scientist Marshall Berman is delighted to
find "abstract art integrated into a traditional setting
without any fuss. Abstraction is not perceived as a
threat."

Barzda monument. St. Casimir Lithuanian Cemetery, Chicago, 2000.

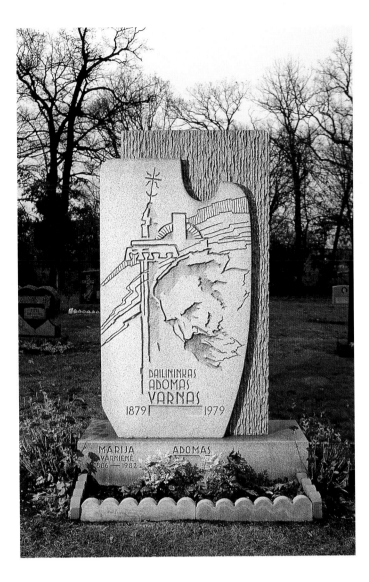

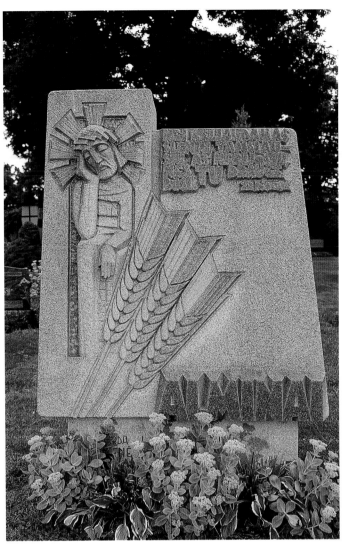

LEFT Varnas monument, a complex memorial to the artist consisting of his self-portrait in a dramatic realistic style incised on a stone shaped like a painter's palette. The stone is topped by a stylized image of a tilted wayside cross. Lithuanian National Cemetery, Justice, Illinois, 2000.

RIGHT Alminai family monument with enormous wheat stalks, a patriotic reminder of Lithuania and a eucharistic symbol. The type of Christ figure next to the wheat is known among Lithuanians as "The Worrier"—and elsewhere as "The Man of Sorrows"—because he takes upon himself the sins of the world. St. Casimir Lithuanian Cemetery, Chicago, 2000.

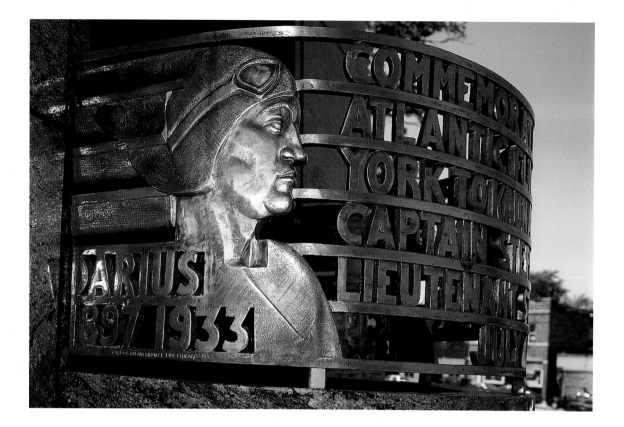

Monument to Darius and Girenas, Lithuanian heroes, designed by Raoul Josset, Marquette Park, Chicago, 1935

This monument commemorates the transatlantic flight from New York to Kaunas, Lithuania, by Captain Steponas Darius and Lieutenant Stasys Girenas on July 17, 1933. It is inscribed: "Erected by Lithuanian Americans in memory of the heroic flyers who met with tragic death upon the threshold of their goal. Anno Domini MCMXXXV."

The bronze globe charting the trajectory of the plane as it makes its way to Europe presents a world defined by two places: New York and Lithuania. At the base of the monument, the faces of Darius and Girenas show a mixture of determination and terror. Their muscles are tense and their eyes lack pupils. Theirs are the faces of men who know they are about to die. "They are heroes in Lithuania. If they had made it alive, they probably wouldn't be heroes," says sculptor Ramojus Mozoliauskas.

For many years, the back of the monument has been used by neighborhood children as a slide. To discourage them from climbing up the monument, park employees grease the ramp.

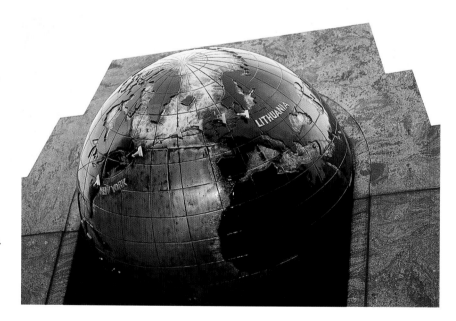

ABOVE Monument to Darius and Girenas, detail. Northeast corner of Marquette Park, Chicago, 1999.

BELOW Monument to Darius and Girenas, detail of the globe. Chicago, 2000.

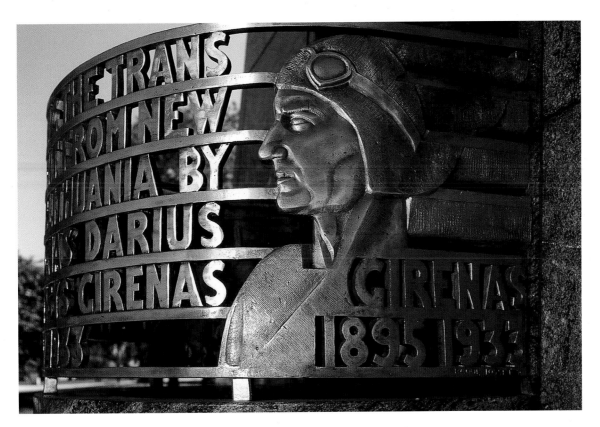

LEFT Monument to Darius and Girenas, detail. Chicago, 1999.

BELOW Monument to Lithuanian aviators Darius and Girenas, who died in an effort to replicate Charles Lindbergh's famed transatlantic flight. Designed by Raoul Josset, Chicago, 1999.

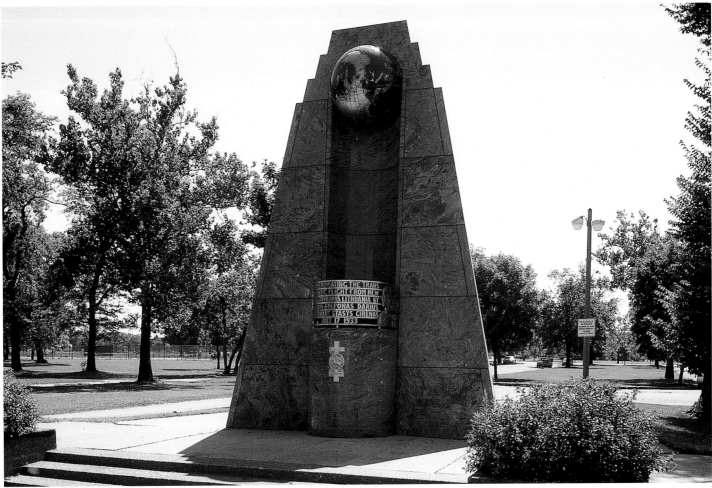

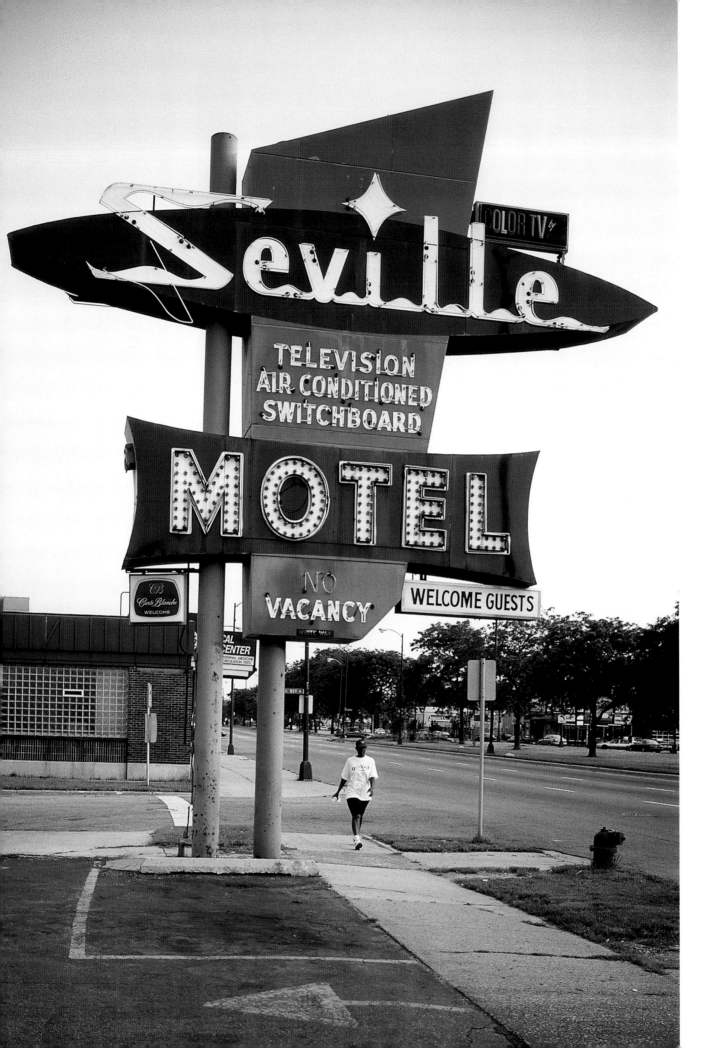

The 1950s: "It Broke the Old Rules"

Audiences respond strongly to the objects and the architecture of the 1950s. Architects had an unlimited range of materials to make any building the way they wanted: steel, concrete, sheet metal, neon lighting, plastic, enamel, glass, and aluminum. These materials could be used in any combination to create theatrical designs that contrasted with the Miesian ideal of pure structural expression.

People felt like they were on the cutting edge of a new and exciting time, the last stylized era. It was the closest thing to living the American dream. Tim Samuelson commented on this enthusiasm, saying, "It was a style that was comfortable, that reminds people of the unreal world of growing up in the fifties, of the new technologies: prepared foods, snacks, and things to amuse you, and always a sense of things being modern. Everything was accessible to the middle class. Now people live in a high-pressure society and 'keeping up with the Joneses' is difficult."

The younger people see this period as a distinctive new style that is irreverent, that was not afraid to use fresh colors and textures and to mix different things that had no good reason to be together. Those who lived through the 1950s find these forms comfortable because they echo times of their lives they remember with fond nostalgia. Others find it old-fashioned and anachronistic, hollow and laughable.

OPPOSITE Sign, Seville Motel. Northeast corner of Stony Island Avenue and 91st Place, Chicago, 1999.

Motels by the "Lost Highway"

These motels sit along once-important highways that were reduced overnight to secondary roads by the new federally funded expressways. Now period pieces, they were first built as ultramodern places to relax and get comfortably away from the pressures of everyday life. Most families could not afford cutting-edge modernism at home, so being able to stay in such a motel was itself a vacation. People who preferred to travel by car with their families liked to stay in modern buildings rather than in stodgy old downtown hotels. The idea of a family getting away in an automobile of the period, with its fins, elaborate chrome grilles, and flashy taillights, was the epitome of modern living. Today, however, people who live near these motels see them as "old-fashioned, outmoded junk," still too new to have acquired nostalgia value.

Avenue Motel (demolished in 2000), downtown, Chicago

The Avenue Motel was located near the beginning of Route 66, with apartments and inside parking. It reflected a time when people wanted to bring the car everywhere. Architecturally, this motel's massing of elements was impressive. If it had been refurbished, its stylishness would have attracted visitors, and it could again have become profitable.

ABOVE Avenue Motel. The blue and red glazed bricks were part of the 1950s palette, an architecture that sought to be noticed. 1154 South Michigan Avenue, Chicago, 1999.

BELOW Empty lot left after the demolition of the Avenue Motel. Samuelson believes that the Avenue didn't have a chance because Mayor Richard M. Daley of Chicago is part of a generation that has little regard for this type of architecture. Chicago, 2000.

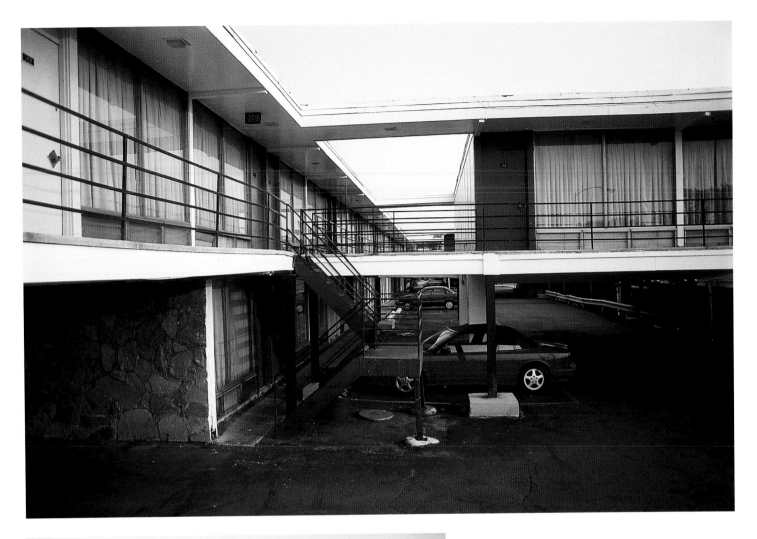

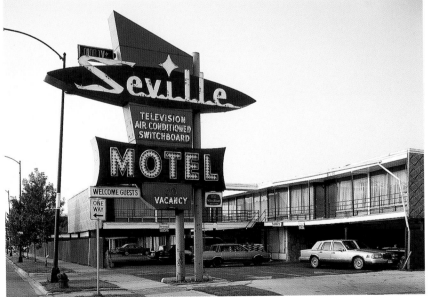

Seville Motel, The Modern Motel for the Modern Family, Stony Island Avenue, Chicago

The Seville Motel is located at the eastern automobile entrance to Chicago. On stilts, the motel seems to float, separating cars from people, embodying the modernist dream of the multilevel city. Complementing the simplicity of Mies van der Rohe–inspired, factorylike raw beam supports and stairs are colorful mosaics reminiscent of the Eameses' California style. The wall tiles have abstract modernist designs popular in many magazines of the time. However, this building has no monumental spaces. It is a bottom-line, easy-to-maintain place offering space for rent.

ABOVE Seville Motel. Northeast corner of Stony Island Avenue and 91st Place, Chicago, 1999.

BELOW Seville Motel. Chicago, 1999.

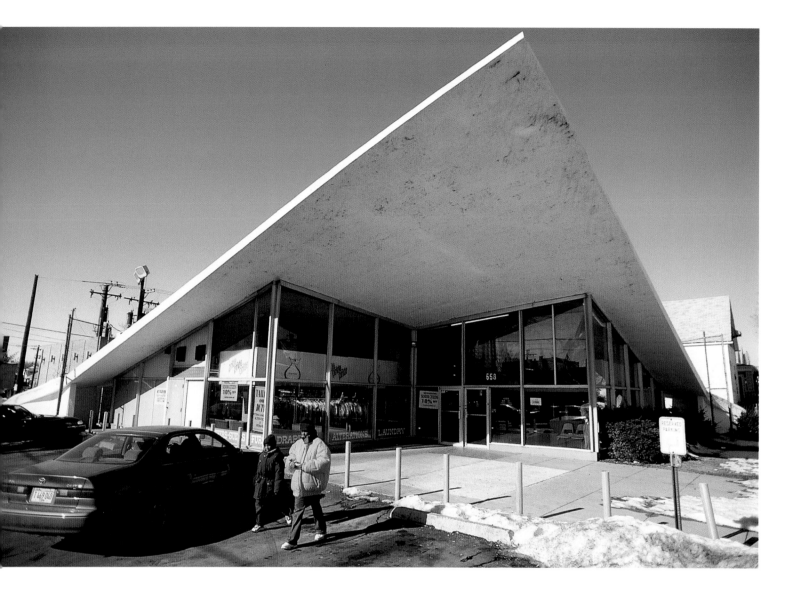

Pride Cleaners, a pure 1950s building, where technology goes
showbiz. Samuelson is trying to make this building a city landmark,
but an official of the landmark commission wanted to know what the
big deal was about saving it, arguing that "there are buildings like
this all over California." Samuelson replied that that might be true,
but surely there aren't many buildings like this in Chicago. Northwest
corner of 79th Street and St. Lawrence Avenue, Chicago, 2001.

Commercial Buildings
and Extinguished Neon Signs

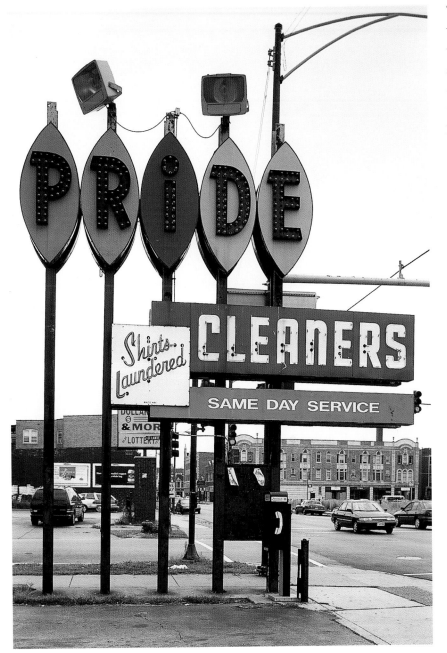

White Way's neon sign for Pride Cleaners. Chicago, 2000.

Pride Cleaners, a structural tour de force, Gerald A. Siegwart, architect, 1959, 79th Street, Chicago This is architecture to attract attention, making one wonder what holds it up. With its sweeping cantilevered roof, it seems to be flying from the corner, about to collide in one's face; it takes off, using a lot of space for sheer effect, meaning to stop people in their tracks. An entire supporting structure had to be built to the level of that flaring concrete slab until the concrete was set. Then the support was dismantled.

Pride Cleaners is a distinctive period piece whose architects explored the use of material for pure design showmanship. For that reason it is atypical of Chicagoan practicality. The building is intact, with its original colors and signs on the windows. Saarinen's TWA terminal at JFK Airport is a source of inspiration. Architectural historian David Smiley describes the style as "funky with funny angles and funny shapes, space agey, exuberant and zooty."

Remarks Dan, the owner of Pride Cleaners, "People in the neighborhood have gotten used to it; They have been seeing the building for at least thirty-five years." For him, "The office is normal. It does not affect anything working. The outside is strange. It looks like a band shell. Before they put up the fence, children used to climb to the roof to skate."

Samuelson argues that to preserve the building, one must first "get the owner to respect it." What is great about this building, he believes, is that it has remained intact. The owner should be convinced that "the building is his best friend, that the longer it lasts the more it will be valued. It will put him ahead of the competition."

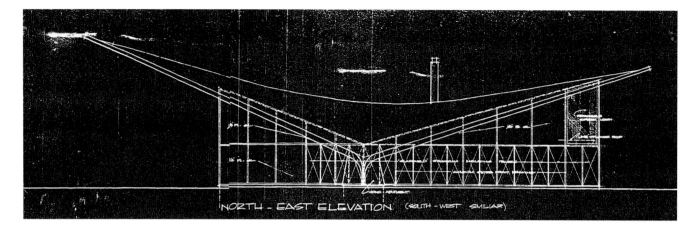

NORTH - EAST ELEVATION (SOUTH - WEST SIMILAR)

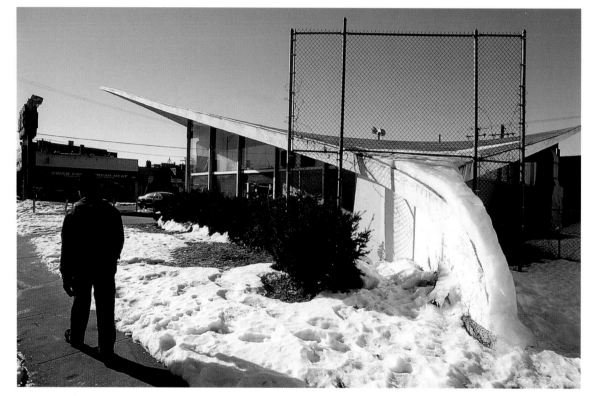

ABOVE Elevation for Pride Cleaners, late 1950s. Chicago.

MIDDLE Roof, Pride Cleaners. Chicago, 2000.

BELOW Pride Cleaners. The interior still has the original signs and colors. Chicago, 2001.

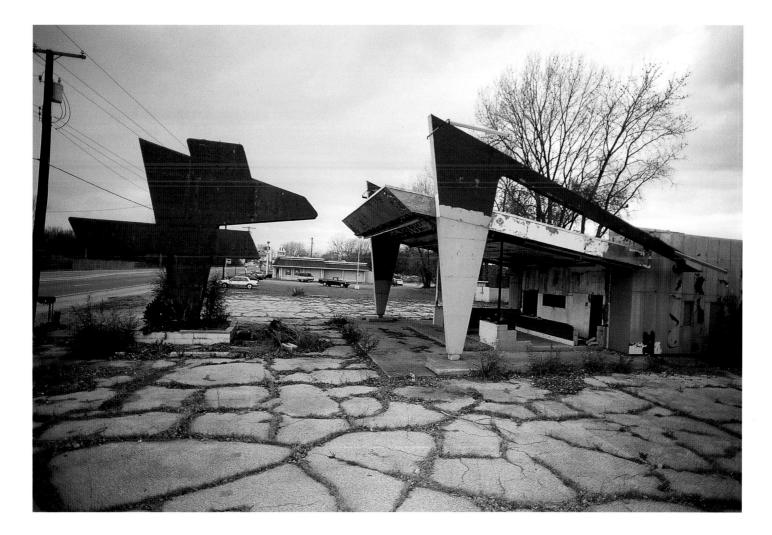

Ruins of Carroll Hamburgers next to the large sign that advertised it to drivers on Fifth Avenue and Bigger Street. The former franchise has been transformed into a pair of abstract scuptures that conjures the image of a giant grasshopper conversing with a bird. The contrast between the mysterious ruin in the foreground and the bland Kentucky Fried Chicken that replaced it (shown in the distance) represents changes taking place in roadside architecture since the 1950s. Gary, Indiana, 2000.

A former Carroll Hamburgers, "a franchise that didn't make it," Gary, Indiana West of downtown Gary, along Fifth Avenue, on what once was one of the most traveled highways in the nation, among liquor stores, truck stops, and fast-food restaurants, is a building that, according to Oryn Carlisle, one of its former owners, "broke the old rules." It seemed "to have been copied from something from the West Coast." He sees its late 1950s modernism as "something eye catching, intriguing to people, attractive to automobile travelers in a hurry. It made them stop and see, and when they were there they bought something." The shiny enamel, aluminum, and glass gave the business a clean and reassuring appearance, important to people who might otherwise think that food made quickly would not be sanitary.

At the time, this area was booming. U.S. Steel employed thirty thousand people (down to fewer

than nine thousand by the year 2001), and its sub-sidiary, American Motors Body Parts, was nearby. Mr. Carlisle operated a very successful Kentucky Fried Chicken franchise in the former hamburger joint. "When the KFC people saw the building, they said it had to go. This was the most outrageous building they had seen." At the time, the company was "trying to standardize its image."

The former franchise has been empty since 1980. The coral paint from its KFC days is peeling, and red enamel is showing from underneath. So, too, the sign saying, "A Serving a Second," left from the days when hamburgers were sold there. The lights have long since been disconnected and the glass removed. In the parking lot, grass grows through the cracked pavement. In the former franchise, designs that were thought to define the future are already disintegrating.

Tim Samuelson asks: "How often do you see this type of building in ruin? Where do you ever see an abandoned McDonald's? The 'nostalgia people' keep them in their eternal youth. Even your own pleasant imagery has a mortality. Ruins make you question the reality of your own perception of what was wonderful." Carroll Hamburgers is revealing itself, Samuelson says: "You can see it coming through after all the years of accretion. It has the excitement of a striptease." He would like to spend a day with a ladder and a scraper to uncover some of the building's former glory. I admire Tim's energy and his desire to get to the original forms, but I want more layers added. I like ruins to become more ruined. As an antidote to the architecture of global capitalism, I look forward to seeing Carroll Hamburgers overgrown and collapsing.

Mr. Carlisle observes: "The building is an eye-sore now. That is all it is." I joke with him that the building is not a fast-food restaurant but the ruined remains of an early space station left there half a century ago, waiting for Flash Gordon to return. The 3400 block of Fifth Avenue is not in Gary but on Mars. I was expecting to be told that I was crazy, but, much to my surprise, Mr. Carlisle laughed, asked for my name, and told me that he wanted to buy a copy of *Unexpected Chicagoland*.

I returned with Samuelson to the former Carroll Hamburgers. After a snowstorm, the structure looked like a pile of junk. He commented: "Maybe we didn't see the building for the falsity that it is. It is a little wooden concrete block building wearing a flashy enamel metal mask. Instead of being power-ful, it was cheap and vulgar." What led to the build-ing's loss of aura? Samuelson believes it "could have been the light, it could have been that it was peeling enamel metal on the top of snow." I felt confused that the same structure could be perceived in such contradictory ways, and let down because I could not trust my own eyes.

ABOVE Will Bailey, a former construction worker, who keeps his car in a garage behind the former Carroll Hamburgers franchise. He calls himself "one of the senior citizens of Gary, Indiana." To Samuelson, Bailey was "like the old prospector going through the Klondike with his donkey and shovel and rope. Instead of a donkey he has an old Ford."

OPPOSITE Former Carroll Hamburgers seen head on, looking like a "former space-age hamburger shack," according to an art historian. Gary, Indiana, 2001.

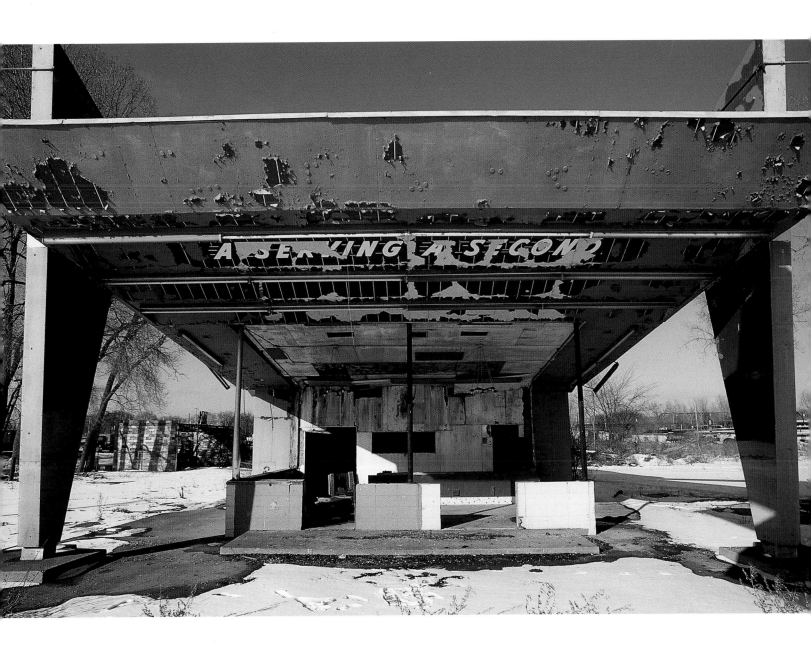

An American windmill,
Benton Harbor, Michigan, late 1950s

Perhaps its isolation, its whiteness, and the starlike sputnik perched on its squatty frame made me see Roxy Hamburgers as an American windmill, awaiting its Don Quixote.

Rich Hensel, a local designer, calls the Roxy "one of those places that became superfluous as society moved on." He added: "It is one of those phenomena that occurred during the period of highway expansion and we were creating a food culture that went along. We went on to the next phase, and all that was symbolic of progress and modern society became more blight."

An art historian comments, "I have seen those old run-down things. They look pathetic. The owners didn't have a vision that these buildings were going to last. Their only concern was with attracting customers. Today, they're wastelands."

This metal building is of a type called a "pre-engineered building." The components are stamped out of metal and packaged as a kit, to be purchased by catalogue and erected on any site desired. Thus, one may find identical buildings serving as machine shops, laundries, or insurance offices anywhere in America.

Once a small-town restaurant trying to be hip, the Roxy had a double personality. I liked the contrast between the utilitarian structure, on the one hand, and its big-city sign and crazy roof sputnik on the other.

With plenty of parking, plantings around the building, fading red, white, and blue trimming on its base, and a star outlined in neon on its roof, the vacant restaurant is not yet a ruin. Roxy Hamburgers may again offer wholesome food in a fun place.

Roxy Hamburgers, closed in 1999. The spiked sign on the roof, known in the trade as a "sputnik," rotated like a twisted star. In the 1970s sputniks were popular features of restaurants, nightclubs, and car dealerships. Then they went out of style; people got tired of the look, and they were hard to maintain. Main Street by Fourth Street, Benton Harbor, Michigan, 2000.

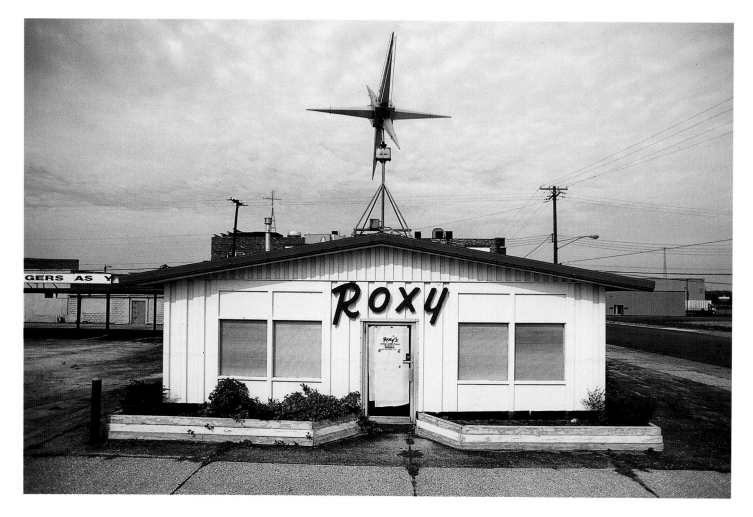

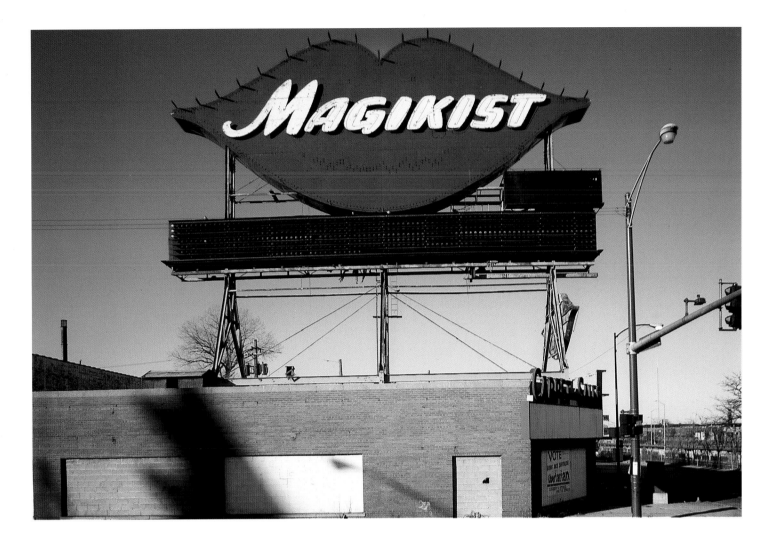

The end of the Neon Age

Neon signs called attention to businesses that might have otherwise been overlooked. They drew drivers into stores that made up the new commercial strip, one of the transformations brought about by the automobile in the 1950s. From the 1930s through the 1950s, Chicago was a hub of the neon-sign manufacturing industry, a period the industry calls the "Neon Age." In the late 1950s, neon lost its novelty and was replaced by plastic signs, which were easier to maintain.

The more elaborate neon signs were constantly in motion. "The lamps would come around and around and the arrow would point to the front door," said Bill Ganley, describing a type of sign very common for restaurants, motels, and liquor stores. "It was a choreography," added Samuelson, "the signs would dance before your eyes."

Though the sign "Thirsty? Stop at Discount

Liquor Mart" no longer works, Samuelson can still see it blinking in his imagination: "*on* to ask the question 'Thirsty?' and then the light blinks *off*, to give passersby a little time to think. If it didn't change, it wouldn't have half of the effect," he says. Bill Ganley was impressed by the drinking glass shape on top of the porcelain sign, by the double tube of neon spelling the word "liquor," and by the lights that once flashed around the border. Lou Simon, a former owner of the liquor store for forty years, appreciates the sign because it is unique. It is a memory, he says, "of where I worked and the customers I had." It has been there "since before Pearl Harbor."

"All these shops [sign manufacturers] started with two or three people doing simple signs, then they brought in an artist," said Ganley. Forms were influenced by motifs in abstract paintings and modern

One of Chicago's largest neon signs was for Magikist, a rug cleaning service. The sign lit up from the center, line by line, until its face was completely illuminated. Magikist posted similar signs on each of the city's three major expressways. Cicero Avenue and the Eisenhower Expressway, Chicago, 1995.

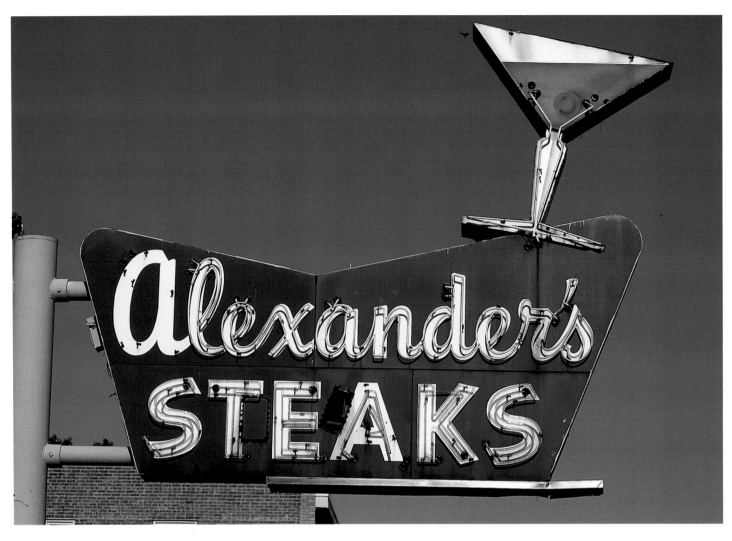

furniture; for instance, the kidney shape seemed to be adapted from coffee tables; others took on period standards like bow ties and ovals. In large and complex signs, several of these shapes were assembled on a skewerlike pole to form what people in the trade called a shish kabob.

In their additions and subtractions over time, signs reveal forgotten aspects of local history. As businesses expanded their offerings, they tacked new signs onto the old. A theater, for example, might add an announcement of air conditioning, a motel might attach an offer of free color television or a pool.

Typically, when a new business took over the premises, the sign would be renovated. When asked why he took down the plastic Dick Hoyt Typewriters sign that had stood for half a century in downtown Hammond, John Taylor said, "Those rotten old signs don't do me any good. Why would I want a

ABOVE Alexander's Steaks had the best steaks on the South Side of Chicago. The sign's boomerang shape and cocktail motif make it instantly recognizable as a relic of the 1950s. 3010 East 79th Street, Chicago, 1999.

BELOW Sign for Don's—later Wong's—Chop Suey. Halsted Street and 118th Street, Chicago, 1999.

sign that says Dick Hoyt The Typewriter Man when I run a heating and air conditioning business?" The former business fell behind the times, along with Hammond itself. The building stood vacant for decades until Taylor bought it for his company in 2000. He offered the sign to me, but I had no means to transport it back to my small Manhattan apartment.

As layers of paint peeled off the enamel surfaces, the names of prior businesses emerged. Signs reflected economic and social changes in the neighborhoods. As crime rose, some owners placed wire mesh or Plexiglas in front of their signs to protect them from damage from rocks or bottles. Businesses unable to replace a neon sign refaced the old one with chip board and put spotlights on it.

Today, according to Ganley, people are looking for memories. "They remember as a young child certain neon signs, an ice cream cone, a movie theater, a car; things that represented entertainment and happiness. They were very impressionable at that point. Today they want to capture that time when they were six or seven years old." The most powerful influence on the design of neon signs today, he says, is "the old Chicago look," as epitomized by the six-story-high Chicago Theater sign.

Young people often like signs that are worthless to an older generation. For Doug, the artist at White Way, signs like "Thirsty" on the liquor store are "garbage," and "visual pollution." His young assistant, however, who had never seen them before, finds them great and "gets all excited."

After they became obsolete, most signs were treated as junk. Ganley remarks, "There is no movement to preserve them. They were taken down, loaded up, and carted off to the scrap yard."

Neon sign for Discount Liquor Mart makes a subliminal message—thirsty—very explicit. Says Bill Ganley, "That is the state of mind they want you to be in when you come to get the amber nectar of the Lord." According to Sue, the liquor store's owner, a collector from Wisconsin tried to buy the sign. 4953 Milwaukee Avenue, Chicago, 2000.

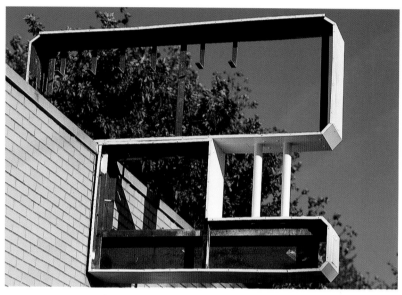

ABOVE Federal plastic sign for Dick Hoyt The Typewriter Man.
State Street near Sohl Street, Hammond, Indiana, 2000.

MIDDLE Frame for former typewriter business sign, painted for
reuse. Hammond, Indiana, 2000.

BELOW Sign for Hammond Heating & Air Conditioning replaces the
old sign. Hammond, Indiana, 2001.

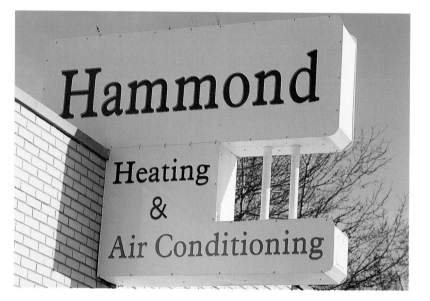

The neon sign for Dari Castle is partially revealed under the sign for Bailey's Grill. Broadway and 19th Avenue, Gary, Indiana, 2000.

Sign for Rothschild Liquors, covered by a thick plate of Plexiglas. Bill
Ganley explains the need to protect the sign: "If you live on the edge
of the ghetto, people who dislike you or who dislike the way you do
business get a little angry and use your sign for target practice. This
is a problem mainly with liquor stores." Roosevelt Road and Central
Park Avenue, Chicago, 2001.

Little Nikos's remodeled sign evoked very different responses. For
Bill Ganley, the sign was an expression of the melting pot: "Pizza is
Italian; barbecue is African-American; gyros, Greek; and shrimps,
Cajun." Samuelson cherishes the expression of paternal love he sees
in the child's portrait with his little bow tie, but an art historian finds
grotesque the lack of an organic relationship between the disembodied
head and the rest of the sign. That is, this picture, like others, struck
a rich vein of commentary. Far from being impoverished because of
their inability to say everything visually, photographs are like
tugboats, pulling along opinions and observations. North side of
Garfield Boulevard at Martin Luther King Jr. Drive, Chicago, 2000.

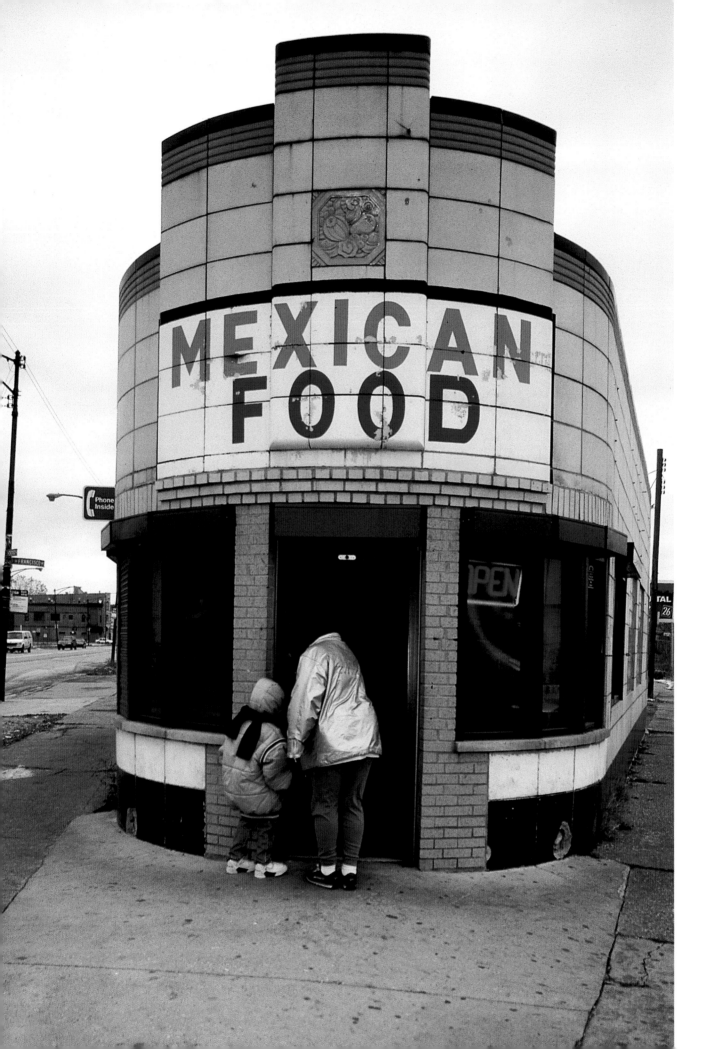

Hardheaded Practicality:
"You Have a Need, You Get to the Point"

"Mexican Food," Chicago Avenue, Chicago
"That is Chicago, always to the point." Samuelson is fond of this "sweet little jewel box of a building." He comments: "Every time I go by I think it is going to be gone. It seems so isolated in that corner. Probably it is difficult to do anything else with that lot. Nobody has reason to tear it down."

OPPOSITE Let's Mexan It Restaurant. The "Mexican Food" sign, with bold letters in the colors of the Mexican flag, contrasts with the building's delicate Art Deco style. Grand and Chicago Avenues, Chicago, 2000.

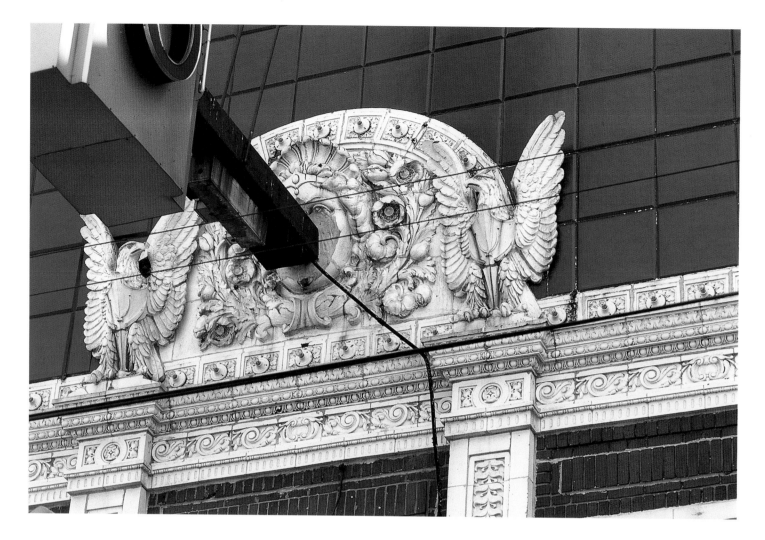

"Chicago's Pinocchio,"
Apollo 2000 sign, Cermak Road, Chicago

This sign could have been attached higher up, thereby preserving the decoration that it now interrupts. Javier Galindo, the owner of Apollo 2000, remarks: "It's an atrocity. They killed the building. It was done about sixty years ago." The edifice, built in 1917 as the Marshall Square Theater, is now used for banquets, dances, and concerts. Former vice president Al Gore visited the Apollo during the 2000 presidential campaign and complimented Mr. Galindo on the beauty of its Greek revival interior.

"The Marshall Square Theater was built during a period when the operators of movie theaters were trying to shed the image of being crass," says Samuelson. "People thought that the movies were not respectable. The investors that built these structures used terra-cotta to give them respectability, to show that the movies were a true art form like the theater." Regarding the theater, Samuelson adds, "They put on this beautiful face, but when their marketing strategies required the installation of a large blade sign that could be seen up and down the street, they didn't hesitate to put a piece of steel right in the face and didn't show the clemency to clean the carnage by removing the rest of the face."

Apollo 2000 sign. Cermak Road and Marshall Boulevard, Chicago, 2000.

Cherub with industrial light fixture mounted in its belly, apartment building, West Side Chicago
It was a cherub with a flower in his belly and a bulb came out of it like the pistil, but they had to replace the bulb and couldn't find a socket like the ones of the 1920s. The later owner didn't see the romance intended by the architects; all he saw was an electric light. The wiring was there, so they installed an industrial light fixture.

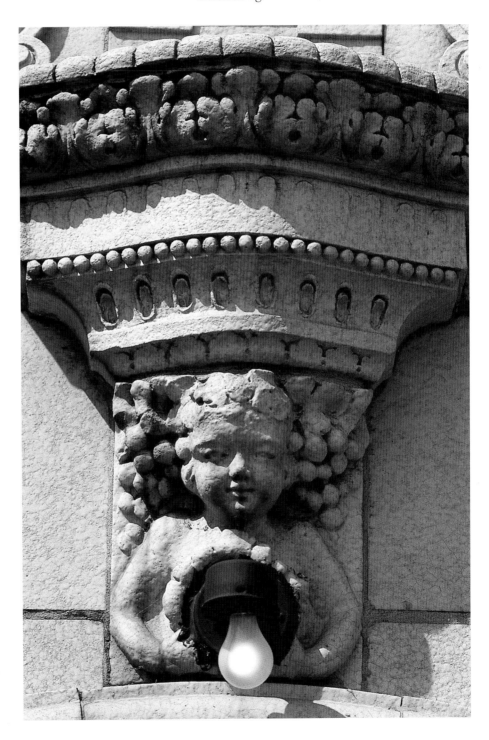

Cherub with an industrial light fixture attached to his belly.
4400–4402 West Washington Boulevard, Chicago, 2000.

HARDHEADED PRACTICALITY *83*

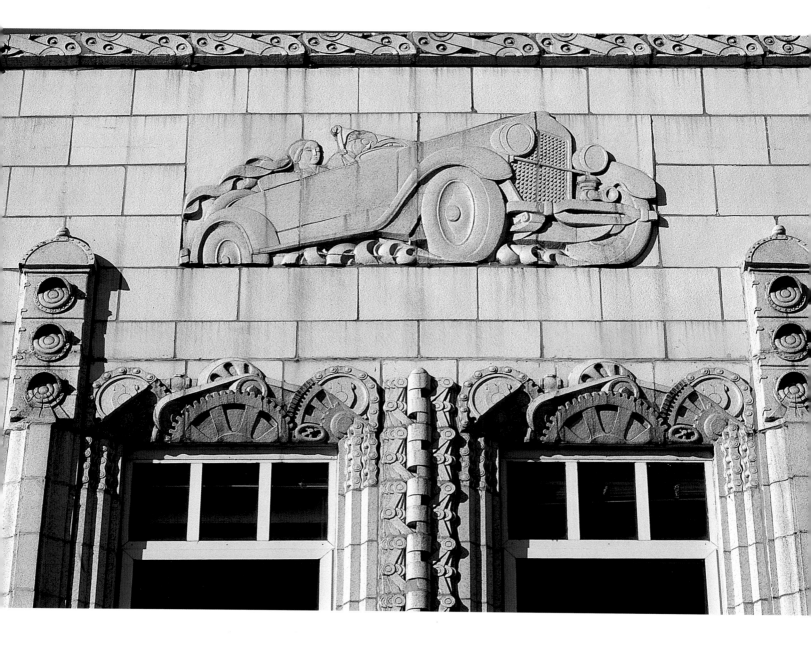

Detail of the former Ritz Garage, a flight of architectural fancy.
M. Louis Kroman, architect, 1929. The *AIA Guide to Chicago* calls it
an "Art Deco paean to the glamour of the roadster." Southwest
corner of 55th Street and Lake Park Avenue, Chicago, 2001.

Terra-cotta

For a long time Chicago was a center of the terra-cotta industry. The clay is accessible and cheap, and can be shaped into anything.

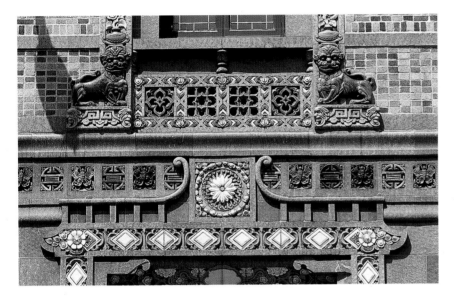

"Chinatown City Hall," On Leong Chinese Merchants Association Building, Chicago, 1927
This building, designed for the On Leong by Christian Michaelsen and Sigurd Rognstad, unmistakably marks the neighborhood as Chinese. It had a merchants hall, a dormitory for Chinese immigrants from the mainland, stores on the ground floor, and game rooms—until they were raided by the police. On Leong helped in getting Chinese immigrants to settle in the fringes of the old red light district, where real estate prices were low, and they encouraged newcomers to build in Chinese styles. The architects, even though of Norwegian descent, "got their Buddhist iconography right," Samuelson says.

Michaelsen and Rognstad had been trained to design typical Chicago-style commercial buildings. For this project, they had to figure how to do a Chinese building from scratch. They adopted motifs they found in monographs on Chinese architecture. Architect John M. Y. Lee sees in the building a basic commercial structure to which towers and decorations have been added.

ABOVE On Leong Chinese Merchants Association Building, detail. The flower at the center has been described variously as a Japanese daisy and a Chinese lotus flower. Chicago, 1999.

BELOW On Leong Chinese Merchants Association Building. Michaelsen and Rognstad, architects, 1927. 2216 South Wentworth Avenue, Chicago, 1999.

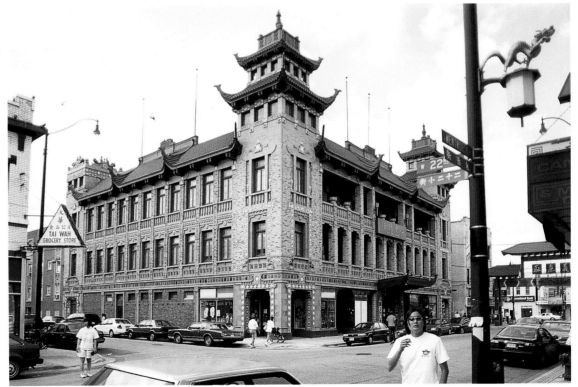

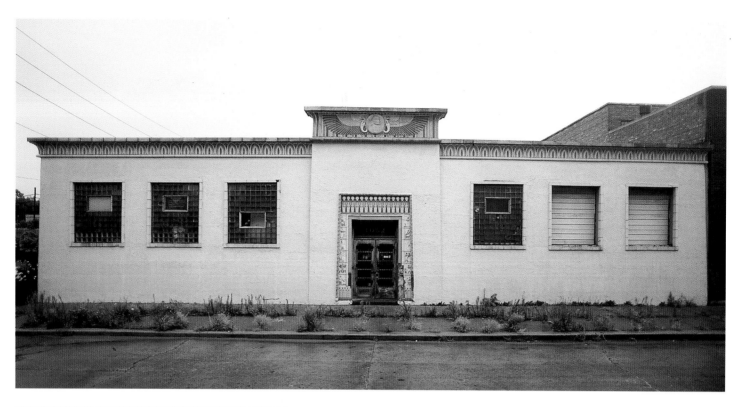

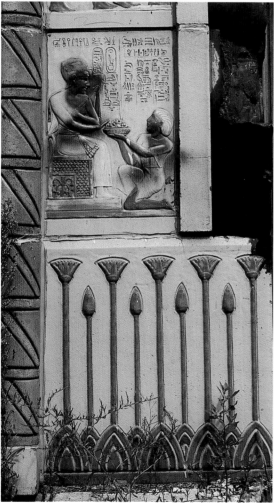

Egyptian Lacquer Works,
West Side, Chicago, 1926

"Would you ever expect to find a little Egyptian temple in an industrial area on the West Side?" asks Samuelson. Egyptian style was chosen to express timelessness and durability, the values embraced by Egyptian Lacquer Works, the company that once occupied the building. Even their wooden packing crates bore Egyptian motifs. The hieroglyphics on the building actually form meaningful texts. Fritz Albert, the designer, was an amateur Egyptologist. The building was designed by the Lockwood Company, architects and engineers.

This building is on Carroll Avenue, formerly an area of factories, now popular for its artist lofts. Once, at night, scavengers tried to remove the ornamentation, but neighborhood artists came out with baseball bats to defend the building.

ABOVE Egyptian Lacquer Works. 3052 West Carroll Avenue, Chicago, 1999.

LEFT Egyptian Lacquer Works, detail showing hieroglyphics. Chicago, 1999.

ABOVE Egyptian Lacquer Works, detail showing a row of cobra heads. Chicago, 1999.

LEFT Egyptian Lacquer Works, detail showing hieroglyphics. Chicago, 1999.

Uptown Broadway Building, Chicago, 1927

A plaque next to the entrance of this building reads: "This property has been placed on the National Register of Historic Places by the U.S. Department of the Interior."

"It looks like a movie theater without a movie," remarks Tim Samuelson. He takes me to the east end to show me how narrow the building is. "It is all front and no building, like a Hollywood stage set." He takes me to the west side of the building to see a sign saying, "Built by Al Capone," but the sign has disappeared. He comments on the stores it houses: Equator, African Wonderland Imports, Apsara Videos, Odile Hair Braiding, law offices, and Solret Hair Braiding. The people are of varied origins and races, and they look poor. They pass by, absorbed in their thoughts.

The Uptown Broadway Building is not one of Samuelson's favorites; he refers to it as "an overblown architectural confection." He regards it as an example of "terra-cotta abuse" and compares it to "an overdone, heavy, old, and expensive piece of furniture with gold and carvings," adding, "sometimes too much is too much."

On the other hand, I think of it as a spectacular building in a setting full of disconnected, transient people. The surrounding area reminds me of the movie *Blade Runner*. Samuelson agrees that the area around the Uptown Broadway Building would make a wonderful setting for a movie, commenting, "Such elegance by the side of the El! The neighborhood is nothing but contrasts and contradictions. It is a great urban thing."

An art historian I chatted with asked, "Is it famous?" She added admiringly, "Such a find, such a fantasy, such a narrow building. It reminds me of Venetian buildings that mix Roman, Eastern, and Islamic motifs. It represents the freedom to make a building carry any associations you want. Interesting and unusual buildings like this should be preserved."

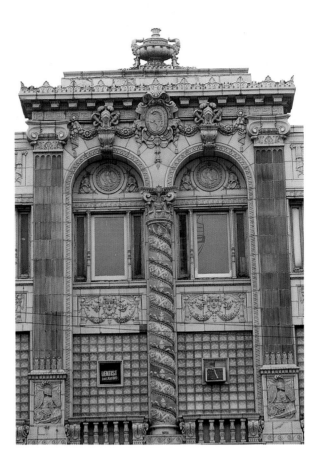

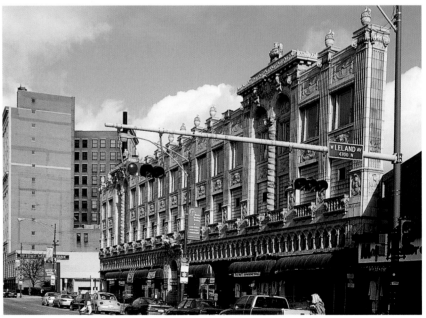

ABOVE Uptown Broadway Building, detail. Chicago, 2000.

BELOW Uptown Broadway Building, built in 1927, at the peak of terra-cotta's popularity. Walter W. Ahlschlager, architect. Banners on the street announce that the building is "A Certified Historical Landmark." 4707 Broadway Street, Chicago, 2000.

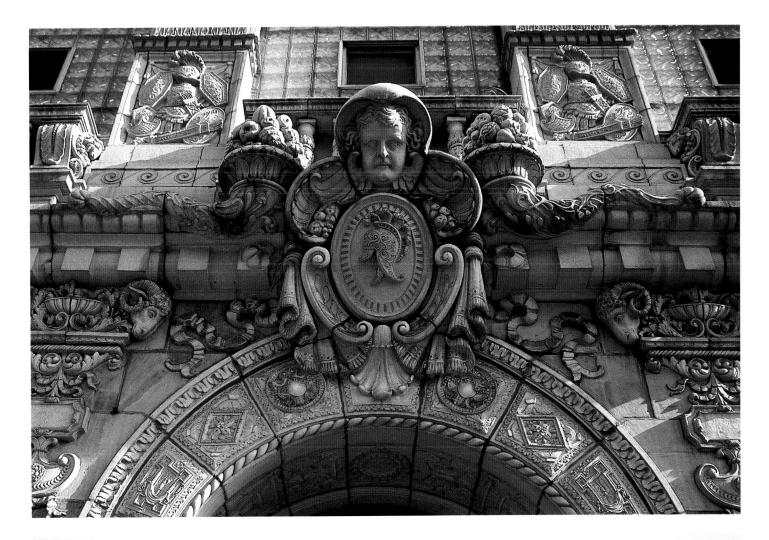

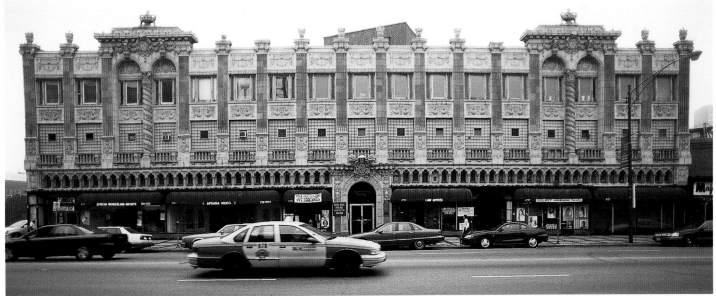

ABOVE Uptown Broadway Building, detail. Chicago, 2000.

BELOW Uptown Broadway Building. Chicago, 2000.

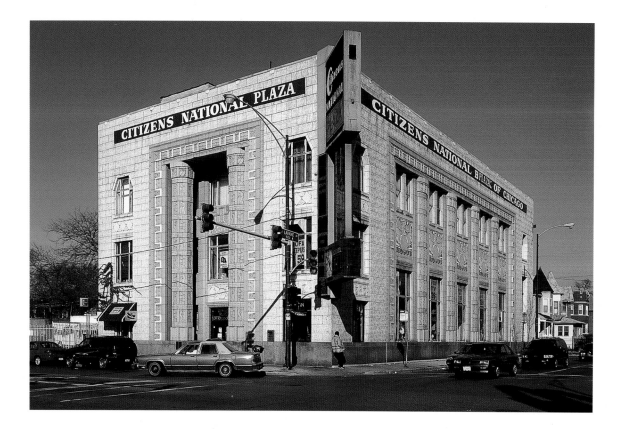

Former Laramie State Bank, remodeled by Meyer and Cook, architects, Chicago Avenue, Chicago, 1928
John Young and his partner, Earline Ruffins, bought this huge former bank building and transformed it into the only furniture store in the area. To make ends meet, they added a take-out hot dog concession and a place for people to pay their utility bills. Before they got the building landmarked, they had a standing offer from a buyer to purchase it. He intended to demolish it to build a vegetable market. The partners refused to sell, and now the former bank is falling to pieces and faces very expensive work. Repairing a landmark is a costly undertaking. The work often must be done using original materials that are hard to find and are much more expensive than ordinary ones, and standards set by the Landmarks Commission must be followed. For the former Laramie State Bank, changing the windows alone would cost half a million dollars, and that still leaves the expense of such things as roof repairs and a new furnace.

The building was redesigned in 1928, when the neighborhood was a magnet place to live for upwardly mobile young people. The former

Laramie State Bank was remodeled to attract new money with its color and ornamentation. It contrasts with older, more somber money temples.

ABOVE Former Laramie State Bank, now Citizens National Plaza. 5200 West Chicago Avenue, Chicago, 1999.

LEFT John Young and Earline Ruffins, owners of the former Laramie State Bank, now Citizens National Plaza, next to the plaque that declares the building a city landmark. Chicago, 1999.

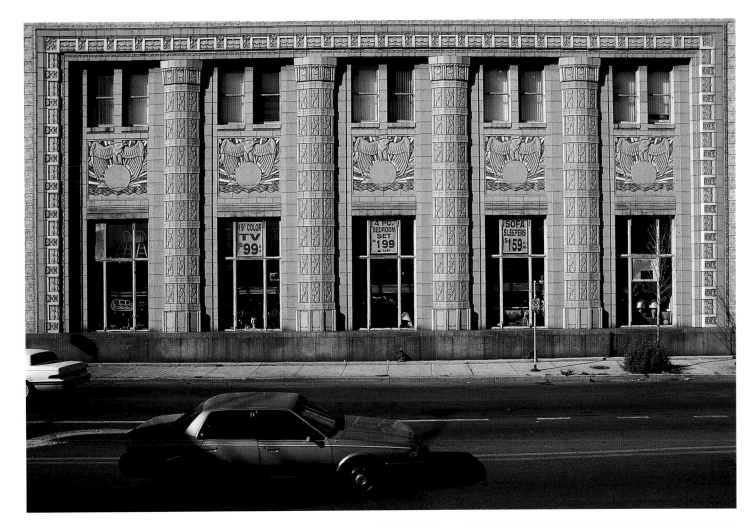

ABOVE Former Laramie State Bank, detail of the Laramie Avenue side. Chicago, 1999.

LEFT Furniture display, former Laramie State Bank. Chicago, 1999.

RIGHT Terra-cotta panels equating hard factory work with dollars. Former Laramie State Bank, Chicago, 1999.

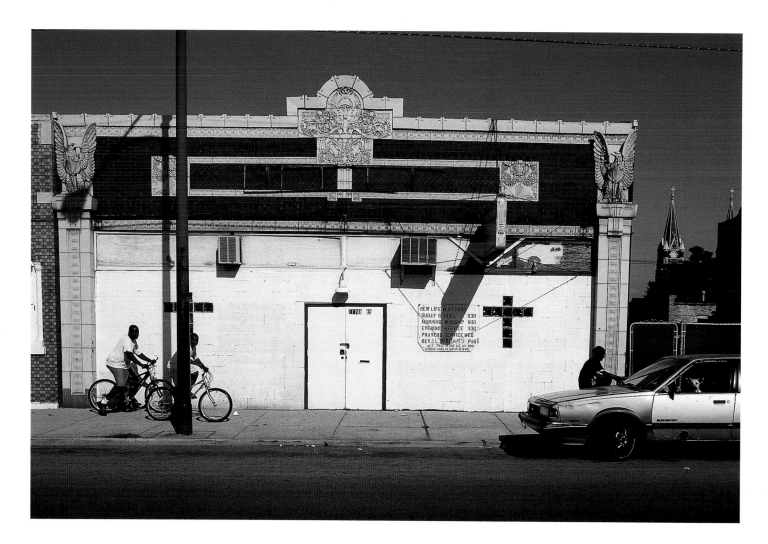

*Sullivanesque decorations on the facade
of New Life M. B. Church, Roseland, Chicago*

The decorations on this building, formerly a hardware store, were supplied by Midland Terra-cotta Company, which marketed them as "Sullivanesque." For architect Louis Sullivan, each part of a building, however small, emerged from the whole design, clearly not the case here.

Sullivan's architectural philosophy was that each building had to be a vital new solution that would express its time and place and exhibit its materials and structure honestly, not pretending to be something else. No two of his creations would be the same. He never talked about his design process from an artistic point of view; the buildings simply came from within. Samuelson believes that architects who claimed that they were honoring Sullivan by merely adapting the outward character of his architecture ended up insult-

ing him. Yet if one forgets that the loose imitations compromise what Sullivan stood for, Samuelson concedes, the derivative decorations add to the beauty of the city and keep the great architect's idiom alive.

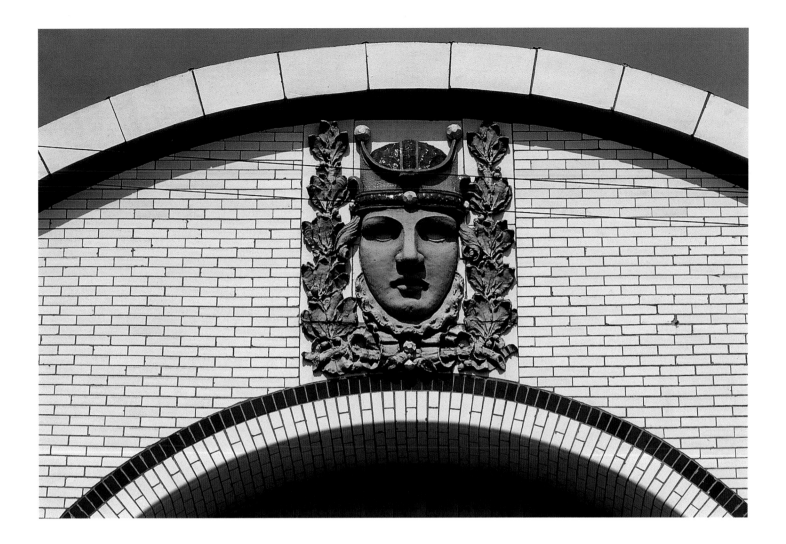

OPPOSITE TOP Sullivanesque decorations lend interest to the New Life M. B. Church, a former hardware store. 11743 South Michigan Avenue, Chicago, 2000.

ABOVE Ornament, originally designed for a movie theater, now serves as an icon for the Assyrian American Association. Henry Ross, architect, 1912. 1618 Devon Avenue, Chicago, 2000.

OPPOSITE BOTTOM New Life M. B. Church, detail of Sullivanesque decorations. Chicago, 1999.

Wright on the Ropes:
"Why Shouldn't Frank Lloyd Wright
Be Abandoned? Everyone Else Is."

The Waller Apartments, West Side, Chicago, 1895
These were very small apartments for families who
were just starting out. As residents became estab-
lished and had children, they moved to larger places.
These apartments, a semiphilanthropic effort by
E. C. Waller, were built for the same economic group
served by early public housing in the 1930s.

When he designed the apartments, Wright had
been out of Sullivan's office for only two years, and
he had not yet found his own style. The ornamenta-
tion is like nothing he did before or after. He stepped
the bricks in and out, achieving a harmonious repeti-
tion of form. The simple cornice, with its series of

small spheres, shows Wright's original turn of mind.
Every vestibule has four doors, so that each family
had its own entrance. The apartment block had a
symmetrical composition with one arch at each end.

The architectural continuity of the Waller
Apartments has been destroyed. One of the units is
missing, and two stand out after being rehabilitated
by the Landmarks Preservation Council of Illinois.
The color of the clean facades does not match that of
the uncleaned ones, and the bricks don't line up, rais-
ing the question of why the job was left incomplete.

The Wynant House, a Frank Lloyd Wright American System Built House, Gary, Indiana, 1916

For this dwelling, built in 1916, the wood was trimmed and cut to size in a factory, and the house was put together by a contractor. This method, called the "American System Built House," saved money by using mass-production techniques. This way, people could get a better house than they could have afforded by hiring a carpenter to cut and trim wood bought from the lumberyard. Wright was always tinkering with the idea of affordable housing of high quality. He took a risk by designing these houses in an unconventional style and expecting the general public to flock to them.

Built before America's entry into World War I, Wright's prefab houses were advertised as dream houses, masterpieces for everybody. The writer Sherwood Anderson wrote promotional materials for them. Few in number, Wright's prefab houses keep getting rediscovered in unexpected places, having been ignored by architectural historians.

The Wynant House is so decayed that restoring it means rebuilding it. This Prairie School house was last occupied in 1975, according to preservationist Christopher Meyers, who first discovered that the wreck was an authentic Frank Lloyd Wright house. The floor is torn out, the wood is rotten, and the plaster has fallen. An effort was made to preserve what was left of the building by covering the roof and windows with plastic and fencing the perimeter, but that did not stop it from taking in water. The house has foundation problems, and it looks skewed. The wood is so rotten that "you could take one of those two-by-fours and wring it like a dishrag,"

Wynant House, back view. Unlike other American System Built Houses that were so transformed by additions that they are unrecognizable as deriving from Wright, this dwelling, even though in ruins, still reflects the architect's vision. Southwest corner, Fillmore Street and Sixth Avenue, Gary, Indiana, 2000.

comments Samuelson, who has never seen a house in such bad shape. It is rare, he adds, "that a building has been left to the elements for so long that the basic structure just rots away and collapses." Meyers complains that a splendid house like this was ignored because, as a prefab, it never entered the Wright canon. But for others who wanted to move the house to California, Texas, Virginia, or Maine, the main obstacle to rehabilitation was its location.

John Taylor, a local heating and air conditioning contractor, gives his reasons for the neglect: "It is a tiny crackerbox house, it is not like the Oak Park ones, and you are living in the heart of the ghetto when you are done rehabbing it."

Tiny compared to the Robie House and Fallingwater, the Wynant House glows with humble magnificence. In late 2000, just as its forms were going to become a pile of debris, the dwelling was being rebuilt.

I ask Tim Samuelson: Why shouldn't Frank Lloyd Wright be abandoned? He replies: "Frank Lloyd Wright was creating more than just a building; he was creating buildings that everybody could notice and everybody could enjoy. Some buildings talk to you and give you delight. You don't need to know anything about architecture, you respond to them, they're appealing to the senses. What is amazing is that Wright's houses stood out when they were built and they stand out now, and something with a distinctive character is worth having around. His houses are something in the neighborhood that people from the outside come to visit. And having a delight in the neighborhood is a good thing. Nobody thought of the Wynant House as an ordinary building. There is something different about it. It gives a character and a presence to that neighborhood."

ABOVE Wynant House, 1916, one of Frank Lloyd Wright's American System Built Houses. The roof was recently removed, and the house is being rebuilt. Gary, Indiana, 2000.

MIDDLE Wynant House, interior view, roofless. Gary, Indiana, 2000.

BELOW Wynant House, interior view. Gary, Indiana, 2000.

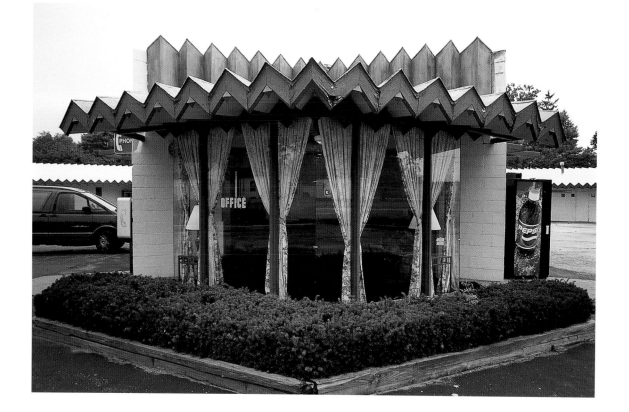

Snowflake Crystal Motel in St. Joseph, Michigan;
renamed Villager Lodge, 1959

Designed by the Frank Lloyd Wright Foundation, this snowflake-shaped building is unlike any other motel. It was done on a module. The building is very complicated; they had to make custom concrete blocks, at an angle, not square. The Snowflake never had a chance, since as soon as it was completed the federal government announced the interstate highway program that eventually bypassed it.

Mr. Patel, the manager, considers the former Snowflake Crystal a commercial enterprise and threatens to change everything so that it can turn a profit. He has already changed the name of the motel to the Villager Lodge because people found the former name laughable. He resents visitors like me who come and look at the building but don't stay there. According to Patel, the city "doesn't care and would like the land redeveloped. The building is old, but only one in ten thousand appreciate it."

Samuelson doubts that Frank Lloyd Wright, then in the last years of his long life, ever saw the Snowflake Crystal. He would like for a foundation to buy it and convert it into a summer camp for archi-

tecture students. The students would come in and help restore the building one quadrant at a time. They would take paint samples to determine the original colors of the building and gather as much of the original furniture as possible before it is sold. Speakers would lecture after work. There would be parties in the courtyard.

ABOVE Office designed by the Frank Lloyd Wright Foundation for the former Snowflake Crystal Motel, later renamed the Villager Lodge. 3822 Red Arrow Highway, St. Joseph, Michigan, 2000.

BELOW Interior view, office. Former Snowflake Crystal Motel, St. Joseph, Michigan, 2000.

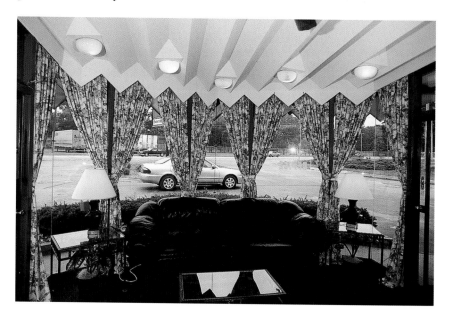

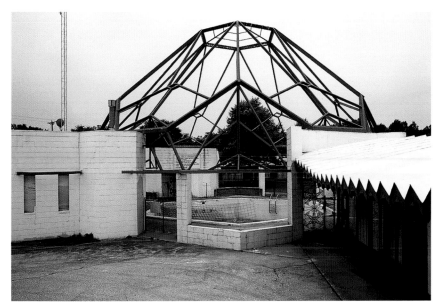

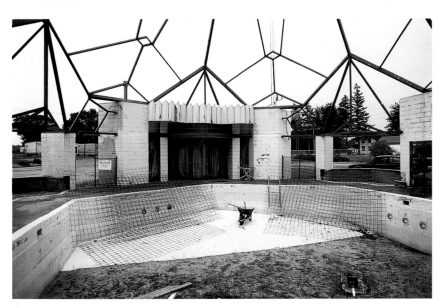

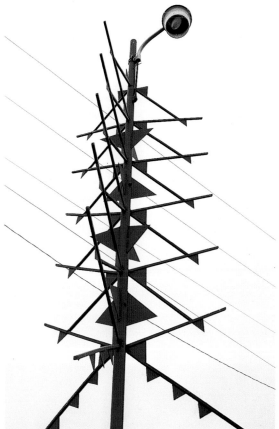

ABOVE View toward swimming pool, former Snowflake Crystal Motel. St. Joseph, Michigan, 2000.

MIDDLE LEFT Swimming pool, former Snowflake Crystal Motel. St. Joseph, Michigan, 2000.

RIGHT Light fixture, former Snowflake Crystal Motel. St. Joseph, Michigan, 2000.

BELOW Armature over the swimming pool, resembling the ceiling of New York's Guggenheim Museum. Former Snowflake Crystal Motel, St. Joseph, Michigan, 2000.

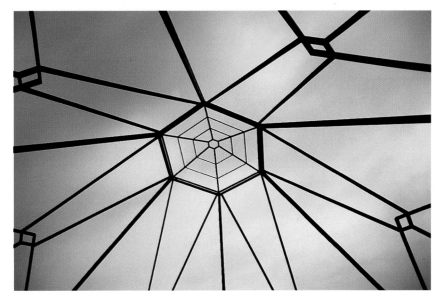

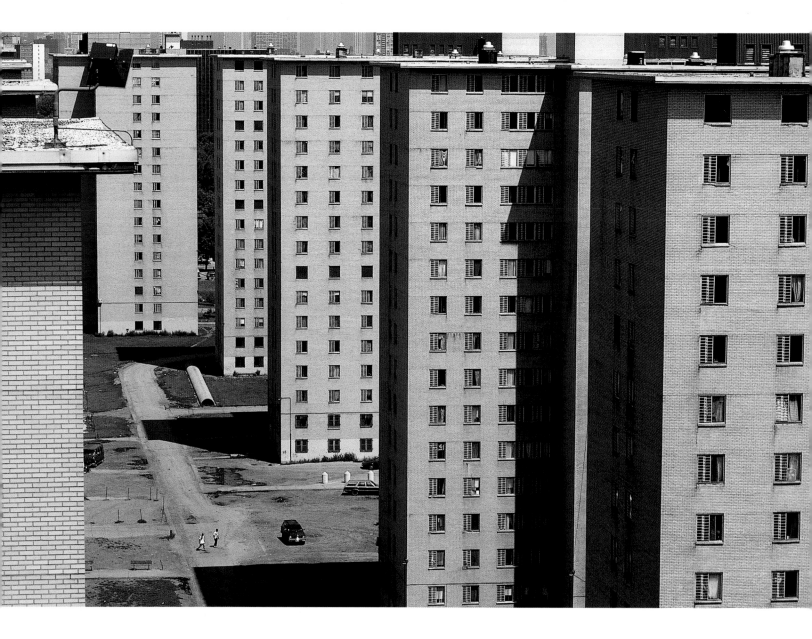

View north of the Robert Taylor Homes from the roof of 4555 South
State Street. Compared to the huge buildings, people seem as tiny as
insects. Chicago, 1995.

Modernism and Postmodernism

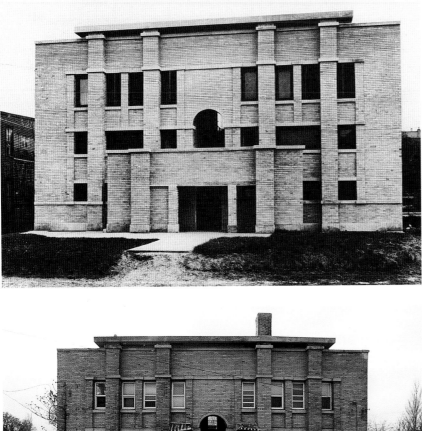

ABOVE "Cornell Store and Flats," seen from behind.
1232 East 75th Street, Chicago.

BELOW "Cornell Store and Flats," seen from behind. About ten years ago, Mr. Morgan put up a forbidding iron fence to stop people from trespassing. "They were coming using the front as a toilet," he says. "They would piss in front and shit around the building. I don't want them to get in here." Surprised at the irony of the building being compromised by excrement Samuelson comments, "It is 75th Street. You thought people would be breaking in and stealing your stuff and putting your life at risk." Chicago, 2000.

Modernism among the junk piles: "Cornell Store and Flats," Walter Burley Griffin, architect, Grand Crossing, Chicago, 1908

Grand Crossing, on the Illinois Central line, was once a thriving community. Later it became an industrial area. Now it is a lifeless backwater. This little building was designed by one of the masters of the Prairie School, Walter Burley Griffin. It represents one of the very rare ventures of the school into urban, commercial architecture—in this case, an apartment building with shops in the front on the ground floor. None of the shops remain. Griffin was one of the most talented of Wright's assistants. This was Griffin's last building in the United States before he left for Australia to build its new capital, Canberra.

The building, with its strong geometric design, is like no other in the city. The facade's projections and recessions create a wonderful effect of light and shadow. In front, a sidewalk rises from the street, so that the building is seen sitting on a platform. Behind, without the platform, an additional lower story is visible, with the entrance to the apartments through a warm and welcoming arch that contrasts with the rigid character of the rest of the structure. The building is topped very neatly with a terminating slab. Interestingly, this is a rare example of the back of a "store and flat complex" being given as much architectural distinction as the front.

Samuelson remarks of the building: "I tried to get the Chicago Landmarks Commission to designate it a landmark. But it is hard to make the case for a building sitting in the middle of junkyards, and one whose principal front faces the alley and seems to be strangled in a gigantic headlock by an iron fence."

Sid Morgan, the building's present owner, has never seen another like it. He was able to buy it at a decent price. He tells me: "The tenants like it; they do everything to stay."

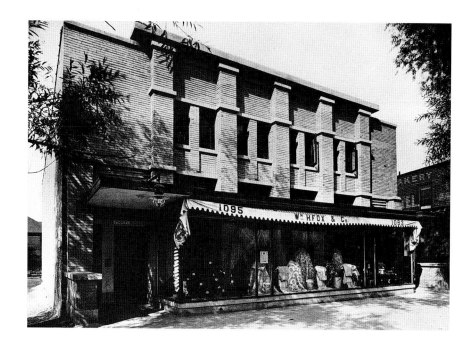

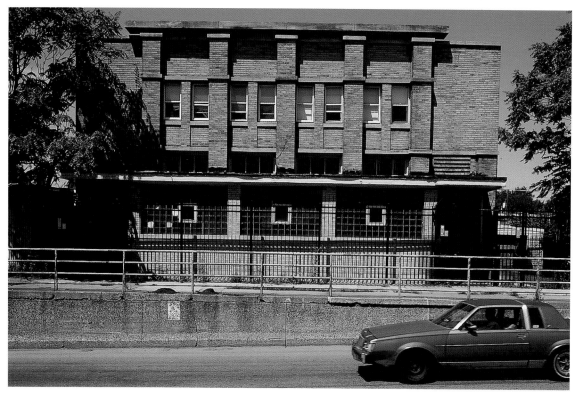

ABOVE Facade, "Cornell Store and Flats."
Walter Burley Griffin, architect, 1908.

MIDDLE "Cornell Store and Flats," street view. Chicago, 2000.

RIGHT Sid Morgan, owner, "Cornell Store and Flats." Chicago, 2000.

Bruce Goff's Myron Bachman House, remodeled in 1948, North Side, Chicago
Architect Bruce Goff often said that the way to approach a project is to throw away all preconceived notions of what a building should be. Earlier, when he served with the Seabees, he used corrugated aluminum to make Quonset huts. When he got the commission to remodel this 1890 wood-frame house, he returned to this humble material. The result was a transformation. The owner was, as usual, happy with the outcome, because Goff's policy was to pay close attention to his client's budget and lifestyle.

Many people in the neighborhood thought that the remodeling was terrible. The *Chicago Daily News* published a mocking article entitled "Have You Seen This One?" Another of Goff's projects, the Ford House, built in Aurora, Illinois, is one of his most famous. The owners, tired of being criticized by their neighbors, put a sign on their lawn saying, "We don't like your house either."

RIGHT Myron Bachman House, detail. Chicago, 2001.

BELOW Myron Bachman House, remodeled in 1948 by architect Bruce Goff. Commented Samuelson: "It is interesting to see the house in context. Part of its drama is that as you walk along the sidewalk it seems ready to leap out in front of you." 1244 West Carmen Avenue, Chicago, 2001.

A postmodern relic: Stanley Tigerman's Pensacola Place, North Side, Chicago, 1981

At a time when people were questioning the Miesian idea of a building with much glass and very little masonry, Tigerman decided to reconsider that tradition for Pensacola Place. Like others, he questioned whether a community can be made of "sterile" high rises. Tigerman's answer was a modern building that offered the illusion of being many different things, all designed to give the imagery of home to a high rise. A four-story horizontal building houses a supermarket, parking garage, and apartments. The flat top of this structure serves as a patio, with a swimming pool, and the base for a row of duplex apartments made to look like a row of small wooden Chicago houses, complete with tiny backyards surrounded by chain-link fences. These houses are surmounted by a modernist apartment high-rise, a slab at a right angle to the front of the building. The high-rise component has vertical rows of curved balconies that, shaft-like, lead up many stories to teardrop-shaped windows on either side, suggesting the form of an Ionic column, an homage to classical architecture.

In the past, Samuelson found the building troubling, because it made jokes about architecture. But now he finds that the structure is functional. The parodies give the well-constructed building visual interest. "Architecture," he says, "should lighten up once in a while."

Now, Pensacola Place is in limbo. It is too old to be new and too new to be old, a type of postmodern experiment that few architects still attempt. Many people regard Pensacola Place as being merely out of date, because it represents an architectural viewpoint from the recent past. Perhaps eventually they will accord it more intrinsic value. It is on the verge of needing major repairs, and the temptation may be to change it completely, destroying its unique merits.

Pensacola Place Apartments, view from parking lot. Stanley Tigerman and Associates, architects, 1981. 4334 North Hazel Street, Chicago, 2000.

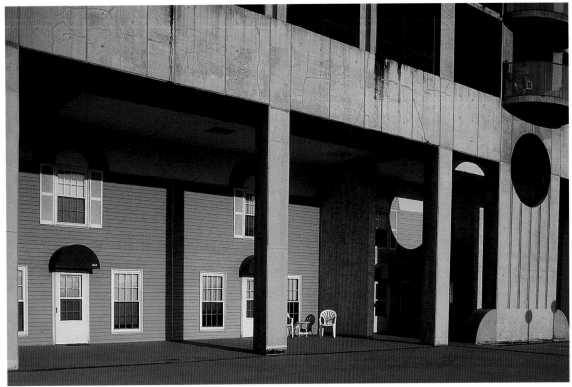

ABOVE Pensacola Place Apartments, view from North Hazel Street.
Chicago, 2000.

BELOW Pensacola Place Apartments, detail, aluminum-sided
townhouses on the fourth floor. Chicago, 2000.

Warren Williams, an engineer with the Chicago Housing Authority, poses happily on the roof of 3653 South State Street, part of Stateway Gardens. The all-inclusiveness of his gesture embraces the projects, which are in the midst of being demolished. 2001.

"That Is Where Poor People Went": CHA Family High-Rises

I visited the ABLA Houses on the last Friday of 1995, waiting at the maintenance shop for an hour until a worker could open up the door to the roofs for me. The small, noisy, smoky room was a command post. The mood was a mixture of warmth, humor, and worry. On the wall a sign said "Life Goes On." As demands for repairs poured into the office, I transcribed an office worker's flow of comments into the receiver, including frequent affirmative repetitions of the callers' complaints: "The water is coming there; it is a mess. It is coming from the wall. I am suing the fucking building. Tell them your building is flooding from that apartment.... I should have stayed my ass out!... I need cement for that hole over there. Water is leaking? I have 300 people on the line... Hold on, man. Hold, please. Thanks for holding. Have you put in this order before? What is your name? Where do you live? Account number? Hot or cold? ... They had to break in... they took the door out. They got the door from another apartment, I cannot lock the door... The toilet cracked? Shut the toilet off... I am going home. Happy New Year!"

ABOVE Elevator lobby. Rockwell Houses, Campbell and Washtenaw Avenues, Chicago, 1995.

MIDDLE Kim and her daughters in their living room, Rockwell Gardens, 2514 West Van Buren Street, Chicago, 1995.

RIGHT Tina, foreground; Gary, left; and Keith, center. Ida B. Wells Houses, 3855 South Ellis Avenue, Chicago, 1995.

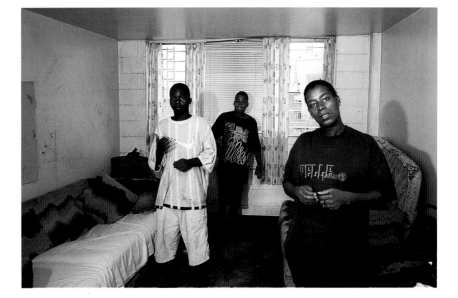

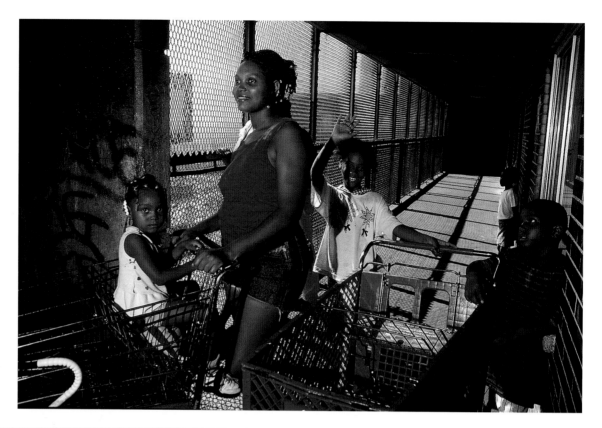

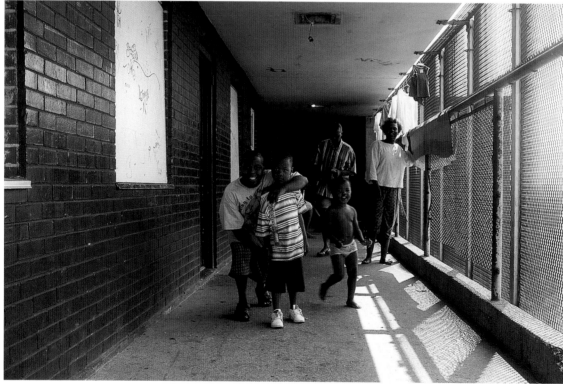

ABOVE Ann and family waiting for the elevator on the way to get free food from a local church. Sudhir Venkatesh, a sociologist familiar with the development, explained that a few shopping carts were kept around the building as community property, to be used to bring home groceries. Robert Taylor Homes, 4037 South Federal Street, Chicago, 1995.

LEFT Jamel, Cootie, and family. Rockwell Houses, 2501 West Monroe Street, Chicago, 1995.

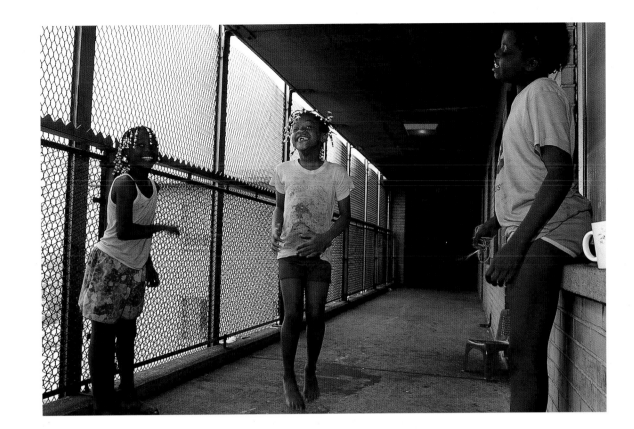

ABOVE Darleisha, Levita, and Gwendolyn jumping rope. The hallways of high-rise public housing are seen as the safest places for tenants to meet. Sometimes people leave their children there. Robert Taylor Homes, 5266 South State Street, Chicago, 1989.

LEFT Mary and baby. Robert Taylor Homes, 5100 South State Street, Chicago, 1999.

"Da Bone Yard!!!" 3615 South Federal Street,
Stateway Gardens (1959), Chicago, 2000
Alvin Rose, executive director of the Chicago
Housing Authority, told the U.S. Commission on
Civil Rights in Washington, D.C., in 1959, "You can't
call Stateway a ghetto. It is beautiful." I had gone to
3615 South Federal Street, a vacant seventeen-story
high-rise, to photograph graffiti, artwork, the con-
tents of refrigerators, and the surroundings, learning
about life in this project from what was left behind.

Some of the work was decorative. There were
flowers, hearts, tropical landscapes, birthday and
Valentine's greetings. Others represented "gangsta
life," epitomized by a mural of a graveyard presided
over by a skull smoking a long cigar. Surprisingly,
only one of the nine pictured headstones had dates.
Other decorations included portraits of celebrities
taped on the walls, among whom whites and blacks
were evenly divided.

I had been visiting the projects since 1980. But in
fall 2000 it was a different experience. The Bobcats
(small bulldozers) were busy inside, bringing down
interior walls. Workers were throwing appliances
and debris down the elevator chutes and removing
asbestos so that it would not contaminate the air dur-
ing the demolition. Wrecking balls were swinging
from cranes, destroying the outer walls. In freezing
weather, I saw small children with their mothers
leaving nearby occupied buildings, while dealers
loudly advertised their drugs and frisked visitors
coming in.

The residents and the wreckers formed separate
territories. Those inhabitants of the complex looked
at the ongoing demolition and went on with their
lives, while the wrecking crews did their work
behind a tall fence. On my next visit to 3615 South
Federal, it was reduced to an empty lot.

Graffiti was densest on the walls next to the eleva-
tor landings. Most of it consisted of scribbled nick-
names such as Duce-D, Ms. Angie, Ms. Mo-Mo, and
Sunshine. The popular "Long Live Ganster Kasper
Till the World Blows Up," which comes in many ver-
sions, was also there. Among the most bitter denunci-
ations was Ms. Kee-10 Nu's confession that she is
"lovin no nigga cause a nigga aint shit to love!!"

ABOVE Children at the swimming pool, 37th and South State
Streets, Chicago, 1987. This pool was rarely used; when opened, it
attracted so many people that children had no room to swim and
could only stand there and splash water.

BELOW View east from the lobby, Stateway Gardens.
South State and 36th Streets, Chicago, 1995.

An original voice was that of Charles Thomas, a Michael Jackson impersonator. He declares, "Jesus has been here in Charles Thomas body." He offers to lead people from the projects to "The White Sox Park U S Because White People Wants to Help the People in the Projects. My People in the Projects Have so Much Fear. They Are Scared to Come Out and Enjoy Life Because of Drugs, Killing's Gun's.

ABOVE LEFT Plaster medallion of the Virgin Mary on a bedroom wall. The Catholic religious symbol was surprising in a place where the residents are mostly Protestant. Stateway Gardens, 3615 South Federal Street, Chicago, 2000.

ABOVE RIGHT Portraits of "The Chicago G Boys" against a background of high-rise public housing and tridents—the symbol of the Gangster Disciples. Stateway Gardens, 3615 South Federal Street, Chicago, 2000.

BELOW "The World's Got Me Going Through Ah Thang," bedroom-wall mural of a graveyard by Shay. Although the mural shows nine tombstones, only one has birth and death dates. Stateway Gardens, 3615 South Federal Street, Chicago, 2000.

Bring Your Guns and Drugs to the White Sox Park." The White Sox stadium is just across the Dan Ryan Expressway from the building.

"Some of the commemorative stuff on the walls is immediate, sometimes it is written on the very day of a killing," explains Jamie Kalven, who has worked in the development for several years. He adds, "Most graffiti is by kids beginning to step away from home and taking a name, other is about everyday life, like the one saying 'Happy Birthday Mother.' Stateway itself gets represented. The whole building is a kind of text: gang stuff, kids asserting their identity, and religious fanatics."

ABOVE 3615 South Federal Street, part of Stateway Gardens, a project designed by Holabird and Root and Burgee, architects, 1959. Chicago, 1995.

BELOW Refrigerator with foodstuffs left behind by residents of Stateway Gardens. 3615 South Federal Street, Chicago, 2000.

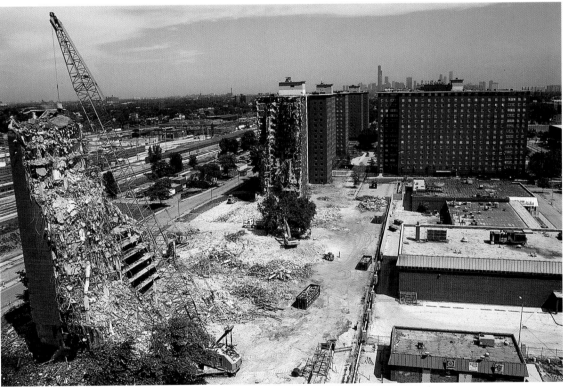

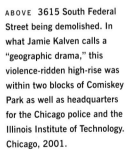

ABOVE 3615 South Federal Street being demolished. In what Jamie Kalven calls a "geographic drama," this violence-ridden high-rise was within two blocks of Comiskey Park as well as headquarters for the Chicago police and the Illinois Institute of Technology. Chicago, 2001.

RIGHT View north from 5100 South State Street. The mighty and familiar assemblage of sixteen-story-high buildings that stretched for two miles along the Dan Ryan Expressway is being razed. Chicago's skyline looms in the distance. Chicago, 1999.

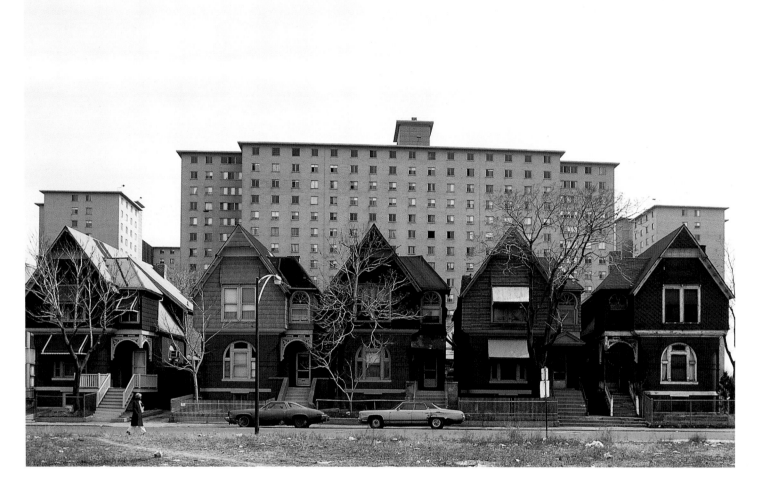

Unto dust, *Lake Park Houses*,
South Side, *Chicago*

Tim Samuelson's eyewitness account of the demolition of the Lake Park Houses runs as follows:

It was like a movie, but a silent movie and very anticlimactic. It was not the big boom you had expected, more like a little pop, pop, pop, then you see sections of the buildings beginning to come down. You were expecting more of a crushing sound as the buildings hit the ground. This gray, gritty dust blew right across the drive. Then the sun was coming out and it turned it into an orange cloud. You could not see Lake Shore Drive or anything; it was like you were at the center of this gigantic cotton candy. There was an acrid smell like on the Fourth of July when kids are setting off firecrackers on the street. You were literally blind, you couldn't see anything, could hear voices, hear people cough.

Then the sun shone through, and the dust settled, and everyone and everything was caked in dust. Kids in strollers were completely gray, like they were moving sculptures. People were trying to brush their clothes, but the dust wouldn't brush off, and their faces and hair were covered with this grit too. A mother asked her little boy, "How was it?" And the boy answered, "It was great." Then the mother said, "It was awful, the dust and the dirt. God knows what was even in it, even asbestos." A dust-covered caravan of people walked back to their homes. It was about 9:00 A.M., and I was dressed up to go to work, but I had to go home and wash up. They had shut down Lake Shore Drive and the trains were not running.

OPPOSITE Three occupied high-rises, part of the Lake Park Houses. The English-style cottages in the foreground were designed in the late nineteeth century by the English-born architect Cicero Hine. View along 42nd Place toward Oakenwald Avenue, Chicago, 1980.

ABOVE Row of Victorian houses left after the demolition of the high-rises. Architectural historian David Smiley comments, ironically, "Of course, the neighborhood is okay now." Chicago, 2001.

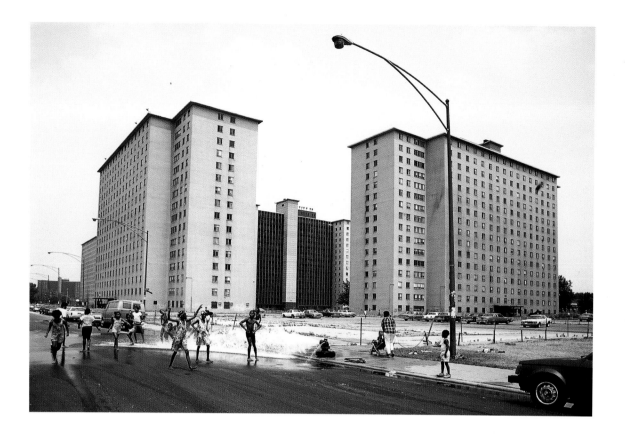

Robert Taylor Homes, Chicago:
"It was fun while it lasted, now it is time to move
on. Power to the People!"

A daily sight for hundreds of thousands of drivers who pass by them every day are the Robert Taylor Homes: formerly twenty-eight buildings, each sixteen stories high, with a total of 4,500 apartments. Completed in 1962, they stretch for two miles along the Dan Ryan Expressway. The Robert Taylor Homes were isolated and segregated from the start, and they became more so as the businesses and homes to the east were left vacant and then demolished. Here, as in other Chicago Housing Authority projects, some of the poorest people in the nation—the majority of them women and small children—live in badly maintained high-rises controlled by gangs.

The Robert Taylor Homes have posed a continuing challenge to anyone interested in urban American poverty and segregation. Forming a long narrow stretch of red and white buildings of stark modernistic design, they were conceived by the Chicago office of Skidmore, Owings and Merrill. The plans were signed by Nathaniel Owings, one of the part-ners of the firm. Samuelson calls them "a big mistake, good intentions gone wrong, a relic of an unsuccessful idea, big slabs sitting in isolation right on the expressway." "They could not have been swept under the rug," he says. He sees their demolition as the only way out, commenting, "The Robert Taylor Homes had reached the end of their useful life. It takes courage to erase what is perceived as a mistake."

In the 1930s Chicago had built smaller units of public housing that, in Samuelson's opinion, could have been "nice living environments, with an open area between buildings, every unit having individuality and many entrances." The architects of the Robert Taylor Homes "blew up the old prototypes, and the new high-rises were too big for their own good." Individually, the buildings were like those in other smaller projects such as the now-demolished Lake Park Houses and the soon-to-be-demolished Washington Park Houses. But these did not make any grandiose urbanistic statement, and so their demise has less symbolic weight.

View north from 4500 South Federal Street. Robert Taylor Homes, Chicago, 1988.

Over two decades of photographing the Robert Taylor Homes, I have always wondered how such powerful forms affected the consciousness of the residents. People seemed so small when compared to the big buildings and the high-rises so disconnected from ordinary life.

It is difficult to imagine the accumulation of filth that I saw inside the buildings: stinking stairways and elevator lobbies, elevator cabs that reeked of urine, and garbage disposals that seemed permanently clogged. On the ground floor, gang members stared at visitors. Sometimes the lights were out in the elevators or they did not stop where one wanted them to stop, a situation made worse by the crowding.

In the hallways children skipped rope and rode bicycles, people got haircuts, and families barbecued. In a dangerous environment, the hallways were the safest place for people to live out their daily lives. Residents had tenant meetings and birthday parties there.

On the roof of the elevator penthouses the architects placed the only curves in the design. Samuelson proposes to bring one of these elegant penthouses down to the ground to house his Museum of the Projects, a place to remind people that the Robert Taylor Homes were there. My commemorative plans to preserve the identity of the development are less ambitious: I would like an elevator cab to be preserved in its present condition for visitors' use at the Chicago Historical Society.

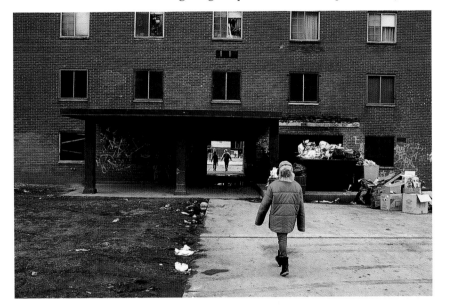

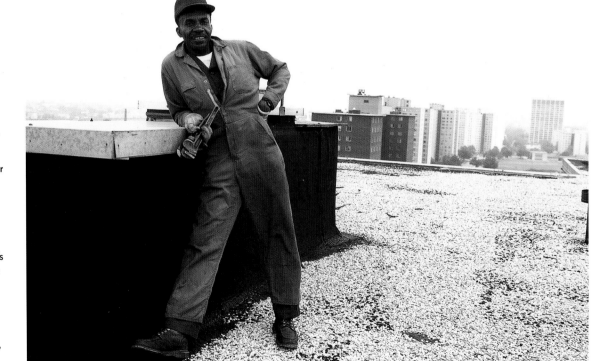

ABOVE Entrance to 4840 South State Street, Robert Taylor Homes. Chicago, 1987.

RIGHT Curtis Smith, elevator repairman for the Robert Taylor Homes, on the roof of one of the high-rises. Curtis advised me to tell inquisitive people that I worked for housing and was there to improve things. Curtis's son had followed in his father's footsteps and become an elevator mechanic at the Sears Tower, literally and figuratively reaching the pinnacle achievement of his profession. South State Street, Chicago, 1989.

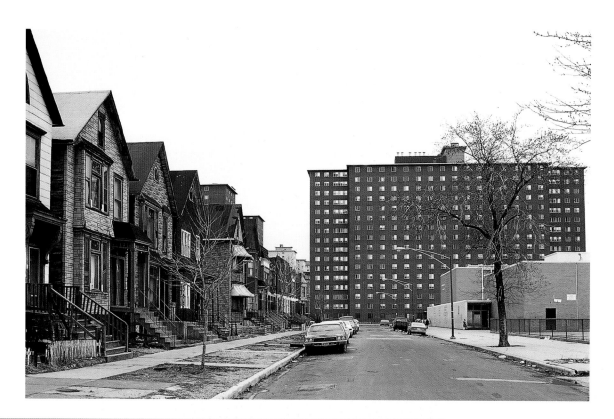

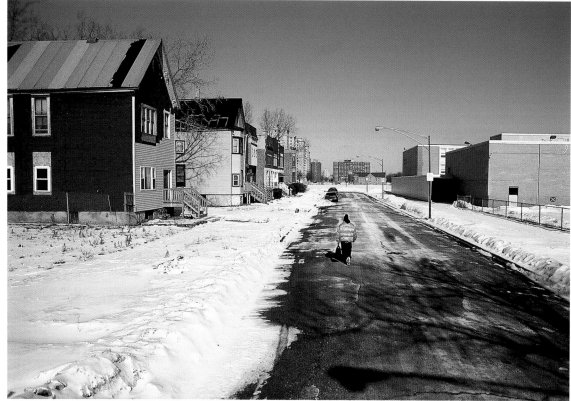

ABOVE View north along Dearborn Street from Garfield Boulevard, the southern end of the Robert Taylor Homes. The detached frame houses at the left of the photograph are like those declared slums and demolished to make room for high-rises in the early 1960s. Chicago, 1980.

LEFT View north along Dearborn Street from Garfield Boulevard, the southern end of the Robert Taylor Homes. Upon seeing the buildings disappear one by one, Samuelson commented, "Soon you will see downtown." Chicago, 2001.

A small bulldozer tearing down the interior walls of 5266 South State Street to remove asbestos prior to demolition. Robert Taylor Homes, Chicago, 2000.

Churches

Pilgrim Baptist Church, South Chicago, ca. 1890
Parts of *The Blues Brothers*, a very funny movie and a Chicago cult classic, were filmed in the sanctuary of this church. Samuelson describes it as: "an old wooden church far away from the city center. It had a cross tilted at a crazy angle on the top of the steeple—it was removed and is now in storage. There used to be a lot of churches like that, but there aren't many left."

Minister H. C. Hudson tells me that Pilgrim Baptist Church was formerly a German Lutheran church, but for eighty-three years it has had an African-American congregation. The black population of South Chicago has been moving out, but members of the Pilgrim Baptist Church continue to come to services from such nearby suburbs as Palatine, Harvey, and Chicago Heights.

OPPOSITE Pilgrim Baptist Church, originally a Lutheran church built in the 1890s. The building was used as a set for the movie *The Blues Brothers.* Southeast corner of 91st Street and Burley Street, Chicago, 1999.

"A Monument to Robbins," Growing in Grace Ministry Church of God, Robbins, Illinois, 2000
I first encountered this church, at 138th Street, a decade ago when I expanded my documentation of Chicago to two black suburbs south of the city limits: Ford Heights and Robbins. These communities had been ranked as the first and third poorest suburbs in the nation by the 1990 census.

In January 1991, the True Pentecostal Church, Apostolic Faith, was at 3800 West 138th Street. Reverend Cornelius Mondane Jr. bought the church in September of that year for twenty thousand dollars. "You could stand on the floor and look through three floors and see the sky," he said. "My idea was to fix it. That building was on the demolition list when I bought it. On the main streets of Robbins, if you have any raggedy eyesore, they tear it down. Had I not stepped in, they would have torn it down. I could have spent my money in a better community," he added, but "Jesus never walked away from the poor."

Mondane loves the building, calling it "a monument to Robbins." He wanted to "restore something in Robbins so people could say there was something decent." He had a "whole brand-new roof put on" and painted the church battleship gray. Now the congregation is asking him to paint it white because "God is pure and clean, and churches need to be white."

The deteriorating True Pentecostal Church, Apostolic Faith. To Samuelson, the church resembled a toolshed next to a grain elevator. 3800 West 138th Street, Robbins, Illinois, 1991.

LEFT The True Pentecostal Church, now acquired by the Growing in Grace Ministry Church of God in Christ, with a brand-new roof and battleship gray paint that makes it look like a barrack. 3800 West 138th Street, Robbins, Illinois, 1996.

RIGHT The Growing in Grace Ministry Church of God in Christ, with a recent addition to the front. According to Pastor Cornelius Mondane Jr., the building is "an oasis in the desert and a monument to Robbins." Robbins, Illinois, 2000.

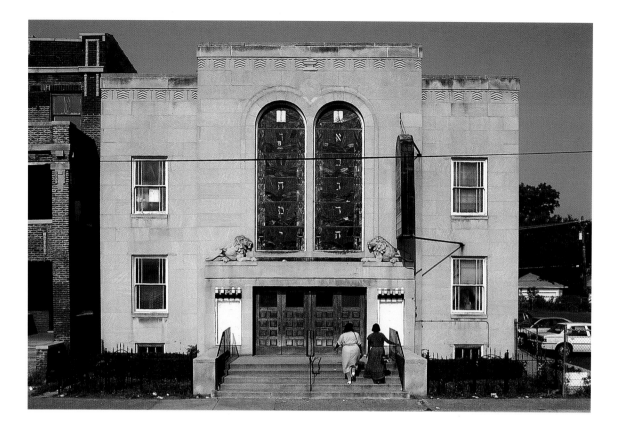

Two former synagogues, Lawndale, Chicago

Lawndale, on the West Side of Chicago, was a large Jewish community with many synagogues. For more than three decades, the area has been predominantly black, and the synagogues have been converted into African-American churches. Still, in glass and stone, the Jewish imprint persists in these houses of worship. For Samuelson, the black congregations in the former temples are part of "a natural evolution. They are like sea creatures that occupy the empty shells of other creatures."

Some of the neighborhood's religious leaders are uncomfortable with prominently displaying symbols on their churches that represent a different faith, but they didn't go out of their way to obliterate them. For almost three decades, the Pleasant Ridge Missionary Baptist Church has been located in a former synagogue on Central Avenue. Pastor Joseph Jones is eager to build a black church "without the Jewish symbols, with Christian cross symbols, symbols which represent our redemption and our salvation." He told me that Jews driving through the neighborhood are surprised to see a surviving piece of their history in unfamiliar terrain. Occasionally,

they stop to ask questions; one man was interested in buying the stained-glass windows inscribed with Hebrew letters.

Former synagogue, now Pleasant Ridge Missionary Baptist Church. 116–118 South Central Avenue, Chicago, 1995.

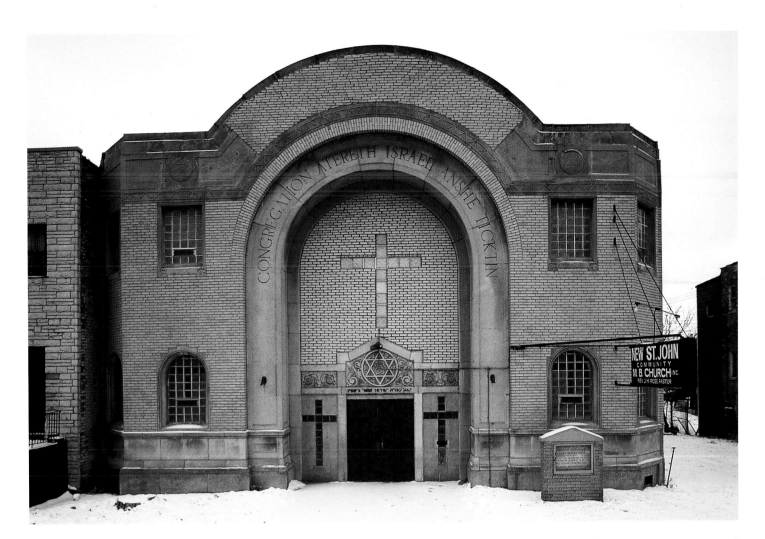

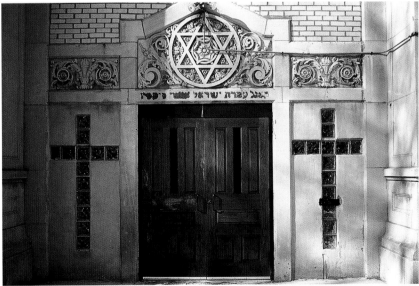

ABOVE New St. John Community M. B. Church, former Congregation Atereth Israel Ticktin. South Millard Avenue between Roosevelt Road and 13th Street, Chicago, 1990.

RIGHT New St. John Community M. B. Church, detail showing the Star of David flanked by glass crosses. Chicago, 2001.

Truth, purity, and beauty:
Christ Temple Mission Church, Gary, Indiana

Three decades ago, according to a neighbor, "There was a tent on the site of the church. Then they started building the church, and that was as far as it went." The neighbor doubts that such a small congregation can get the resources to add to the building. Even as is, the interior of the church is clean, spacious, comfortable, and filled with daylight. Assistant Pastor Antoine Rogers, who is also a truck driver, remarks: "We never had a top. The church is a replica of the old way of Christianity. I'll tell you a secret. A lot of miracles take place here." He is defensive about the appearance of his church and complains: "Beauty seems to be the norm of things. Everybody seems to be looking for beautiful things, but everything that is beautiful is not pure." His congregation is "seeking purity, which is the truth." Assistant Pastor Rogers tells me that their vision is "to make it bigger." The congregation is planning to continue building while conducting services in the basement. When I ask him about the plans for the completed building, he makes a conventional drawing of a church with a steeple and two crosses.

I could not help thinking that Assistant Pastor Rogers would have loved to have an impressive church, and that his drawing was an attempt to capture that vision. Yet I also would have wanted him to stick to his belief in "purity, which is the truth," and in the "old way of Christianity," when "Christ was walking barefoot." I, too, mistrusted beauty. I thought it to be short-lived and often corrupt, but I could not help finding it everywhere and falling under its spell. I was passing through Gary on my way to Chicago from Detroit. During the long drive, I had been listening to poems by John Keats. The final two lines of "Ode on a Grecian Urn" (1819) stayed on my mind: "Beauty is truth, truth beauty—that is all ye know on earth, and all ye need to know."

Assistant Pastor Antoine Rogers. Christ Temple Mission Church. Northeast corner of Maryland Street and 25th Avenue, Gary, Indiana, 2000.

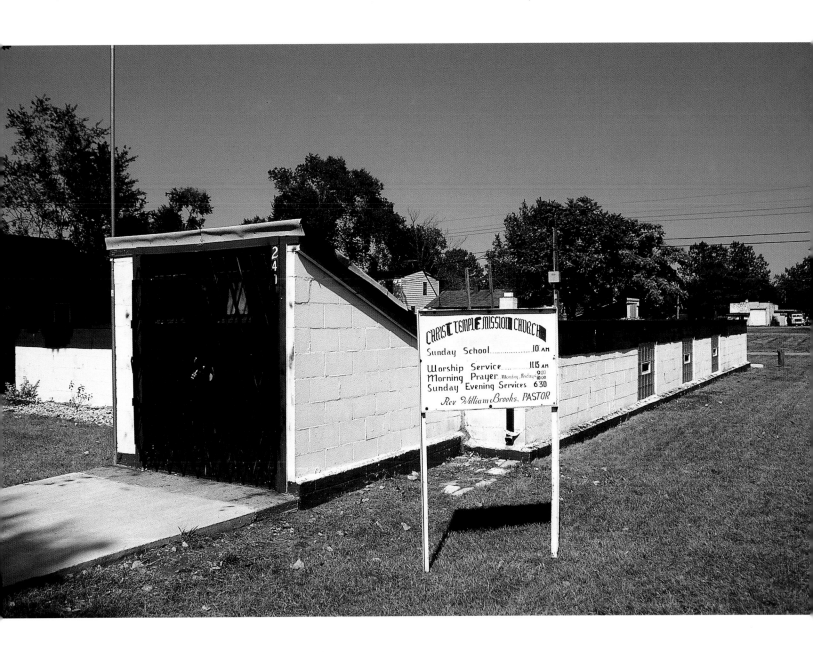

Christ Temple Mission Church. Gary, Indiana, 1999.

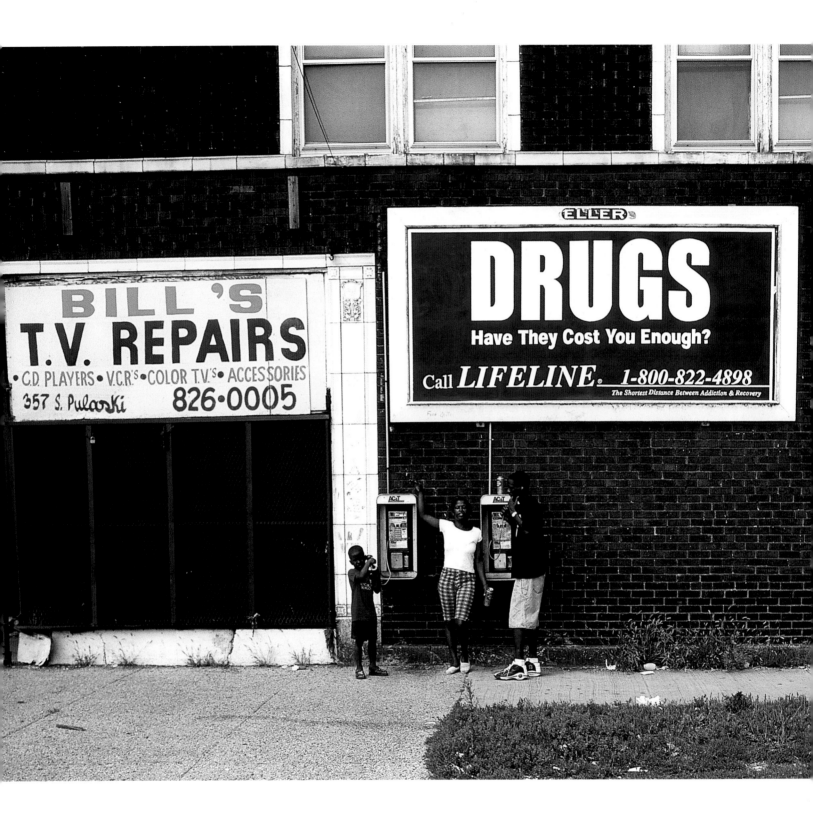

Billboards

OPPOSITE Billboard warning against drug abuse. Northeast corner of Van Buren Street and Pulaski Road. Chicago, 2000.

BELOW Public service announcement, part of a peace campaign. Pershing Road west of Langley Avenue, Chicago, 2001.

The street furnishings of segregation:
Public service billboards

Chicagoland's ghettos, like those elsewhere in the nation, display public service announcements along their main thoroughfares. They enjoin people not to kill each other, advise them to seek help with their drug problems, urge them to change racist attitudes, and encourage the physically abused to seek help. These large announcements are another of the many elements that make ghettos different from the rest of the city. Billboards are often rented out at discount prices or even free of cost by the companies that own them in order to spread the word.

Cities specialize. Los Angeles, for example, devotes most such billboards to sex-related issues: avoiding AIDS and pregnancy and warning against

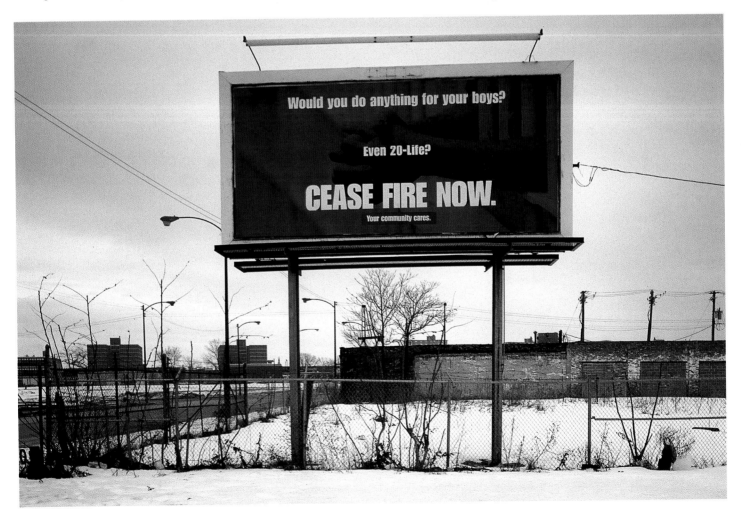

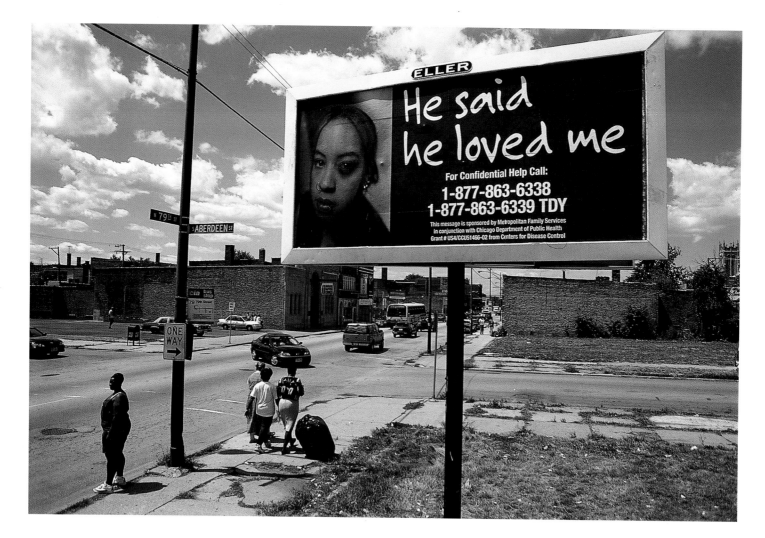

sexually abusing minors. Murder, domestic violence, and drugs are Chicagoland's main themes. Anti-abuse billboards are part of a campaign in areas such as Englewood, where the problem is seen as serious, but not in other, more affluent communities, where abuse also takes place.

The sponsors admit that if these billboards went up in affluent communities they would offend people's sensibilities, adversely affect real estate prices, and be perceived as visual pollution. The director of communications of an organization responsible for a domestic violence campaign wishes that their ads could be seen everywhere and praised New York City for placing similar announcements in the subways, where they reach a much wider population.

As I travel along empty lots on Chicago's South Side, signs form a litany about murder, prison, racism, drugs. An orange billboard against the gray sky and white snow shows a pair of hands through

iron bars, warning against murder. Huge white letters against a black background read: "DRUGS... Have they cost you enough?"

Samuelson remembers the neglected buildings that used to be where the billboards are now. "Standing in isolation," he said, "they look to me like a bizarre urban crop growing out of the city's ruins."

Public service announcement on the subject of spouse abuse, sponsored by Metropolitan Family Services, the Chicago Department of Public Health, and the Centers for Disease Control. Northeast corner of 79th Street and South Aberdeen Street, Chicago, 1999.

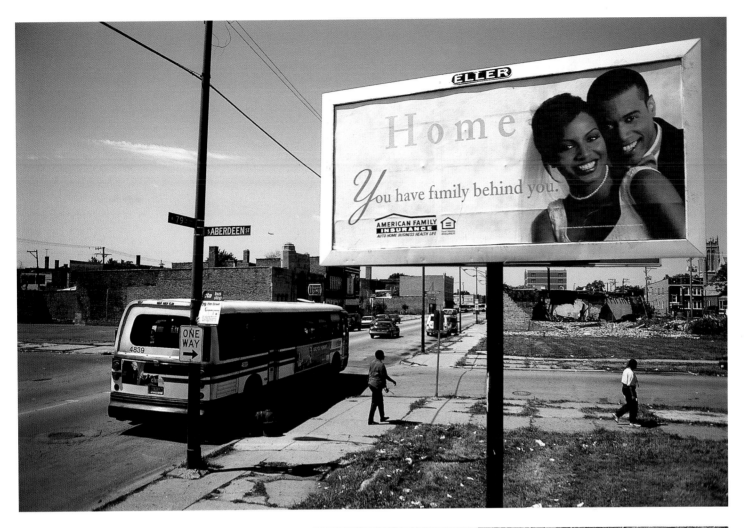

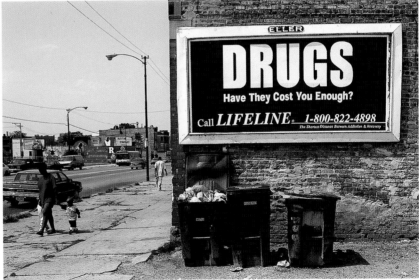

ABOVE Billboard advertisement for American Family Insurance replaces the grim, bruised face of a woman with a smiling couple. Northeast corner of 79th Street and South Aberdeen Street, Chicago, 2000.

RIGHT Billboard, part of a campaign encouraging people to seek treatment for drug abuse. The ghetto neighborhoods where these signs appear are also in need of "treatment." Roosevelt Road by South Springfield Avenue, Chicago, 2000.

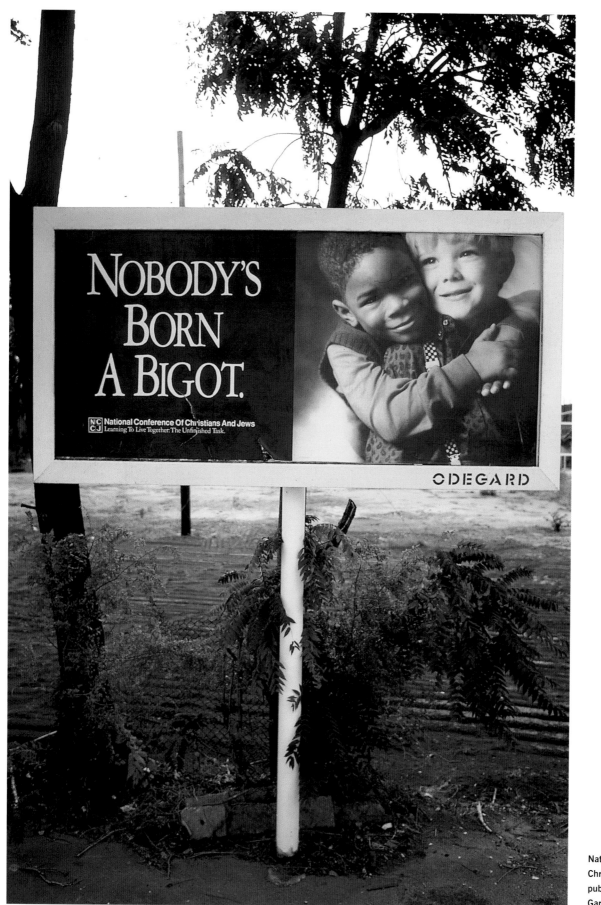

NOBODY'S
BORN
A BIGOT.

NCJ National Conference Of Christians And Jews
Learning To Live Together: The Unfinished Task.

ODEGARD

National Conference of
Christians and Jews–sponsored
public service announcement.
Gary, Indiana, 1991.

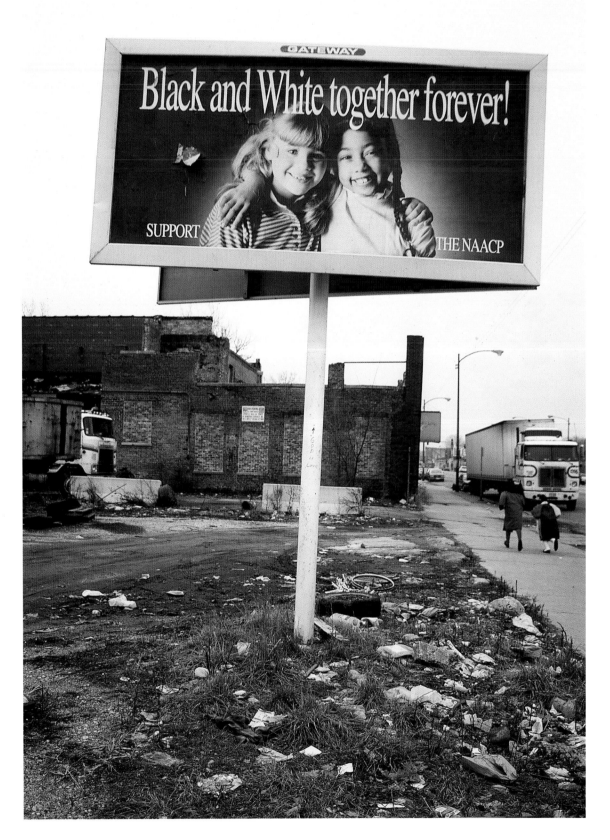

NAACP-sponsored public service announcement placed only in ghettos to combat racism. The message that blacks and whites should be "together forever" is absurd in segregated Englewood. South Ashland Avenue and 60th Street, Chicago, 1992.

Signs from the Heart

OPPOSITE Sign on a vacant storefront. Broadway between Fifth and Sixth Avenues, Gary, Indiana, 2000.

BELOW Painted sign, "Shoe Doctors." The artist had freedom to do what he wanted; the sign took three hours to complete and cost $175. The owner of the shoe-repair shop finds it "eye catching." 4906 West Madison Street, Chicago, 1999.

Assorted signs: "A desire for a world of innocence"
In an era of global communication, can a distinctive local style develop in isolation from mainstream commercial advertising? For two and half decades, I have searched for alternatives to corporate design, for authentic forms coming from isolated communities. This entailed photographing folk-style commercial signs and graffiti in large, segregated urban areas. The signs that I find vary, yet often overlap, in their colors, forms, and placement. Those who commissioned them "would have been delighted to have professionally designed announcements," says Samuelson, "but those are expensive. These people

need to put their money into the basics of what they are trying to do."

Yet others, such as Mrs. Shelly, a South Side Chicago soul-food restaurant owner from Mississippi, hold different opinions. Even though she can afford a professional sign, she asked her nephew Jason to make one on a chip board and to create a "down home look." The bright lights of the city, she explained, "take away from home." Bill Ganley commented: "Her sign portrays her real roots and is part of her heritage … it depicts the place where she learned her cooking, it gives her place a little charisma. She gently persuades us to buy her wares, without burning it on our minds the way corporate America has done."

Itinerant painters and students often make these signs from whatever paint happens to be available. "They are created by people who have a strong desire to express themselves, and this is the one great opportunity they get to create a highly visible piece

of art," explains Samuelson. "If you have an acute sensibility, they look crude, jarring, and grotesque, but to people interested in folk art they are great because of the boldness of their undisciplined character." He adds: "People who made these signs break all the rules, and in doing so, something unique and creative comes about. They don't follow the niceties that one learns in art education. What they lack in technique they make up in heart."

I was delighted to find the sign saying "I DOLLAR, almost everything" in a vacant storefront on Broadway in Gary. I thought it was witty for the artist to have changed from red to white for the letter "t" in the word "almost." But my friend Samuelson disagreed: "Those are pressed-on letters," he said. "The artist ran out of red "t"'s; you only have so many letters." I was unable to discover if Samuelson was right, but, meanwhile, I like to think that this sign was produced by a talented untaught artist.

B & E Country Store.
2452 West Harrison Street,
Chicago, 1987.

ABOVE Mrs. Shelly's Soul Food.
5428 South Ashland Avenue.
Chicago, 2001.

RIGHT The artist who painted
these garments on the wall of
J. W. Warehouse, a used
clothing store, was paid ten
dollars plus the cost of
materials. 3433 West Madison
Street, Chicago, 1996.

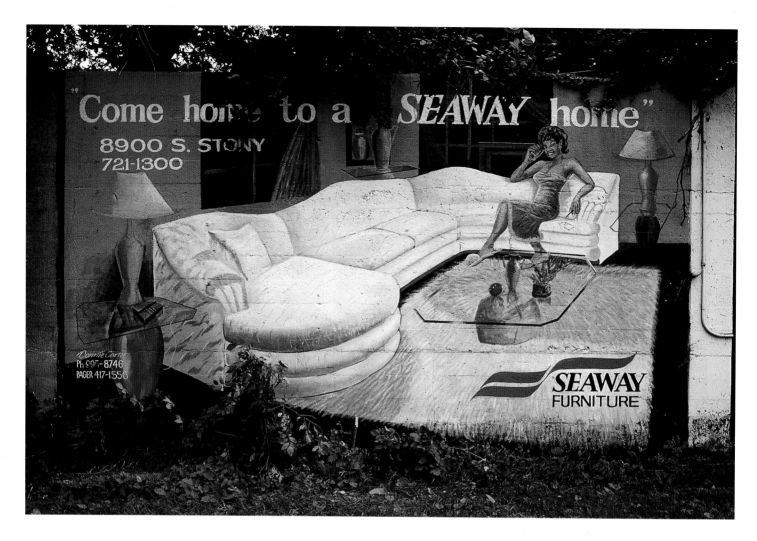

The white couch fantasy, advertisement for Seaway Furniture, South Side, Chicago, 1999

Richard McGuire, Seaway's manager, explains, "The white couch symbolizes status and security; it is luxurious, artistic, and comfortable; it sells well; its style does not go out of fashion. Everyone is entitled to come to a comfortable home." The white couch sells for $2,700, and, normally, children aren't allowed to sit on it. A woman elegantly dressed in at-home wear talks on the telephone, and no family members are in sight. The glass-topped table and shaggy white rug add to the clean, serene look, creating a special place away from the hustle and bustle of family life.

In this outdoor mural, the rug blends with the untrimmed edge of the lawn, creating the inviting illusion that the spacious white living room is open to the outside world.

The white couch, an ad for Seaway Furniture.
South Chicago Avenue and 67th Street, Chicago, 1999.

ABOVE Sign, Shantelle's Beauty and Barber Salon. 3010 Roosevelt Road, Chicago, 1997.

RIGHT Sign, G-Man's Barbershop. Upon seeing me photographing the sign, a passerby asked: "You cut hair or something?" Then, when I asked him what the sign meant, he said: "It's just a design, [inspired by] Snoop Doggy Dogg, something different." Pershing Road, east of South Giles Avenue, Chicago, 1998.

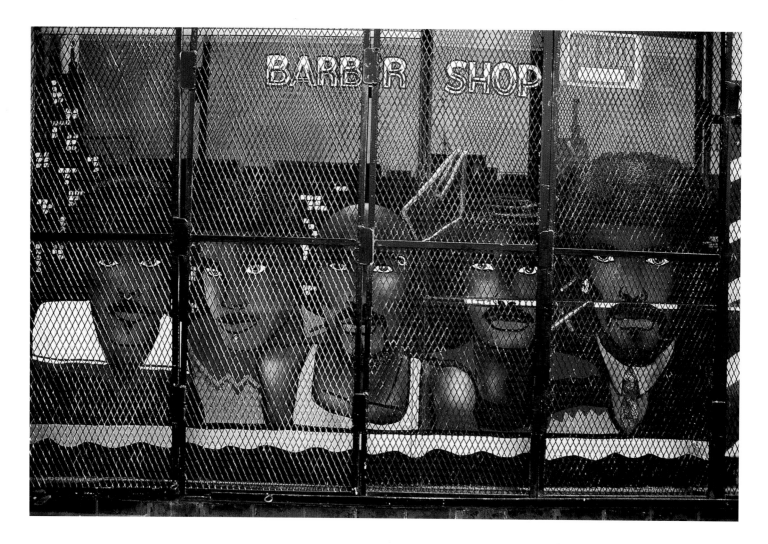

Queen Bee Exquisite Hi-Tech Beauty Salon,
47th Street, Chicago, 2000

In my search for authentic expressions of indigenous, ghetto styles of advertising, I discovered only hybrids. The signs on this beauty salon, for example, that I first took to be examples of pure folk art, turned out to be a local artist's version of images cut out from national-circulation magazines.

"Queen Bee" is a nickname given to the owner of the business by one of her employees. She tells me that she chose the hair styles for the sign from magazines and gave them to Greg, the painter, because she was afraid that, without guidance, "he would mess my window." She included the bald man in the sign because "people come here to get their heads shaven." She wanted to show people who pass by "what they do in the shop." She is proud that the place is hers, and even had her own face painted on the sign wearing a nose ring. She tells me: "I told

him how I wanted it. Greg has done other signs, but none of them looks like this."

The painting depicts six bust-length female figures, again symmetrically composed, and now behind a mesh grille. Their expressions, costumes, and hairstyles are more varied than the men's, designed to be fetching.

The companion sign, also commissioned by Queen Bee from Greg, depicts five symmetrically arranged, bust-length portrayals of young men with various hairstyles, including the clean-shaved head. Originally, the effect would have been to advertise a variety of barbershop customers whose stylistic needs could be accommodated, from the bald one at center whose undershirt suggests athletic exertion, to the man in a suit and tie at right. Yet the artist has produced a most unusual effect, with all the men

Hair styles, male. Queen Bee Exquisite Hi-Tech Beauty Salon. 47th Street east of Vincennes Avenue, Chicago, 2000.

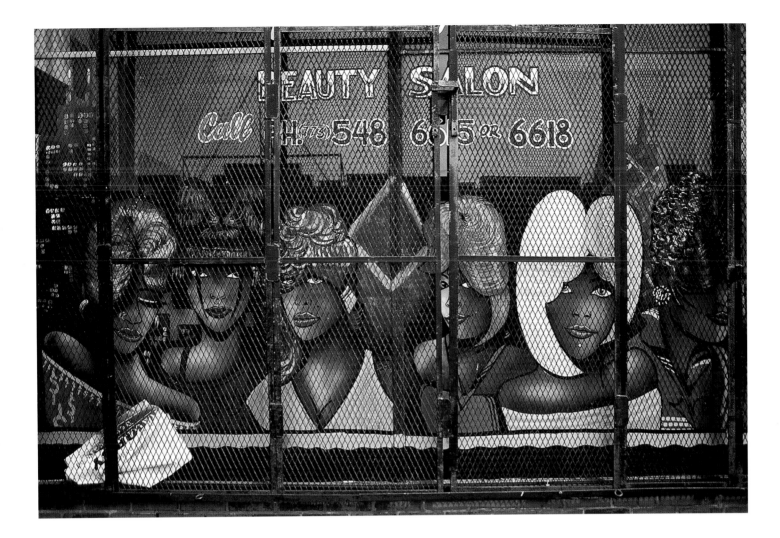

staring out at passersby, their stares accentuating
their prominent eyes. The large faces are juxtaposed
with a strip of urban background, including a high-
rise at left whose lighted windows glitter, picking up
the whites of the eyes. The result is mesmerizing.
The metal mesh protective screen suggests that these
men are trapped behind bars, evoking a reality
hardly intended by the sign painter.

Hair styles, female. Queen Bee
Exquisite Hi-Tech Beauty Salon.
Chicago, 2000.

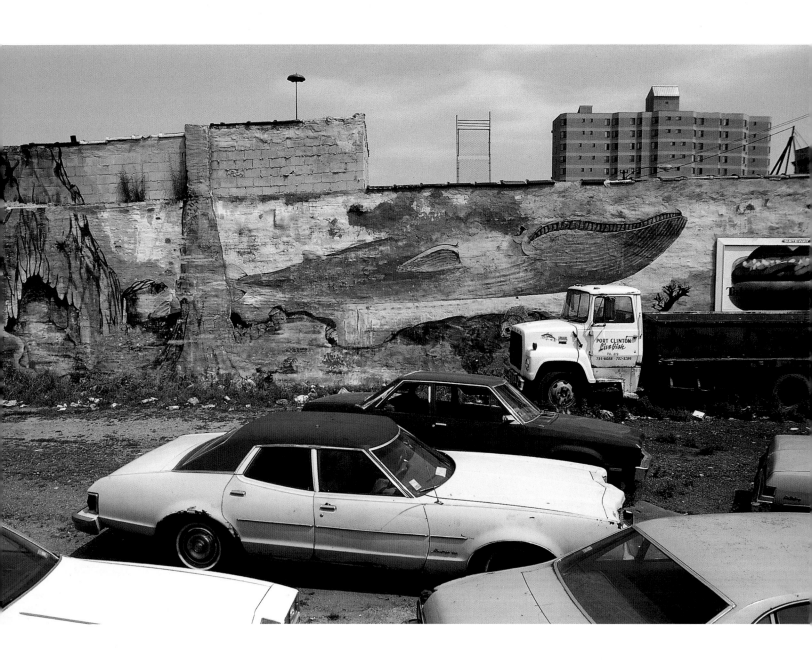

Side wall of River Slim Live Fish.
1228 South Kedzie Avenue, Chicago, 1989.

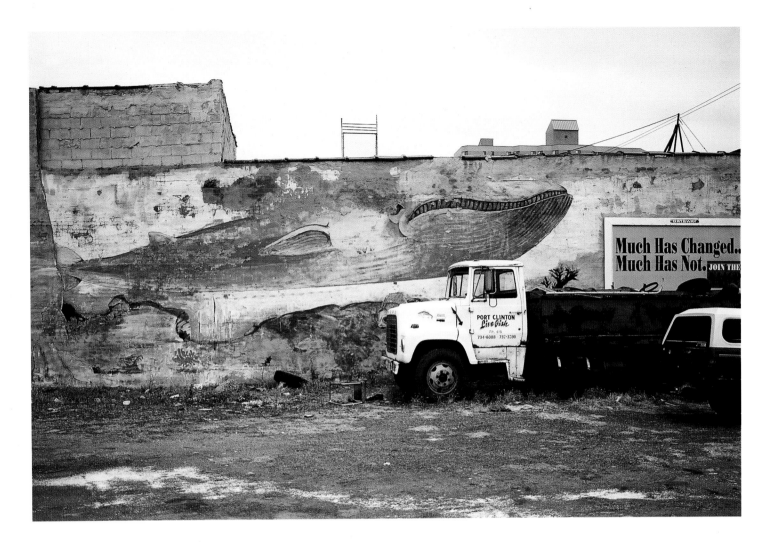

Fading whale, River Slim Live Fish,
West Side, Chicago

In the heart of deindustrialized West Side Chicago, on the side wall of River Slim Live Fish, a large blue whale was once painted. The sign was one of my favorite Chicago images. One day six years ago, I called the fish store and asked the name of the painter. Clarence, the storeowner, identified him as Mark Perrien; I asked him to have Mark call me collect in New York City. A few minutes later he called, mistakenly thinking I was going to offer him a job painting signs in New York.

Perrien had been paid $1,500 for his time, talents, and materials. Feeling ambitious, he wanted to paint the biggest creature on earth. He was disappointed at not being able to carry through on his vision: he lacked paint to add fish to accompany the whale and to give more detail to the ocean setting. There was tension in the way Perrien had conceived the huge

mammal, moving upward as if ready to break out through the top of the building.

Near the whale's head was a billboard. Over the eleven-year period during which I visited the site, the sign advertised the NAACP, hot dogs, several varieties of liquor, violent movies, afternoon talk shows, warnings to crack dealers, and hip-hop fashions. Most memorable was the sign for the NAACP, which read: "Much Has Changed…Much Has Not."

The whale changed constantly. During one visit I saw that it had lost part of its head, on another, its jaw. By the year 2000, the trees had covered what was left.

Side wall of River Slim Live
Fish. Chicago, 1990.

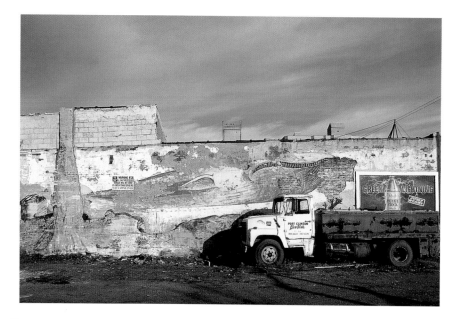

ABOVE Side wall of former River Slim Live Fish. Chicago, 1992.

MIDDLE Side wall of former River Slim Live Fish. Chicago, 1997.

BELOW Side wall of former River Slim Live Fish, Chicago, 1999.

ABOVE Side wall of former
River Slim Live Fish.
Chicago, 2000.

BELOW Side wall of former
River Slim Live Fish.
The painting of the whale has
been completely effaced.
Chicago, 2001.

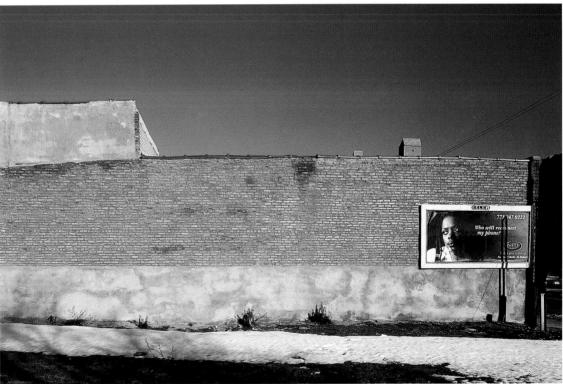

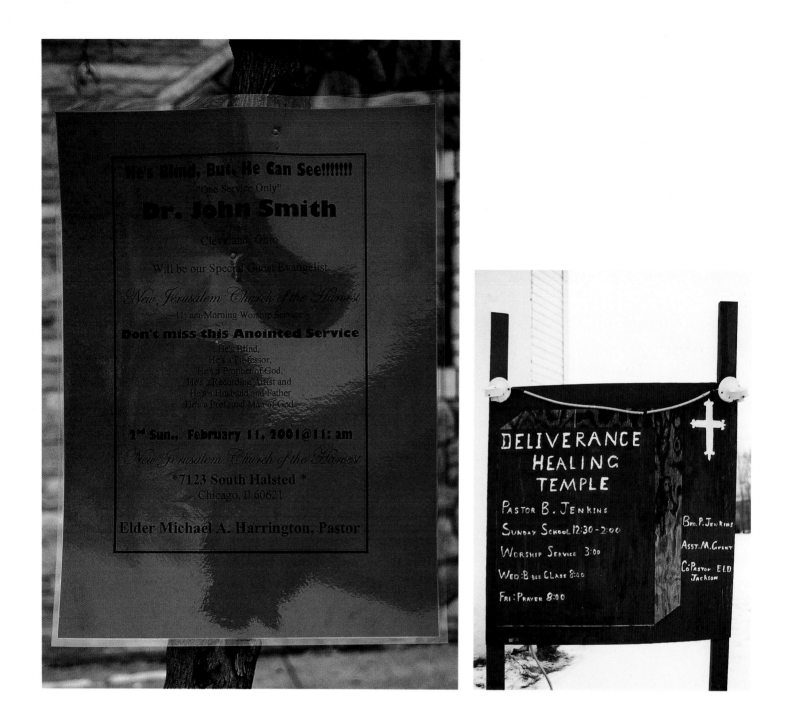

LEFT Sign on a tree. 7123 South Halsted Avenue, Chicago, 2001.

RIGHT Sign, Deliverance Healing Temple.
South Lafayette Avenue near 57th Street, Chicago, 2001.

LEFT A traditional depiction of Our Lady of Guadalupe has been painted over the Romanesque entrance to Thalia Hall, a theater built in 1893, and combined with graphics reminiscent of the Continental Airlines logo—a mind-bending merger of design styles. The Pilsen area, once the social and political center of the Bohemian community, is now a vibrant Mexican neighborhood. 1807 South Allport Street, Chicago, 1999.

BELOW Jesus and his Apostles crossing the Jordan River. Mural by a teenage member of the congregation of Angels All Nations Spiritual Church. Garfield Boulevard west of South Normal Avenue, Chicago, 1992.

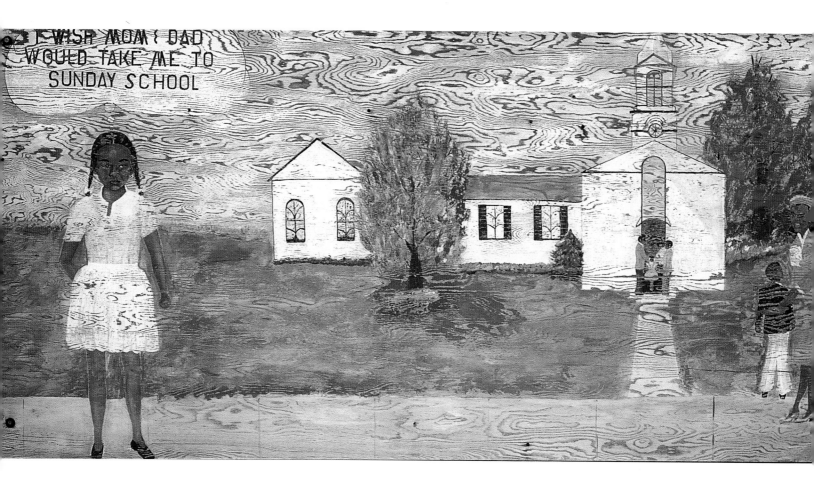

"I wish Mom and Dad would take me to Sunday school," Gary, Indiana, 1985

This fading, folk-art-style billboard beside a road depicts an African-American girl in a white dress standing on a sidewalk at the left, facing us. Behind her at right, in the near distance, is a simple white church, separated from her by a green lawn. The sky overhead is chalky white, painted thinly so that the wood grain of the board support shows through. At far right, a mother and her son approach the lane that leads back to the church; clearly they are on their way to attend service. In the church doorway stands the pastor, socializing with a father and his daughter, who are filing out of the previous service. Above the head of the solitary girl at left is a white message balloon, containing her thought: "I wish Mom and Dad would take me to Sunday school." The girl cannot go to church by herself; she needs an adult family member to mediate. It is a powerful image of loneliness and desire.

Sign, Holy Bethel M. B. Church. "We were having Bible school; that is why it was there," said the pastor's sister, Virgie. "About ten years ago a car run into the sign and knocked it down," she added. 810 West Eighth Avenue, Gary, Indiana, 1988.

Mural by B. Walker depicting St. Martin Luther King crucified.
South Side, Chicago, 1980.

Postscript

My mind is full of grand images of Chicagoland. The distant lights of the city on a dark night as one looks west across Lake Michigan have an amber glow, suggesting resurrection. As portrayed in the black-and-white photographs of the 1950s by Harry Callahan, the passersby in the sunny Loop at noon have the solidity of iron, as if the city had given birth to a new race of humans. Sociologist William Kornblum describes children of the 1930s and 1940s carrying buckets of beer home from the local taverns for their fathers' refreshment after a day working at the South Chicago steel mills. No glass was needed; the men would drink straight from the bucket. In the stillness of Gary's entropic present, I miss the industrial hubbub of the city I visited in the late 1960s. Its foul smell, dense, eye-smarting smoke, and crowded, sinister streets both attracted and repelled me.

I found inspiration in William Cronon's *Nature's Metropolis: Chicago and the Great West*, a book that vividly re-creates Chicago's spiderweb of railroads and waterways, the latter with hundreds of Great Lakes freighters carrying iron ore and coke to feed the steel mills and grain to feed the eastern markets. Of the legendary Union Stockyards, only the entrance arch remains. During his visit there, Rudyard Kipling commented: "They were so excessively alive, these pigs…and then they were so excessively dead." By the time I first visited "Porkopolis," it, too, was dead, leaving behind an enormous hole and later an equally enormous empty lot. Nowadays the fabled stockyards are mostly truck depots, semi-trailer parking, and great stacks of shipping containers renamed "Intermodal Transportation Center."

The images I found most memorable were of an expanding Chicago. My challenge was to produce similarly memorable images of decline. I photographed the Rust Belt clashing with the new economy, as if they were two tectonic plates. The neon sign of Harrah's Casino at Buffington Harbor (Gary), for example, glitters against perhaps the largest concentration of ruined steel mills in the world. People who have written about the area refer to the mills at sunset—how their matte metallic surfaces absorb the light and reflect it as a yellow-orange glow, made even more intense by the haze through which it passes.

Samuelson and I were exploring the identity of a Chicagoland that "has the wrecker breathing down its neck." We didn't know the form our project would take, yet we felt that it would shape itself as we went along. We imagined ourselves banished from Chicago, pictured the places to which we would long to return, and asked in each case what was the nature of their attraction. We wanted our work to flow spontaneously and hoped that our enthusiasm would be communicated to our audience. I had the wild hope that by adding color, local voices, time-lapse photography, and Samuelson's gift for metaphors, we could do for Chicagoland what Eugène Atget had done for Paris. I admire Atget's exquisite early-morning images

of a disappearing city at the turn of the century. How was it that pictures representing wells and narrow alleys, fragments of a medieval past, endangered professions such as street vendors, and quaint storefronts became iconic?

A photo editor who was working on a large documentary project about Chicago criticized our approach. "Whose Chicago is this?" she asked. I understood her to mean we had no right to claim the city. A foundation official to whom we applied for support asked about our sampling techniques to ensure that our presentation of the city was real, not bogus. A sociologist asked why we didn't approach residents of nearby Rust Belt communities for their own list of landmarks to document.

I replied that we were constructing out of fragments a region that, we hoped, would scream "Chicagoland!" Our choices came from our guts, from what took us by surprise and gave us delight or sadness. I argued that for decades we had walked streets, driven through alleys, entered abandoned buildings, and talked to many people—those who could hardly articulate a word as well as some of the most eloquent urban experts in the nation. I wanted to say that we had earned the right to do this book.

We briefly discussed the possibility of asking the public (through newspaper and radio spots) for their own versions of "Unexpected Chicagoland." But we

Blinking stars meet rust: Harrah's Casino, a new neighbor to abandoned and semiabandoned steel mills and oil refineries. In this area by Lake Michigan, industry existed for a century and now is coming to an end. View north from Buffington Harbor, Gary, Indiana, 2001.

decided it was more important to produce a study stamped with our own personalities, even if it meant missing significant sites. We did, however, benefit from several slide presentations before completing the manuscript. Members of the audience approached me to say what they liked and disliked about the project, and thus I learned which themes and images made the strongest impact.

Our choices encompass a period of a century and a quarter, most of Chicago's lifetime. They include a wide variety of buildings, objects, and landscapes, and they reflect the culture of most of the city's ethnic groups. The people we spoke to, the books we read, the sights we saw, and our own preferences and abilities guided our choices. The grime of Chicagoland is on the soles of our shoes.

The preliminary photographic survey of every site and object was a simple task. But since the people we interviewed offered contrasting views of our subjects, I often had to rephotograph the sites at a different time of day, sometimes using a flash. Some buildings needed to be shown in their neighborhood contexts, others required views of their interiors, some needed details, and others had to be photographed in winter after the leaves that covered them had fallen.

We were not surprised that our sites brought different responses from different people. The Meyercord Company office in Chicago, a building that helped define the Art Moderne style, struck its owners as just "an old building that resembled a bomb shelter." To the Italian architect Fabrizio Lepore, on the other hand, the promotions for Jim's, a place that sells Chicago's best hot dogs, reminded him of the profusion of signs in Naples. To their neighbors, other sites were even invisible. The elegant 1891 neomedieval entrance to a now-demolished Chicago apartment building by Louis Sullivan had never been noticed by the manager of the porno shop next door, even though he walked by it every working day.

Finally, some consensus emerged on the desirability of turrets. To children living in public housing, a turret was like the bell tower of a nearby church. "It is there for decoration," one told me. To an architectural critic, it evoked a defensive position: "In medieval castles, soldiers poured hot oil down from the turret onto the invaders, and it still symbolizes domestic security." Nefertiti, a merchant operating in Chicago's West Side ghetto, regards turrets as "the focal point of power, the first thing one sees when one approaches the store."

The remains of Carroll Hamburgers in Gary was seen by one of its former owners as an eyesore, while to us it was a vision of a once-futuristic building in ruin. On a later visit, after looking at the shoddy building against the white snow, we decided we had been fooled. Why was this ruined franchise sending contradictory messages? If different images of the same building gave opposing impressions, what did this say about our judgments? We expected other people to offer inconsistent views of the sites but assumed the stability of our own perceptions. This was not always the case.

Whose visions are these? When I started *Unexpected Chicagoland*, I saw the project as reflecting our private perceptions, an undertaking perhaps diminished because of its lack of an explicit social purpose. Yet residents' reaction to the photographs convinced me otherwise. People showed interest in the way our images made visible the combination of change and permanence in their surroundings,

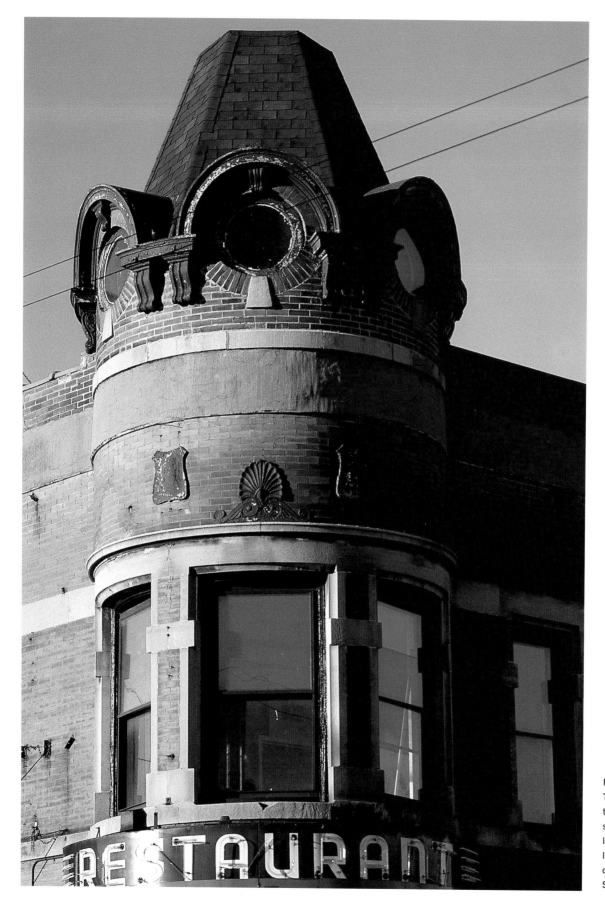

Former Schlitz saloon.
The Schlitz Brewing Company
typically bought the land for a
saloon, built the building, and
leased it to an operator who
lived upstairs. Southeast corner
of Broadway and Winona
Streets, Chicago, 2000.

reconnecting them with their almost forgotten pasts and strengthening their sense of identity.

Upon seeing two of my photographs, Arthur Williams, the manager of Paul's Snack Shop on 16th Street and South Pulaski Road, commented: "Here is a place on the West Side of Chicago that still exists. The store has not been burnt or wrecked." He added: "We used to see that tower. What was I doing when that tower was still there? Life passes so fast, you don't realize it sometimes. . . . What have I done since then? The corner is still here." Through images, Arthur could clearly explain to a younger man what the community had been like. "When I was raised around here there were trolley cars. Who talks about it now? You can't see them," he says. The photo of a fish market reminded Arthur of his life before the market was demolished, and of the preacher who owned it. Arthur's involuntary reminiscences, inspired by my photos, reminded me of *Remembrance of Things Past*. I was impressed by the intensity of his recollections, but even more by the fact that his feelings had little to do with the images that evoked them. He was experiencing a Proustian moment, groping for experiences that were just beyond the level of consciousness and fearing their loss. The tension animated him.

"People always enjoy seeing photographs of their buildings or their neighborhoods, and often they want copies," Samuelson commented. "When I make contacts this way, I am always remembered the next time and always welcome. They are surprised and proud that someone is interested, and that their community has something special. . . . If you just show up and look at the buildings you are generally regarded with suspicion. You look unfamiliar. People believe you may be involved in something detrimental to their well-being. You may be a building department inspector or a policeman. When you produce an old photograph of a building, it immediately shows that your interest is out of the ordinary, it shows the building in an earlier incarnation, seeming familiar but very much removed." Samuelson's photographs were taken before most local residents were born. Seeing them, people learned about the history of the city and came to appreciate their surroundings more.

For sculptor Ray Mozoliauskas, our images of Chicago reveal a history that includes him and other Lithuanians. He likes seeing the old bridges, cemeteries, streets, and churches, because "this is the heart of Chicago." Mozoliauskas dismisses as "propaganda" books that show "the Picasso sculpture, the lake, McCormick Place, the skyscrapers, the water tower, and the Loop," places that reflect the lives of the "big fancy fellows."

Often, after looking at images of their neighborhoods, local residents showed their interest by asking to see the rest of my photographs. Their comments revealed invaluable familiarity with the places I had shot. Chicagoland has been theirs for decades. In contrast, planners, architects, and historians were more distant, and used vague words to describe the photographs. They found them "evocative," "poetic," representative of the region's "character." Some told us they had grown up in places much like these.

NO TABULA RASA

I envisioned places where the toxic "Home air" as quoted from Jean Shepard was redeemed by the return of vegetation, animals, and birds. These are urban areas in transition, where elements of industrialism that once thrived are still being preserved amid nature's takeover, with its gradual decontamination. In Chicagoland, the pattern is to start anew, from scratch. Officials who clear metallic jungles and their surrounding neighborhoods threaten to erase history in the process.

As examples of successful reclamation projects that inspire the imagination—instances, that is, of "the industrial sublime"—landscape architect John Beardsley cites the pioneering Gasworks Park in Seattle and the two-hundred-hectare site of the former Duisburg-Meiderich steel plant in Germany, now Landscape Park Duisburg North. In the latter, "the furnaces appear like craggy mountains glimpsed through a forest." Chicago has many factories converted into lofts and a few examples of extensive restoration, the most important of which is now in progress in Pullman. The tower of the former Sears, Roebuck and Company headquarters has been preserved and is now surrounded by new family homes, while the entrance to the former Union Stockyards stands alone in a parking area covering hundreds of acres. Yet so far there is nothing here like Gasworks Park. It sits on the crest of a hill on the shore of a beautiful urban lake, a power plant

Remains of the Woodlawn Methodist Church on Minerva Avenue and 64th Street, Chicago, 1998.

stripped down to its guts, showing its pipes, tubes, and tanks. Even though the ground underneath is one of the most toxic sites in Washington state, the park is a very popular place. Graphic designer Art Chantry remarks of it: "They kept this eyesore rather than tearing it down, surrounding it with greenery, and let its rust take over. It looks like a sculpture."

SMITHSONIAN OF DECLINE, OR THE SMIZONEAN MUZEUM OF POVERTY

In my book *American Ruins* (1999), I proposed the creation of a Smithsonian of Decline. This museum would tell the story of America struggling to live with obsolescence; with wasted, broken things; and industries, businesses, neighborhoods, and objects that have lost out and are being erased from history. This book is meant to be an addition and a corrective to that great but relentlessly upbeat and incomplete Washington, D.C., institution. The Museum of the Eternal American Present: a place where a few carefully chosen artifacts are preserved in pristine condition, while others are scrapped, and the buildings that housed or supported them are left abandoned or demolished. Baltimore preservationist Eric Holcomb sent me a photograph of a sign that he took across the street from the ruins of the former Flag Court House Project in Historic Jonestown in East Baltimore. Spray painted on a piece of plywood and placed on an abandoned row house, the sign read: "Future Site of the Smizonean Muzeum of Poverty."

Sign on an abandoned row house announcing: "FUTURE SITE OF THE SMIZONEAN MUZEUM OF POVERTY." Reading it, I felt that someone had heard my call. 1001 block of East Baltimore, Jonestown, Baltimore, 2001. Photo by Eric Holcomb.

I interpreted this message as an outraged and ironic denunciation of the ghetto, but also as confirmation of the defining character of these landscapes. Here in *Unexpected Chicagoland*, as in my whole quarter-century project of documenting the United States of the poor, I have tried to tell the other side of the story of American economic growth, innovation, and technological power. I have photographed struggling urban environments to prevent our forgetting what these places looked like, how they changed, what residents did to adapt to their surroundings, and what they thought of the results. Out of fragments a city emerged: Chicagoland—the eroding metropolis between the covers of a book.

Rust Belt communities are the only repository of the history of deindustrialization. Never before has so much that was so productive been rendered so useless. Here we experience sadness, but it is mixed with what the German Romantic writer Heinrich von Kleist called "the extraordinary beauty of things that fail."

I felt at home inside the small bathroom of Frank Lloyd Wright's
Wynant House. Amid collapsing walls and rusted light fixtures, I saw
my reflection in the faded mirror on the medicine cabinet: a passing
ghost inside the ruins. Gary, Indiana, 2000.

Nobody Ever Tried to Sell Me a Dead Pigeon

What pushes me to look for a world of purity and innocence in places that are polluted and devalued? Why have I spent most of my adult life searching for enchanted forests in the backwaters of urban America? Because in the midst of dereliction I have found happiness, sometimes even a trancelike state. In feeling a weighty silence, I desire to embrace the world. I survey America's ghettos in search of future sacred spaces, asking, as Louis Aragon did in his "Preface to a Modern Mythology" in *Le Paysan de Paris,* "Will I have a lasting feeling of the wonder of daily life?" I cherish the freedom of places where nothing is for sale, places where nobody has tried to sell me so much as a dead pigeon.

I like the company of those who live in abandoned buildings and of caretakers of wasted and broken things. I enjoy places strewn with consumer goods that have fallen to pieces; ads for products that have long ceased to exist, plants that grow wild, birds that startle me with their sudden flight, and the packs of stray dogs that find shelter among ruins. I collect objects from abandoned houses, derelict factories, and inner-city resale shops to decorate my home.

As an adult I encountered the world of my childhood in the writings of Fray Luis de León, William Wordsworth, and Henry Thoreau. Today I cherish mountains, fields, and streams left almost untouched by humans, yet they are memories that have lost much of their reality. Only in American "plundered paradises," where nature comes together with the creations of industry and commerce, have I found my true home. As the ecology of one place is degraded, nature emerges in another. The Midwest rust belt, with its mixture of rivers, vegetation, and the leftovers of industrialism, is now the equivalent of the Andes and the Pacific Ocean of my youth.

Top Hat Shoeshine. For political scientist Marshall Berman, the inspiration for the sign came from comic books. The image is that of "Mr. Big, the racketeer," he said. "Look at the cufflinks; look at the ring." Inside the store, a sign reads: "Black Man, why do you spend 100% of your money with white people?" South Racine Avenue and 83rd Street, Chicago, 1998.

Acknowledgments

"The magic hand," a sign painter's mark. Car wash, Roosevelt Road
and Sacramento Avenue, Chicago, 1997.

As I travel through the nation's cities, I keep looking through junkyards for rusting and decomposing tractor-trailers, part of the fleet of Dallas and Mavis Forwarding Company. For most of his life, my former father-in-law, Charles Mario Pieroni, the Maecenas who supported my work for almost two decades, ran that company. Dallas and Mavis thrived at the business of moving cars and heavy machinery to and from Chicago, Gary, Detroit, Benton Harbor, Hartford, and many other cities. Charlie's aesthetic differs greatly from mine. He could not imagine why I was interested in run-down cities, since his artistic preferences run to views of Portofino and shapely nudes. Yet, with remarkable generosity, for two decades he covered the shortfall in our family budget and allowed my work to continue. And, most generously, he likes and praises the books that came forth from his support.

My former wife, Lisa Vergara, an art historian, helped me describe what it was that I found so extraordinary in the images I was always bringing home. Sunny Fischer, director of the Richard H. Driehaus Foundation, provided financial support for this project and on occasion even a place for me to stay in her home. Her hospitality and that of her husband, Professor Paul B. Fischer, made my visits to Chicago very pleasant. Without their encouragement and support, this book would have never been completed. Bonita Mall of the Chicago Architecture Foundation (CAF) took Tim Samuelson and me under the sponsorship of her organization, channeled funds to us, and worked with me preparing a traveling exhibition on the same subject. She was friendly and full of good advice. At CAF we were also generously helped by Zurich Exposito and Allison Krier. My friends in academia, in particular Marshall Berman and Robert Fishman, patiently answered my questions, looked at my photographs, and recommended books. Graham Shane and David Smiley of Columbia University, Timothy Gilfoyle of Loyola University, and James Dickinson of Rider University made valuable comments on my work. Historian James B. Lane of Indiana University Northwest added precision to my descriptions of the local industrial landscape. Professor Sudhir Venkatesh of Columbia University and author Jamie Kalven helped me with the complexities of high-rise public housing in Chicago. Bill Ganley and Sam Guard shared with me their practical knowledge of the region. Arthur Williams of Paul's Snack Shop offered colorful opinions on turrets. Christopher Meyers, a northern Indiana preservationist, guided me through Gary and Hammond. Fabrizio Lepore, an architect, made insightful contributions. Eric Holcomb called to my attention Baltimore's "Smizonean Muzeum of Poverty" and provided me with his own photographs of the sign. Julie Lasky patiently listened to my early efforts to describe what this book was about and edited parts of the manuscript, vastly improving the clarity of my writing. Marc Favreau, our editor at The New Press, was helpful, patient, and respectful of our voices. He made the text lean and raised funds to support this book. Leda Scheintaub gave exceptional care to guiding this book through the complex final stages, and Thomas Whitridge made design great fun. To all these friends I am grateful.

A woman and her grandchildren passing the A&F Meat Market on
Martin Luther King Drive and 61st Street. Chicago, 1999.

Selected Bibliography

In this book I have brought together ideas about both the American wilderness and the American city, combined with inspiration from surrealist writings penned in Paris in the 1920s and from the essays and notes of Walter Benjamin. I have gleaned information about objects and structures from the things themselves, from guides to Chicago, from maps and architectural magazines, and from local residents whose comments revealed their long familiarity with such places.

I found few writings dealing with the form that deindustrialization has taken in Chicago. Urban historian Robert Fishman offered the following explanation: "Most of history is about the rise of something. There is a bias toward expansion, and our society is blind to anything that is declining."

Aragon, Louis. *Le Paysan de Paris*. Paris: Gallimard, 1926. Especially, "Préface à une Mythologie Moderne."

Atget, Eugene. *Atget's Paris*. London: Thames and Hudson, 1993.

Beardsley, John. "A Word for Landscape Architecture." *Harvard Design Magazine* (Fall 2000): 58–63.

Benjamin, Walter. *The Arcades Project*. Trans. Howard Eiland and Kevin McLaughlin. Cambridge, Mass.: Belknap Press of Harvard University Press, 1999.

Bluestone, Daniel. *Constructing Chicago*. New Haven, Conn.: Yale University Press, 1991.

Breton, André. *Nadja*. Paris: Gallimard Folio, 1964.

Boym, Svetlana. "Nostalgia, Moscow Style." *Harvard Design Magazine* (Winter–Spring 2001): 4–12.

Buck-Morss, Susan. *The Dialectics of Seeing*. Cambridge, Mass.: MIT Press, 1991.

Bunnell, Peter C. *Harry Callahan, 38 Venice Biennial*, United States Pavillion. New York: International Exhibitions Committee of the American Federation of Arts, 1978: 58, 59, 60.

Cronon, William. *Nature's Metropolis: Chicago and the Great West*. New York: W. W. Norton, 1991.

———, ed. *Uncommon Ground: Rethinking the Human Place in Nature*. New York: W.W. Norton, 1995. Particularly the essays by William Cronon, Anne Whiston Spirn, Jennifer Price, and Kenneth R. Olwig.

De León, Fray Luis. *Poesías Escogidas de Fray Luis de León*. Mexico, D.F.: Editorial Pax México, 1976.

Geertz, Clifford. *The Interpretation of Cultures*. New York: Basic Books, 1973. Especially chapter 1, "Thick Description."

Gunther, John. *Inside U.S.A.* New York: Harper and Brothers, 1947. Section on the Midwest.

Hirsch, Arnold R. *Making the Second Ghetto: Race and Housing in Chicago, 1940–1960*. New York: Cambridge University Press, 1983.

Hunter, J. Paul, ed. *The Norton Introduction to Poetry*. 3d ed., New York: W.W. Norton, 1986. Poems by William Wordsworth.

Lane, James B., ed. *Steel Shavings: Shards and Middle Heaps*. Vol. 31. Gary, Ind., 2001.

Moravánszky, Ákos. "The Visibility of Monuments." *Harvard Design Magazine* (Winter–Spring 2001): 44.

Proust, Marcel. *Le temps retrouvé*. Paris: Gallimard Folio, 1989.

Public Works Historical Society. *Chicago: An Industrial Guide*. Chicago, 1991.

Schwartzer, Mitchell. "The Spectacle of Ordinary Building." *Harvard Design Magazine* (Fall 2000): 13–19.

Shepard, Jean. *In God We Trust: All Others Pay Cash*. Garden City, N.Y.: Doubleday, 1966.

Sinkevitch, Alice, ed. *AIA Guide to Chicago*. New York: Harcourt Brace and Company, 1993.

Venkatesh, Sudhir Alladi. *American Project*. Cambridge, Mass.: Harvard University Press, 2000.

Vergara, Camilo José. *American Ruins*. New York: The Monacelli Press, 1999.

Broken fragment of a face, one of two that decorated a modest
commercial building on Ogden Avenue, west of Trumbull Avenue.
Marshall Berman is reminded of King Oedipus: "It was once grand
and glorious, but got destroyed, yet Oedipus still has a nose to
breathe and a mouth to declare. He is still alive." Chicago, 2001.